RKABLE TREES

ca · Thomas Pakenham

WALKER & COMPANY ✹ NEW YORK

For Ross and all the Baileys —
Barbara, Prospero, Anna,
Beezy and Nicci — who made
these journeys possible and this
book a pleasure to create.

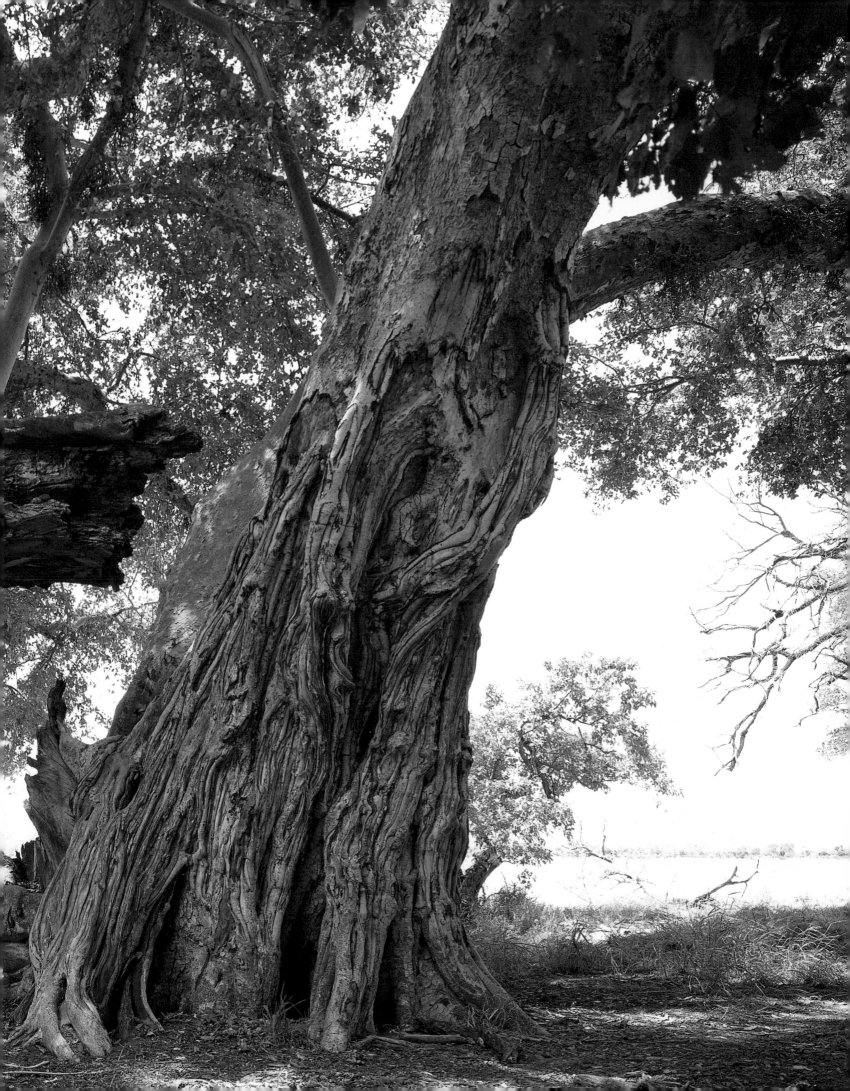

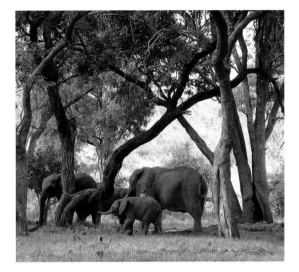

IN SEARCH OF REMARKABLE TREES

On Safari in Southern Africa

Text and photographs by THOMAS PAKENHAM

IN SEARCH OF REMA

On Safari in Southern Af

Contents

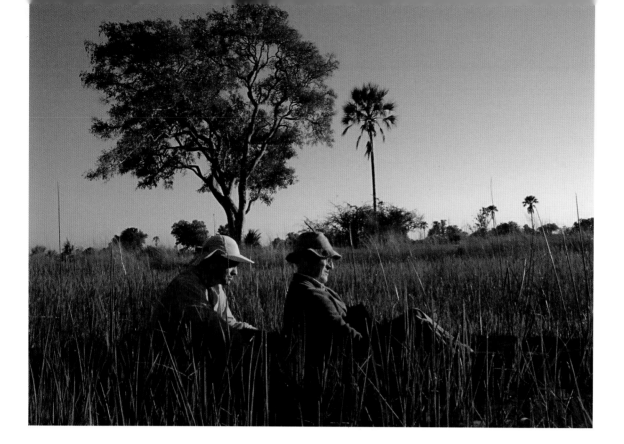

Introduction

HERE'S THE THIRD — AND PERHAPS FINAL — VOLUME OF THE SERIES launched with *Meetings with Remarkable Trees*. It's eleven years since I began on that journey and my luck, like the trees, has been remarkable. I struck a chord with the public. 'You speak for the trees', said one letter from America. Oh what flattery. If only I could.

My idea of a new book on trees had astonished my publishers. What did I know about trees? I was a historian, not a botanist or dendrologist. What could I say that the experts had not already said better? But that was not my idea. My book would not help you identify trees, let alone cultivate them. It might make you more aware of them, even help you better enjoy them. It would be a personal, quirky kind of book. I would make an arbitrary selection of about sixty individual trees (or groups of trees) — many of them very old and some very large. A few would be famous, others completely unknown. But all would have strong personalities. They would all be what I came to call 'wow-trees'.

Above: Exploring the Okavango Delta, Botswana, in a dug-out canoe. I was in front when we surprised a hippo.
Below: Dug-out canoes at Oddball's Camp in the Okavango Delta.

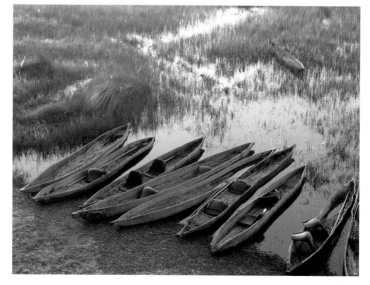

That was the plan. For the first volume I confined my hunt for trees to the territory I knew best: Britain and Ireland, where I live. Then I spread my wings and widened the angle of my lens — zoomed out, as photographers say. In the next four years I was free to roam the world, from the Rocky Mountains of north America to the volcanic island of Yakushimu off the coast of Japan. Of course I barely skimmed the surface. But I hunted trees in all six continents before writing *Remarkable Trees of the World*. Now, in this third volume I have narrowed the angle of my lens once again. The book covers only one part of one continent — southern Africa — with Madagascar, irresistible to tree-hunters, thrown in. I also made a brief foray to Mauritius.

Once again it was only the surface I skimmed. (Only too literally, it seemed, when skimming over Lake Kariba in a Beechcraft with daredevil friends, flying below the height of the tops of the trees drowned by the lake.) In all, I made ten visits to southern

Photographing the Lion's tree in the Kafue flood plain, northern Zambia. The lions were watching.

Camping opposite Baines' baobabs in the Ntetwe pan, Botswana.

Africa in the last four years. I hunted trees in six African countries: Namibia, Botswana, Zambia, Zimbabwe (briefly), Madagascar and South Africa itself. I had numerous adventures, most of them enjoyable. Like many tourists, I am sure I greatly exaggerated the dangers I suffered, when facing a lion, eye-ball to eye-ball, or being chased up a staircase by an elephant. The trees were the biggest and wildest and most magnificent beasts that I saw. And of course I have only selected a fraction of them for this book.

How did I select them? This is the question people often ask, and it's difficult to answer. Size, age and historical associations were often the main criteria, as in my earlier books. But a tree may need other intangible qualities, like beauty, to make it a wow-tree. Where would I find these paragons? Obviously I began with the standard books of botany. I was also greatly dependent on friends. As a wanderer I needed help of every kind. Sometimes a knowledgeable friend would say, 'I suppose you know that huge Breonadia down by that kloof?', and I wouldn't have even heard of the species, let alone the kloof. Gradually I began to assemble a hit list of the species I found most promising. The professional botanists did wonders for me. At first we were at cross purposes. The best examples of a species from the botanist's point of view would be the most typical. For me that might actually be the worst. I wanted the most untypical, perhaps even the most outrageous example. Once my strange tastes were accepted, I became the botanists' slave. I was also fortunate to receive all kinds of suggestions from the general public — in answer to an article about my project in the South African *Sunday Times*. Many were practical and some of huge importance to me. I owe at least ten of the trees in this book to a single benefactor who wrote out of the blue.

Once I had compiled my hit list of promising trees, my wanderings began, in deserts and swamps, and on mountains. My friends performed prodigies to try to help me find remarkable trees. But in the end, chance might decide the issue. Size and age and history are not the only criteria for deciding whether this tree is a wow-tree. It might be the fall of the light or the lean of the tree that would draw my eye as a photographer. I failed with some of the best known and most photogenic trees in the region and succeeded (I hope) with some of the most obscure. I am lucky to have such excellent equipment. I remain loyal to my ancient and laborious Linhof 5x4; it's hot work when the mercury tops 40 degrees, as you have to put your head under a blanket to see the screen. But I took many of the smaller photographs in this book with a cool, modern digital the size of a mouse.

The themes of this volume overlap with the themes of the earlier books. But there is, sadly, a difference — and here I find it hard to remain detached. The threat to trees from various sources seems to be intensifying.

First, there's the destruction of trees by elephants. Too many elephants are now trying find a living in the bushveld along the line of the Limpopo on the borders of South Africa, Botswana and Zimbabwe. Culling was suspended, for good humanitarian reasons, in 1995. But the result is an environmental disaster. Trees and other animals are now paying the price for a huge surge in the number of elephants — a rise of a third in a decade. When I toured the Limpopo river valley in February

Camping beside the fallen trunks of the Dorsland trek baobab in north-east Namibia.

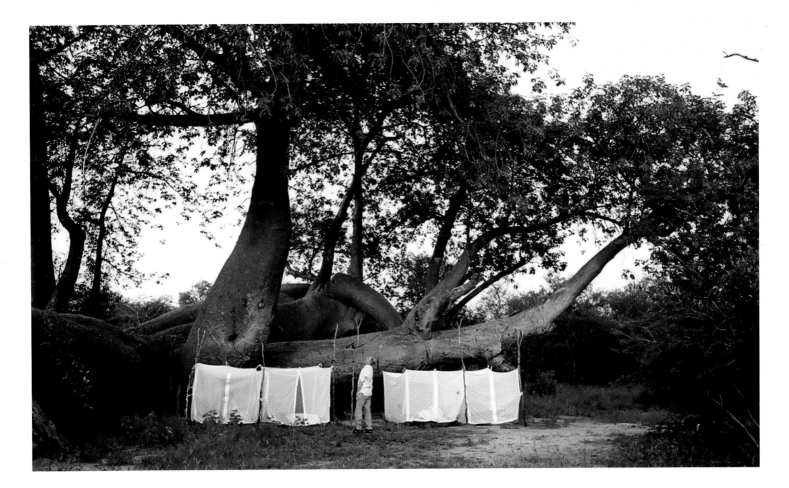

2007 I might as well have been touring a battlefield. Fever trees, shepherd's trees, sesame bushes: all the smaller and more vulnerable trees of the bushveld in this area are being upended and killed by hungry elephants. Sensible, humane culling — the same policy that is used for protecting the balance of the environment in other parts of the world — will have to be resumed. Or the place will become a desert of smashed trees and starving elephants.

Second, comes the excessive zeal shown by the authorities in South Africa towards the culling of 'alien' trees. It's ironic that a government that shrinks from grasping the nettle with elephants acts the bully-boy towards introduced trees. Some species of course, like two of the Australian wattles, are invasive. Where they threaten the environment they must be culled. But the present policy towards introduced trees — 'guests' as I call them in this book — is little short of hysterical. Famous street trees are under threat, like the jacarandas of Pretoria and Johannesburg and countless towns and villages. The celebrated umbrella pines above Cape Town are apparently doomed, either to be felled or to be prevented from regenerating. The Tokai Arboretum nearby — one of the finest collection of eucalyptus in the world — seems equally threatened. The pretext is that these species are invasive, untrue in many cases. The real motive, driven by a small number of hard-line ecologists (white 'ecofascists' they have been called), is to cleanse south Africa of its 'alien' flora — a case of a white immigrant denouncing a green one. In fact it reminds one of ethnic cleansing in the Balkans, and it's as likely to fail. You could also compare these white extremists to the Talibans. It must be sensible to try to protect and encourage native trees and other plants. Not so sensible to try to put the clock back a thousand years and destroy one of the best legacies that Europe gave to Africa.

Last, and most crucial, come the effects of global warming. Eleven years ago, when I began writing about trees, this was an idea associated with cranks. Now it's part of the

Views from the safety of a game car in South Africa. Left to right: lioness at Kruger National Park; white rhino and calf at Lesheba wilderness in the Soutpansberg; Buffalo at Kruger National Park; Zebra at Lesheba wilderness.

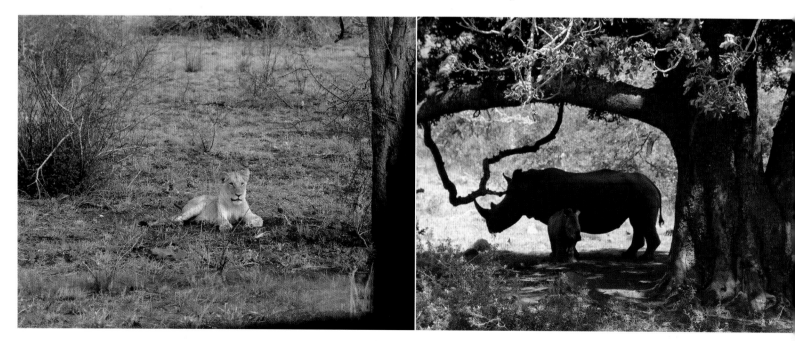

conventional wisdom. The effects are particularly cruel in southern Africa. This last decade has been famous for droughts, and one is gnawing away at the region as I write, in May 2007. Wherever I went I saw the tragic results of a climate changing for the worse. In Botswana, half the great baobabs of Kubu Island have died since I first visited the place in the 1990s. In the Richtersveld, in the arid north-west of the Northern Cape, the kokerbooms (quiver trees) are slowly dying of thirst. In Madagascar, the famous Avenue of Baobabs, an icon for tourists, is slowly failing. Of course global warming is a problem for the whole globe. But we can surely do better than merely wring our hands.

* * *

In four years of wandering in southern Africa I incurred numerous debts of gratitude to people who gave me advice and support. Many of them helped me plan my journeys and gave me hospitality. Some of them drove me, flew me or paddled me in search of remarkable trees. Here is a list of those who helped me most:

Mike and Monica Amm, Asgar and Sirine Barday, Ralph Bousfield and Catherine Raphaely and the staff of Jack's Camp, Walter Barker, Hilton and Megan Bedingham, Jim Bond, Coby Bride, John and Sandy Burrows, Alexander and Sheila Camerer, Peter and Rhona Carte and the staff of the Cavern, Gareth and Hugh Chittenden, Dennis and Mari-anne Claude, Tommy Crowe, John and Jessica Clarke, Peter Crane and the staff of the Royal Botanic Gardens at Kew, Chris Dalyell and the staff of Durban Botanic Gardens, the De Boer family, John and Sara Dewar and the staff of Megwe Camp, the staff of Durban Country Club, Lloyd Edwards, Lydia Ellis, Neels Esterhuyse, Hendrik Fehsenfeld, Jenny Ferreira, Chantelle Gazzilli, Tara and Jessica Getty, Lal Greene, Marcelle Graham, Brian and Jane Griffin, James and Elizabeth Hersov, Tana and Dave Hilton Barber, Nick Hofmeyr,

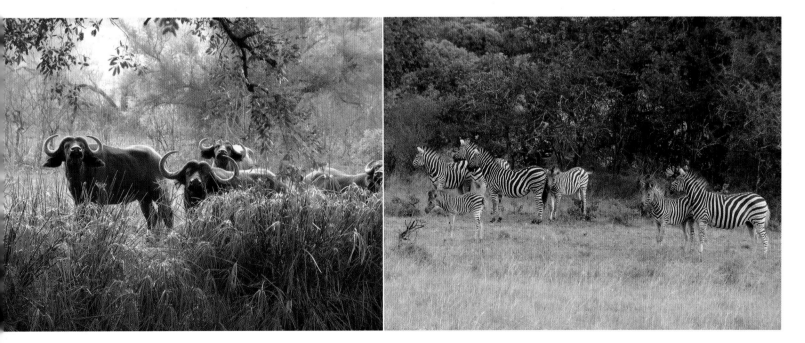

Flying to Oddballs Camp in the Okavango Delta, Botswana.

Brian and Merle Huntley and the staff of Kirstenbosch Botanical Garden, Philip Ivey, David Jeppe, Di and Michael Michael Keath, J.D.M. Keet, Ann and Gavin Hayhoe, Basil Landau, Philip Le Roux, Jabu Linden, Anton Louw and the staff of Getty House Lodge, Chellock Mabaso, Liz McGrath and the staff of the Cellars, Sfilo Madonsela, Christine Malan, Dorothy Malan, Wayne Mathews, Cathy Maunder, Izak van der Merwe, Sarah Morton, Bobby and Lionel Melunsky, Ferdi Myburgh, Geoff Nichols, François Ntoehy, Sandy and Andrew Ovenstone, Brigid Oppenheimer, Patrick Page, Dallas and Rose Reed, Jenny Robinson, Veronica Roodt, Joy Rourke, Mark Read, Joseph Sibiya, Mary Slack, Ricky Taylor, Eric Theron, Andrew Unsworth, Leigh Voigt, Tanya White, Graham Williamson.

In Ireland and Britain I depended on the encouragement of numerous friends and relations, especially the following: my sister Rachel and Kevin Billington, Christopher and Jennie Bland, David and Linda Davies, Timothy Daunt, Olda and Desmond FitzGerald, Maurice and Rosemary Foster, Grey and Neiti Gowrie, Mark Girouard, my sister Antonia and Harold Pinter, Julian and Eugenia Sands, Jacky and Julian Thompson, Daria and Alexander Schouvaloff. I owe a particular debt to three friends in Britain — Tricia Daunt, Lindy Dufferin and Nella Opperman — who came out at various times to share in my adventures.

I must single out two distinguished South African botanists — Elsa Pooley and John Rourke — who personally led me on several expeditions, and later combed the

manuscript for errors. I must thank Camilla Goslett and Jonathan Lloyd of my agents, Curtis Brown, for handling my affairs with such ability. I must also thank the staff of both my publishers, Weidenfeld and Nicolson in London and Jonathan Ball in South Africa, for taking such trouble in bringing this book to maturity. No author could hope for a more creative editor than Michael Dover. It was always a pleasure to work with him. To my South African publisher, Jonathan Ball, I owe the original idea for this book. He has sustained me in numerous ways, and — with his wife Pam — entertained me in his hideaway at Betty's Bay. I owe a huge debt to the six South African friends to whom this book is dedicated: Ross Douglas, Barbara Bailey, Prospero and Anna Bailey, Beezy and Nicci Bailey. Their hospitality was boundless, their contribution to this book incalculable. I am much indebted to my four children for their support and forbearance, especially my daughter Eliza who cast an affectionate eye at my manuscript. Finally, I must pay tribute to my long-suffering wife, Valerie. She is not herself a fanatical lover of trees. But she gave a blessing to my travels and a loving welcome on my return.

An elephant approaching us in Kruger National Park.

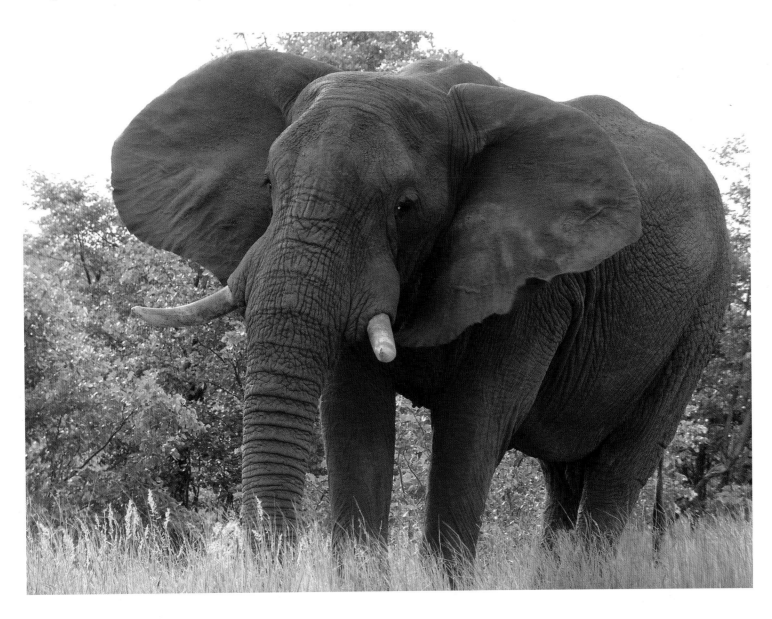

PART I

Big Beasts

A World Turned Upside Down

Baines' Magic Circle

THE AFRICAN BAOBAB (*Adansonia digitata*) is called the 'upside down tree' because its branches look like roots. It comes in every shape and size, from the comic to the sublime, from wizened giants to perfectly proportioned dwarfs. I have chosen five examples for this book, all as different as chalk from cheese. Yet they have most important qualities in common. To look at they are all stupendous trees — stunners. And we know almost nothing of their history. Scientists are baffled by the problem of how to date them, and even their approximate ages are anybody's guess.

Let me begin my safari with the unique circle of seven baobabs to which Thomas Baines has given his name.

I know how I would *like* to approach these extraordinary trees. I would come at sunset with a span of fourteen trek-oxen, as Baines, the explorer-artist, came in May 1862, and outspan my covered wagon under the bloated branches, on the gravelly ridge a few feet above the darkening salt-pan near Kanyu.

No doubt there would be a full moon burnishing the wastes of the Kalahari — a kindred spirit to that grim wilderness. Bats and owls would salute us as we lit our camp fire, and perhaps we would be honoured by the distant roar of a lion. What a camping ground for a poet or a magician. '*In girum imus nocte et consumimur igni*', as I learnt in my Latin class. (It's a magical palindrome, which means that the spell works equally well when read from either end.) '*Into the circle we go and are consumed with the fire*'. Yes, into that magic circle we go and the trees are blazoned with the flames from the camp fire.

In reality the evening when I trekked to those baobabs in July 2006 was cold and wet. The camp fire of acacia logs fizzled out and the great trees were lost in the murk.

We had driven in a battered black Toyota from Johannesburg, a trek for two days along tarmac and dirt tracks, crossing from South Africa to Botswana at Burke's Bridge on the Limpopo, and heading through the bush into the great salt-pans north of

Previous pages: *Five of Thomas Baines' seven baobabs in the Ntetwe pan, Botswana.*

Left: *An irrepressible baobab. It had fallen before Baines' painted it in 1862 and is still alive and well today.*
Right: *Meerkat eating a scorpion beside Chapman's baobab, near Jack's Camp in Botswana.*

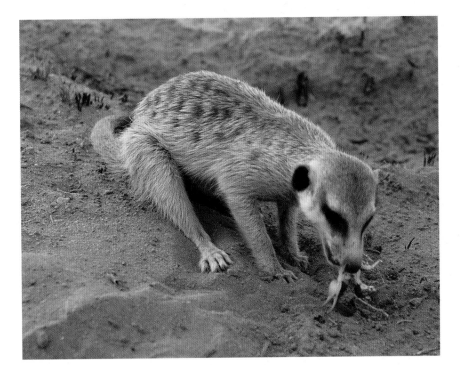

the central Kalahari. The sun finally came out on the afternoon of the second day after we had arrived. I had brought a photocopy of Baines' original water-colour, and it was striking how little had changed in 140 years. There were his seven mighty baobabs or rather there were six of them; the missing one had been replaced by a young one. The wildebeests that he had painted on the pan to the right of the trees duly appeared on cue. The continuity was astonishing. But a careful inspection showed another striking fact. The trees, with one exception, had grown by about a third in girth since Baines had painted them. The exception was the huge, bloated fallen tree on the extreme left, pushed over, no doubt, by some carefree elephant. All those years ago Baines had marvelled that this tree had survived the ordeal and was still putting out green leaves. 'One gigantic trunk had fallen', he wrote in his diary for May 21, 1862, 'and lay prostrate, but still losing none of its vitality, sent forth branches and young leaves like the rest'. In fact, it has grown no fatter since Baines wrote that, which I think is hardly surprising. How would we cope if we had been left for a century and a half with our legs waving in the air?

Baines was the most attractive of the daredevil expatriates who charted the wastes of what is now Namibia and Botswana. Unlike the others — mainly hunter-explorers like James Chapman or missionary-explorers like David Livingstone — Baines was a self-taught artist and naturalist. For fifteen years he had made a precarious living from painting the plants, animals and landscapes he encountered in his travels. Some of the plants, the extraordinary Weltwischia for example, had never been painted before Baines took his brush to them. His courage won him many admirers. He served as a war correspondent in the Eighth Frontier War, and was at one point found quietly sketching between the two firing lines. (He probably survived because he was only five foot three. Still, he had to run for his life.) Yet he was a gentle soul. He had much in common with a modern conservationist. You should kill animals with reluctance, so he believed; from necessity rather than the joy of the chase. He was also well-disposed towards the Bushmen and other Africans who accompanied him on his trips. Unfortunately he had fallen foul of David Livingstone and been dismissed from Livingstone's government-sponsored expedition to the Zambezi — falsely accused, as it later turned out, of stealing the great man's sugar and other stores in his charge. To retrieve his reputation after this bruising affair he had set off in 1862 from

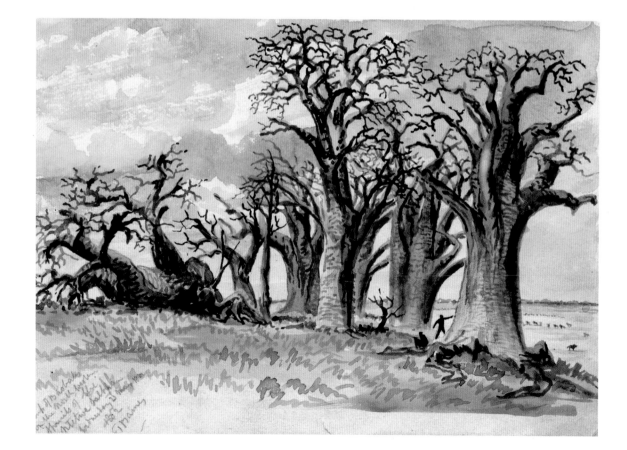

Baines' seven baobabs painted by him on May 21, 1862.

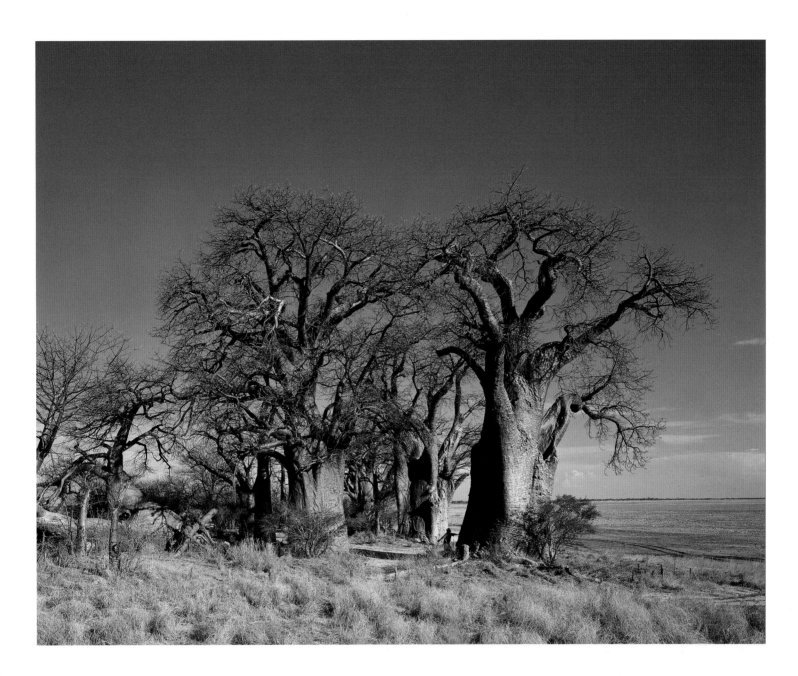

Six of Baines' seven baobabs (with one replacement) photographed from the same angle in July 2006.

Walvis Bay in south-west Africa with his friend James Chapman, the professional hunter, heading for Victoria Falls. It was this that brought the two men a year later to the mysterious circle of seven baobabs beside the salt-pan near Kanyu.

For three days we camped on the sandy peninsula opposite the great trees. When the rain stopped, the orange paperbark and corkwood quivered with elegant birds: a pair of barn owls, yellow hornbills, pied crows, a nightjar. Walking across the salt-pan to the circle of trees, we traced the spoor of a lion in the sticky clay (you can spot a lion because it retracts its claws in the pad), and there were elephant droppings the size of soccer balls. Bit by bit they would be rolled away and buried by dung beetles. But there were no big beasts visible in that vast wilderness — except the baobabs themselves.

Why the circle? At least that part of the puzzle was clear. It was the shape of the gravelly knoll where the trees had sown themselves with the help of some monkeys; or perhaps a herd of elephants had excreted the seeds centuries before. How many centuries before? Baobabs can be 2,000 years old, say some professional botanists, basing their estimates on one or two samples that were carbon-dated in the laboratory twenty years ago. I hate to be a kill-joy. But I cannot help noticing how fast these trees have grown since Baines painted them. My guess is that Baines' baobabs are at most a mere five centuries old. Still, that's a great age in southern Africa where trees grow fast and die fast. And, barring accidents, they might continue to cast their spell over the wilderness for another five centuries.

Letters from a Baobab

HALF A DAY'S DRIVE through the bush from Baines' baobabs, heading south-east to the banks of the Ntetwe salt-pan, you encounter one of the largest and most beautiful baobabs in the whole of Africa. Traditionally, it takes its name from James Chapman. But it has also been called the 'Post Office Tree'. I think I prefer the first name. Chapman liked trees. At any rate he treated baobabs with a great deal more respect than he treated elephants.

Chapman, Baines' companion on that expedition in 1862, had been gobsmacked by this same tree nearly ten years earlier — on July 10, 1852. He had set off the previous year from south-west Africa with two European companions and a large party of Bushmen and Hottentots. His ambition, fired by after-dinner tales of Boer explorers he had met in Natal, was to hunt elephants where no Europeans had hunted them before, and he expected the ivory would cover his expenses. And so it turned out. He and his party massacred about 200 elephants in the next few months; he often escaped the enraged animals by the skin of his teeth. 'My horse, terrified at the elephants thrilling cry, pulled the reins out of my hand and left me on the open plain, staring death in the face without any cover to flee to...'

His encounter with the great baobab at the Ntetwe pan in July was a good deal less harrowing. But he was unprepared for the sight as this was the first baobab he had ever set eyes on.

We were lost in amazement, truly, at the stupendous grandeur of this mighty monarch of the forest, in comparison with which the largest of hundreds of surrounding palm trees sunk into apparent insignificance. The dimensions which we took with a measuring-tape proved the circumference at the base to be twenty-nine yards. It had shed all its leaves, but bore fruit from five to nine inches long, containing inside a brittle shell, seeds, and fibres like the tamarind, enclosed in a white ascetic powder or pulp, which, mixed with sugar and water, makes a very pleasant drink... The roots spread in every direction, and where the ground is hard project two feet above the surface, running for more than 100 yards. These trees are the resort of innumerable squirrels, mice, lizards, snakes...

Little is known of the later history of the tree except that it's supposed to have served at one time as a kind of local post office. This would not be out of character for an old baobab. The cool, cavernous

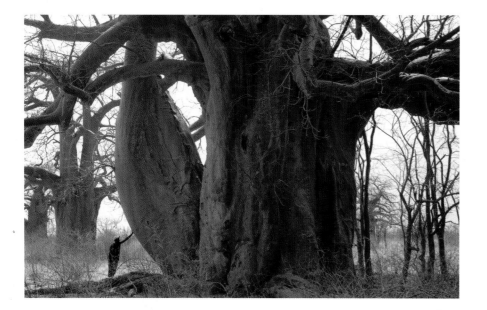

Chapman's baobab — alias the 'Post Office tree' — near Jack's Camp, Botswana. Right: Ralph Bousfield checks the mail.

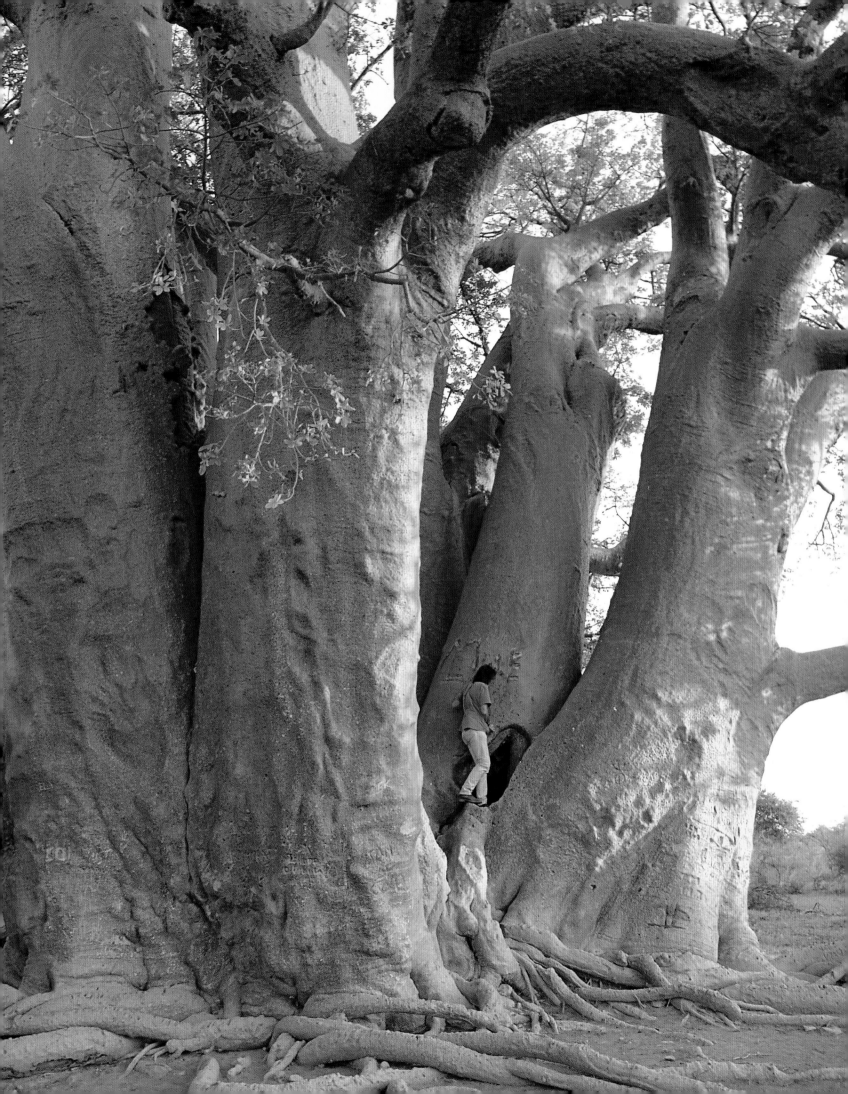

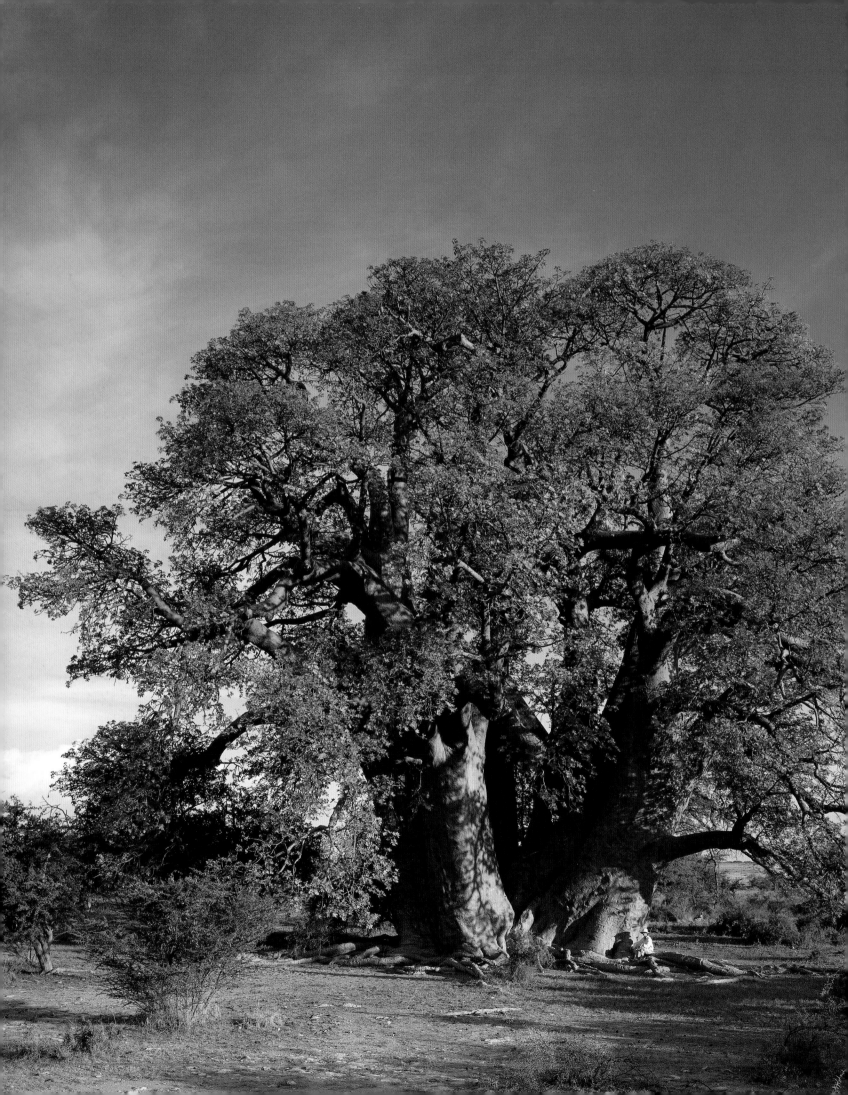

interiors of the creature make commodious rooms. In fact, I believe that, in various parts of rural Africa, baobabs have served as pubs, schools, court houses, prisons and lavatories. So why not a post office? Dare I say, a *branch* post office?

More than 150 years after Chapman outspanned close to the tree, I paid my own respects to the great beast. It was February of this year, 2007. I knew the tree from two earlier visits. (See my *Remarkable Trees of the World* and *The Remarkable Baobab*.) But a third visit was not to be resisted. With three companions I flew in a small tan-and-white Beechcraft, painted with P.J.T., for Papa Juliet Tango, from Polokwani on the east side of the Limpopo. In due course Papa Juliet Tango landed smoothly on the sandy grass beside the salt-pan. It was about an hour from sunset when we reached the tree. Yes, there was the cavity, high in one of the six trunks, where the letters must have been posted. I suppose they were collected later by the addressees. Ralph Bousfield, our guide and host, climbed up to inspect the cavity. Ralph owns the finest game camp in the Kalahari, Jack's Camp, as rich in amenities as the camp of an Indian maharajah. But communication is by wireless, and somewhat moody. I told Ralph I thought he could do with a good postal service — and duly posted a facetious letter suitable for posterity.

And Chapman was absolutely right. The tree is stupendous. Six immense trunks rise from the base, all in perfect proportion.

February is high summer in southern Africa and the tree was now in full leaf. The delicate green leaves in the shape of five fingers (this is why the species is called *digitata*) contrasted with the smooth coppery skin of the bark. It was too late in the season to enjoy the elegant white flowers, which hang down, ready to be pollinated by the local bats. But the rains had been kind. The sandy ground was littered with dead spring blooms like the corpses of small animals. The tree was also full of boisterous summer life: grey lizards, blue rollers, pied crows. Most striking, as Chapman had noticed, were the snake-like roots uncoiling in every direction. Equally striking was the damage to both bark and roots the tree had suffered since my first visit eight years ago.

I cannot guess the age of this prodigy except to say that it must be nearer 1,000 years old than 500. Its gargantuan waist measurement *appears* to be the same as it was in Chapman's day, a little under 90 feet at the base. (I say appears, as the irregularities in the trunks make accurate measurement an arbitrary enough affair.) If this is correct the tree has more or less stopped growing — a characteristic of very ancient trees.

What can I say about the damage inflicted to the tree so recently? The damage to Chapman's tree is no accident. Visitors have chopped off parts of the roots so they can picnic close to the tree. Others have honoured the bark with their names, and (I am told) may have infected it with a lethal fungus in the process. Local villagers have hacked off sections of the bark to use for building. I would have hoped that the tree would still be open for business as a post office in 500 years. Sadly, I have my doubts.

Chapman's baobab from the west. A victim of its admirers.

More Cliff than Tree

WHEN IS A TREE not a tree? When it's a cliff. The Buffelsdrift Giant rises above your head like the pink wall of a canyon, which is only to be expected, as it's one of the four largest baobabs known in South Africa.

I paid my visit on my return from the trip to Botswana to worship in Baines' magic circle. There is no magic here, but the sheer bulk of the beast knocks you flat. I have visited the other four South African competitors for the title of champion baobab of the world, and I have described them fully — not to say fulsomely. (See my book, *The Remarkable Baobab*). All have hollow interiors which have served many uses over the years. There's the Leydsdorp Giant, used as a pub during the 1880s, when the lowveld was bursting with thirsty miners heading for the Barberton goldfields. There's the Hoedspruit Monster, rising like a troll within sight of the northern prongs of the Drakensberg. And there are the two main rivals for the champion's crown: the double-trunked leviathan at Duiwelskloof (you can still buy a pint at the bar inside this tree) and the royal giant at Sagole, where the King of Venda came with his court to view the solar eclipse of 1995.

The Buffelsdrift Giant lacks at present the Tolkienian appeal of these four great beasts. But it looks like a younger tree. Who knows, it may grow into a monster yet. It's owned by a white farmer who seems to know what is best for it: benign neglect. There is no dirt road to the tree. You push your way under a barbed wire fence and follow a cattle-track through a maze of predatory thorns. Then the vast pink cliff blocks the blue sky.

I spent a happy morning exploring those cliff walls. Did I say that the tree lacks the appeal of one of Tolkien's monsters? I must swallow my words. The runic designs on the cliff walls would make a perfect backdrop for Sauron's evil lair.

Right and following pages: *The Buffelsdrift baobab, one of South Africa's Big Five, near Swartrivier in Limpopo Province.*

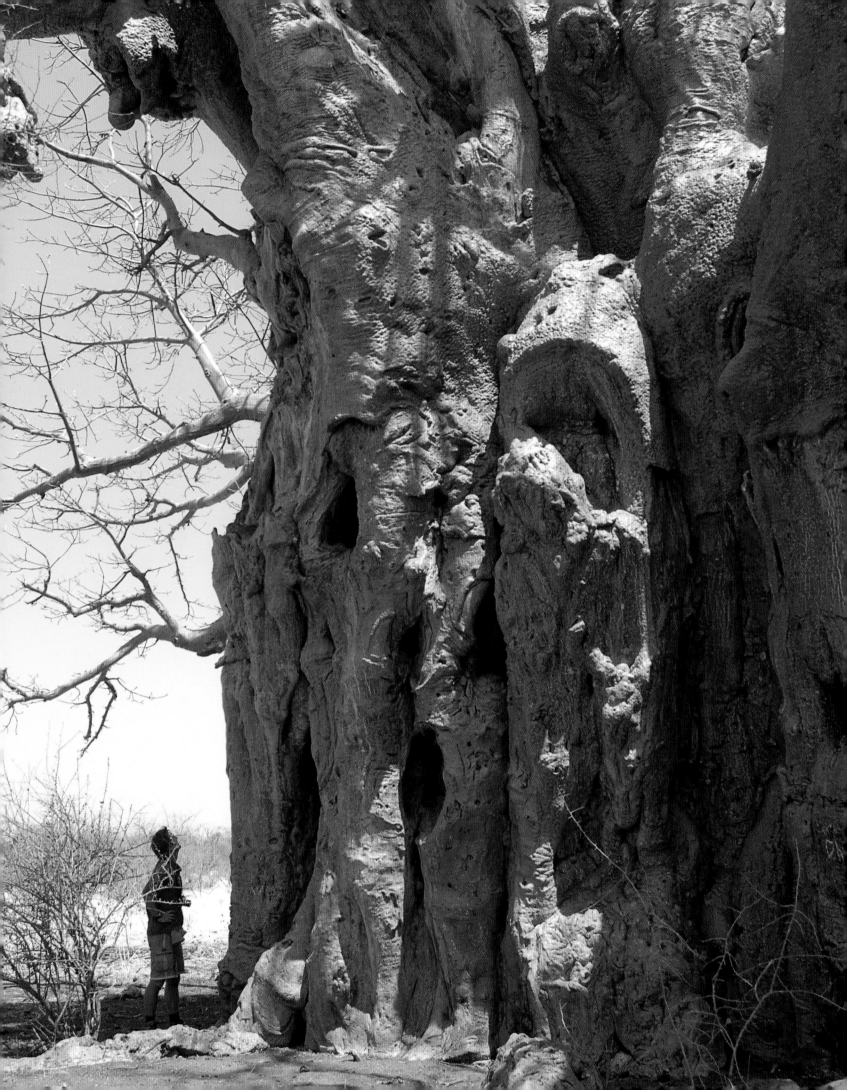

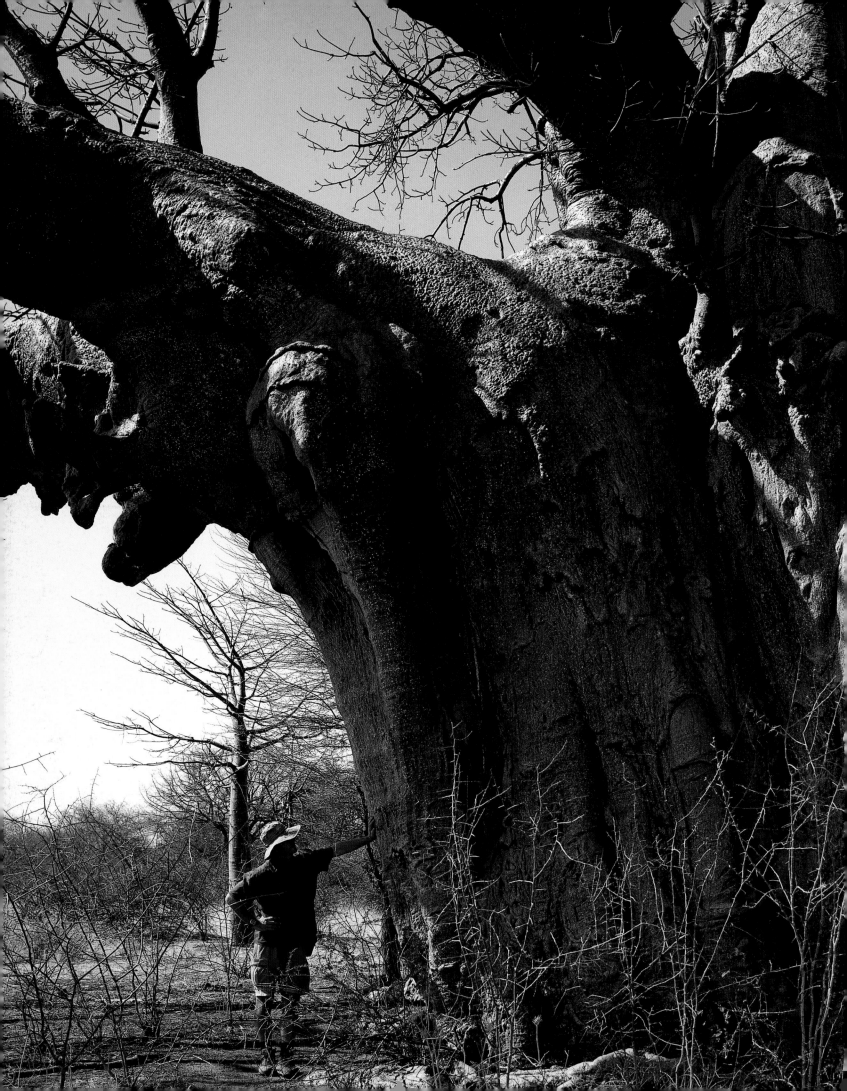

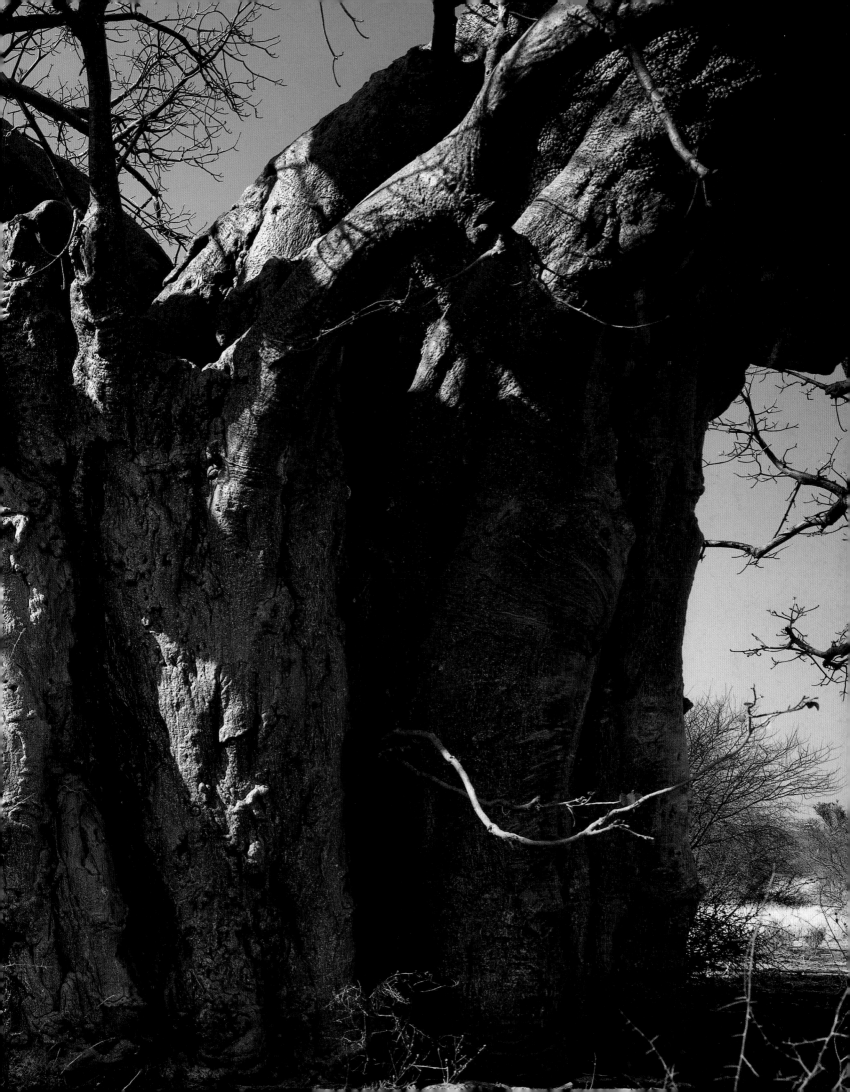

Below: *The Buffelsdrift
baobab from the north.*
Right: *The ruinic patterns
on the bark.*

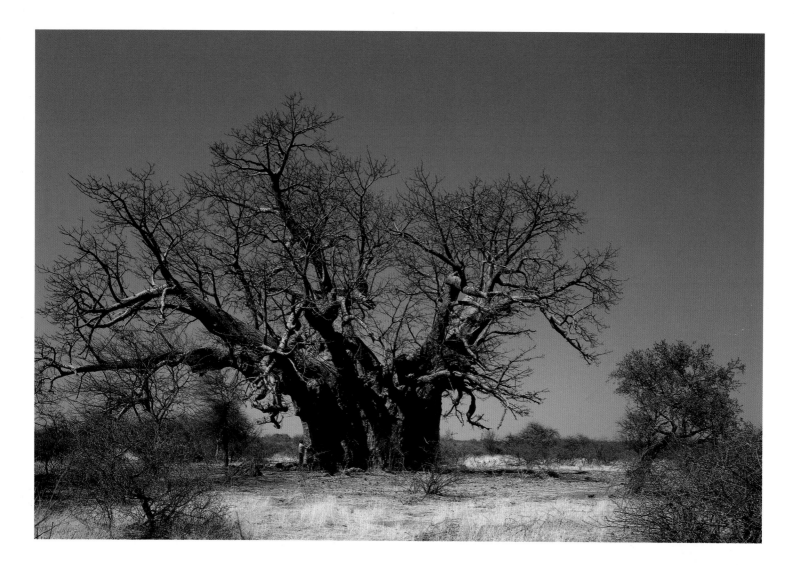

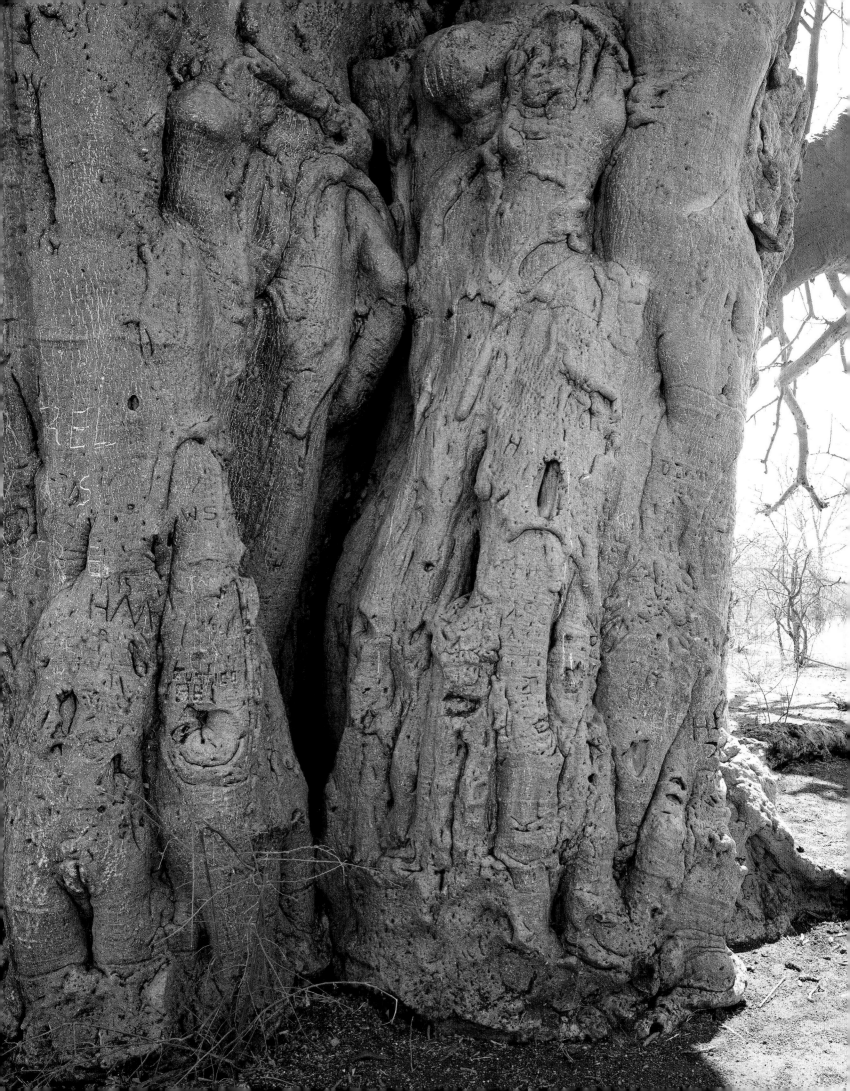

Lost and Found

BEFORE I PARTED from Ralph Bousfield at Jack's Camp in October 2006 he told me a strange story, as we sat under the stars enjoying the flavours of a lively South African claret. He said there was a virgin forest of baobabs lost on an island in the vast wilderness of the Kalahari. Of course it sent my pulse racing. But was this a traveller's tale — with the claret doing the talking? To discover a virgin forest of baobabs, a forest never explored or photographed by a European, this would be the pinnacle of my career as a tree-hunter. Ralph said he had chanced on the trees when he was frisking about in his Cessna one day, but had never had time to drive there. How could I doubt the word of Ralph?

In February 2007 I flew back to Jack's Camp eager for the hunt. For some weeks Ralph had been curiously elusive. He was said to be in Ethiopia, and incommunicado. Then he broke surface and explained the plan. Our week-long safari could combine a trip in the game car to the lost baobabs of Botswana with a wild dash in Prospero Bailey's Beechcraft to some obscure giant baobabs 300 miles away across the border in Namibia. Of course it was now the rainy season and the crunchy white salt of the pans turn to toffee when it rains. We must hope for the best. But the Met forecast was all about rain.

By the next day we were within a hair's breadth — only a few miles, I calculated — of the lost baobabs. My portable GPS (waypoint 'Mud') registered the distance, and I'm afraid I cannot now reveal the coordinates, in case I ever have the chance to return. But I can reveal that it had been an instructive drive. We saw the famous tick tree (*Sterculia africana*) outside a small village of mud huts. The tree had bombarded the ground with handsome yellow seed pods, and the seeds are as aggressive as ticks. (If you touch the inside of the pods you itch for days.) We saw a scorpion scuttling along the sand; fortunately it was devoured by a meer-cat. We saw an ominous spiral of vultures. But all we saw of the lost baobabs were tyre tracks in the salt pan, where some fool like us had become bogged down in the mud, and thought better of it. No one could drive across the pan that day. Far out in that wilderness of grey mud I thought I saw a ghostly line of great trees mocking the cowardice of explorers. No doubt it was a mirage.

Undaunted by the anti-climax, we took off in Prospero's Beechcraft, Papa Juliet Tango, early next morning bound for Namibia. Soon the swirling grey patterns of the salt-pans — an abstract painting in grisaille seen from 1,000 feet up — gave place to the dark green monotony of the bushveld. The country seemed almost without a population, although I did spot a couple of elephants striding god-like towards a watercourse. Our single-engined plane felt very small suspended above the void. What would we do if the engine sputtered and failed? Find a road and land on it, said Prospero,

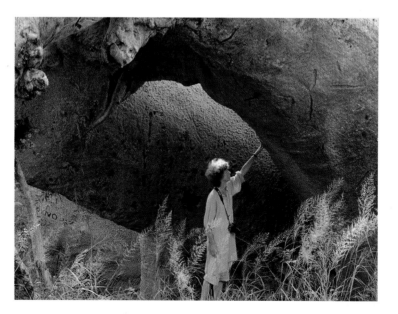

Lindy Dufferin, the artist, and the Dorsland trek baobab in north-east Namibia.

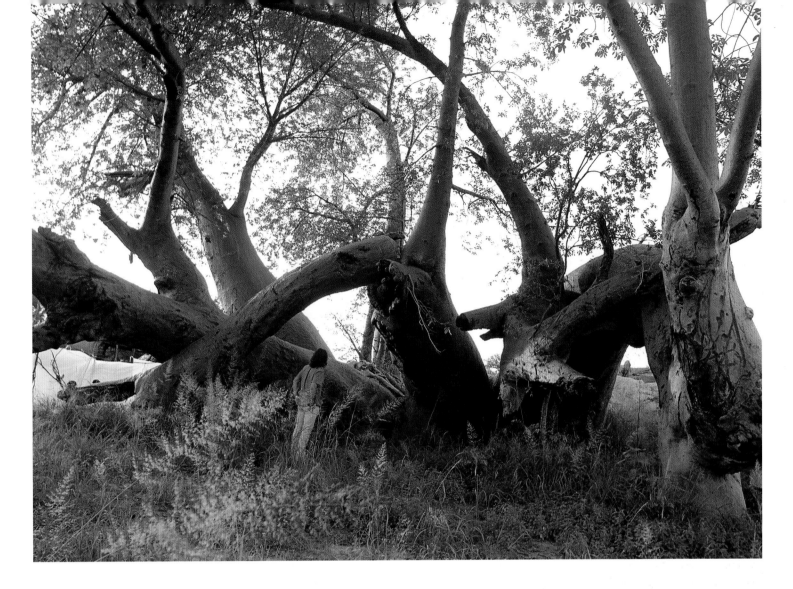

The Dorsland trek baobab
soon after dawn.

Following pages: *The
Dorsland trek giant,
its six legs splayed out
where they had fallen
more than a century ago.*

his large hands firmly grasping the joystick of Papa Juliet Tango. But I could see no road below us in the void, not even a dirt track. Of course the most dangerous moment was at take-off. Ralph, sitting in the co-pilot's seat next to Prospero, had told me of the day when the throttle cable had snapped just after he had taken off in his Piper Tripacer. His father suffered terrible burns from which he died. Ralph risked his life pulling him from the burning wreckage, and spent months in hospital afterwards.

After two hours flying west, Prospero put down the Beechcraft in a small, bumpy field close to the village of Cgae-Cgae. This is largely a Bushmen's village, and we picked up some Bushmen, sharp-eyed trackers who were reputed to know every big tree in Namibia. (Ralph was also hoping to buy a Bushmen's bow and arrows, smeared with poison — just the thing for potting impala, kudu and other game in the traditional manner. The poison we would acquire in due course.) Then we set off in one of the Toyota game cars which had been sent ahead of us from Jack's Camp. Two hours driving

through the bush brought us to the police-post at the border, and by evening we had come to the first of the eccentric giants for which Namibia deserves to be famous.

I have seen some rum trees in my time. But the Dorsland Trek Giant (as they used to call this tree) is the rummest.

Imagine a spider with seven legs splayed out across an acre of bushveld. This is the present shape of the creature. Years ago it must have stood tall and upright: a handsome giant with many trunks like Chapman's tree today. Then, more than 120 years ago, six of its seven, sausage-shaped trunks were knocked flat by a storm. But the creature was irrepressible. Three of the fallen trunks progressively died. Yet enough of the old root system had survived to circulate sap in the other three. New trunks appeared at the ends of the old ones. Gradually the tree took its present demented shape.

We know that the storm hit the tree some time before 1883, because this is the date cut *horizontally* into one of the trunks, which must by then have

already fallen. It was in that year that one of the columns of Boer trekkers passed through the district in search of the promised land. In the 1870s, south-west Africa as far as the Limpopo, the frontier with the Boer republic of the Transvaal, was barely explored by Europeans. No doubt the trekkers were beguiled by tales of gold and diamonds, or at any rate of a land of milk and honey. They were also disillusioned with President Burgers's government in the Transvaal, crippled by disputes and dangerously close to bankruptcy, until it was annexed by the British government in 1877. Although the Transvaal, under Paul Kruger, regained its independence after the First Boer War of 1880–1881, the British annexation helped inspire new trekker groups to break out across the Limpopo. At any rate, from 1875 onwards there were a series of treks by intrepid Boer families, who brought their covered ox-wagons, piled high with household goods, and surrounded with sheep and cattle, to make a new life in the unknown.

To reach relatively fertile land in Angola, nearly 1,000 miles to the north, they had to trek through the wilderness of the Kalahari in what is now Botswana, and the bushveld in what is now Namibia. Together the treks became known as the Dorsland Trek — meaning in Afrikaans the 'Thirstland Trek'. The name gives only a hint of the grim conditions on the journey. Much of the land was waterless and the sheep and cattle died in their thousands. In the marshes of the Okavango, malaria was endemic. Out of one trekboer group of 100, led by Jan Greyling, only seventeen survived. Fortunately there were better leaders: a charismatic Boer, Gert Alberts, and a coloured man called Will Jordan who gave them his protection. Together they brought most of the columns to safety. In due course, some of the survivors reached Angola where they pegged out farms by the Kunene River. Some even made money in the transport business under Portuguese colonial rule, until they were evacuated to south-west Africa in 1928–9 with the help of the South African government. But poor Will Jordan, the coloured man, died miserably, murdered by the brother of a local chief.

I should like to think that both men have a suitable monument in this tortured Dorsland trek giant.

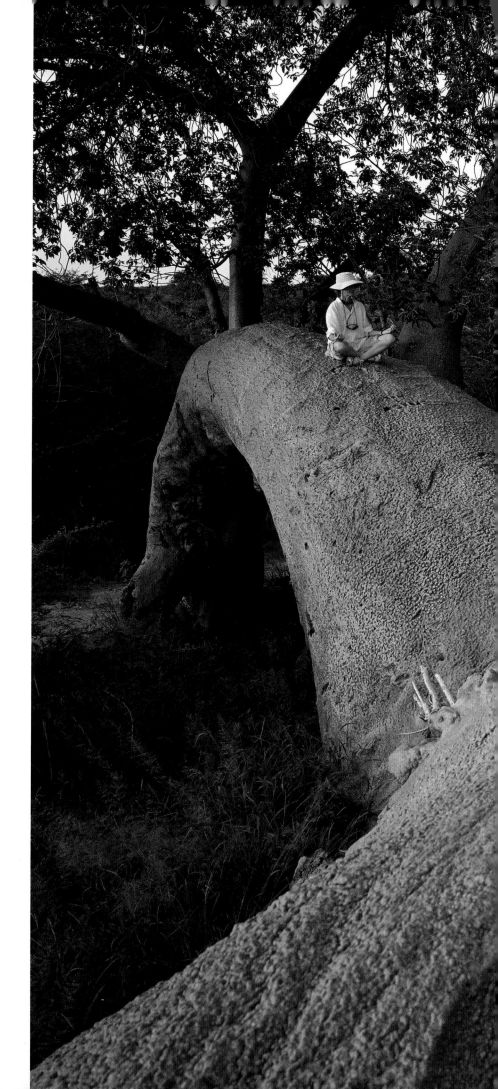

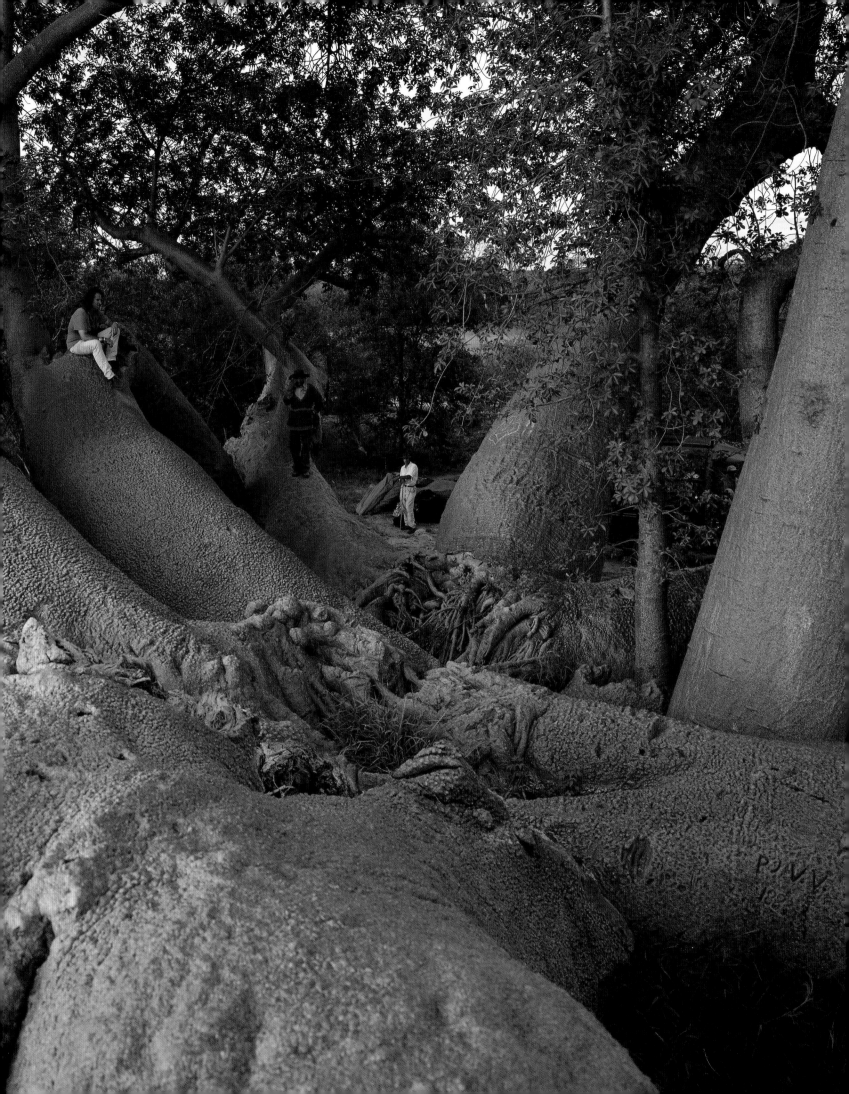

Sheela-in-the-Bush

FOUR HOURS DRIVE from the Dorsland Trek Giant, down a sandy track almost completely overgrown with thorn-trees, we found an even larger creature, and we rubbed our eyes. Here was the largest baobab, unless we were drunk or dreaming, in the whole of southern Africa — perhaps the whole world. Yet its name, the Holbaum (hollow tree) gave no clue to its vastness. Brobdignag it was, a tree from the world of Gulliver and the dreams (or nightmares) of Jonathan Swift. I promptly rechristened it the Brobdignag Giantess.

Could she really be as large as she appeared? We had no proper tape measure, but Prospero, had brought along a 12 metre rope for pegging his plane down after landing. We measured the trunk of the Brobdignag Giantess just before she splayed out her two immense arms — or legs. It came to 3 lengths and about 12 centimetres — 36.12 metres or 119 feet in girth. This is nearly ten feet bigger than the two current champions of South Africa — the Sagole Giant and the Duiwelskloof Pub Tree.

But what are mere dimensions compared to the glories of form? The most astonishing thing about this giantess was the amazing cavern at the centre. It was almost as if, in an earlier era, another immense trunk had grown there, which had eventually succumbed to old age, leaving the side branches to take over as trunks. And what trunks.

We scrambled up three steep steps into the amazing cavern, splashed with the droppings of an owl, which had made its nest high in the roof. A century ago, we were told by one of our Bushmen trackers, this hollow in the tree had provided a refuge for a group of Herrero tribesmen escaping from the German *schutztruppen* — the colonial army of the Reich sent to suppress an uprising by the local Herrero. The rising was in fact suppressed with chilling violence. It was one of the best

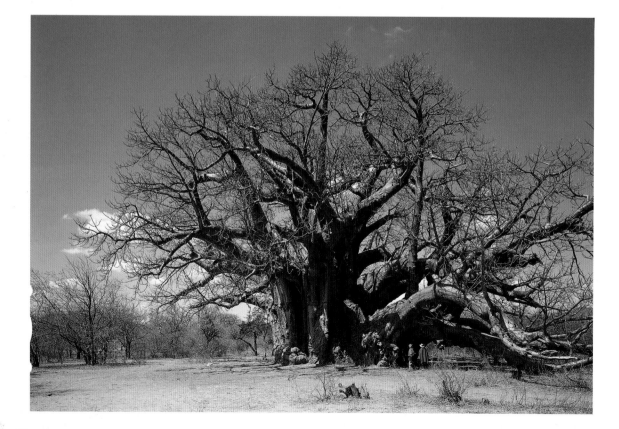

Left: *The Sagole Giant in Limpopo Province, one of the two largest-girthed baobabs in South Africa.*
Right: *The Holbaum in north-east Namibia. Had we found the biggest baobab in the world?*

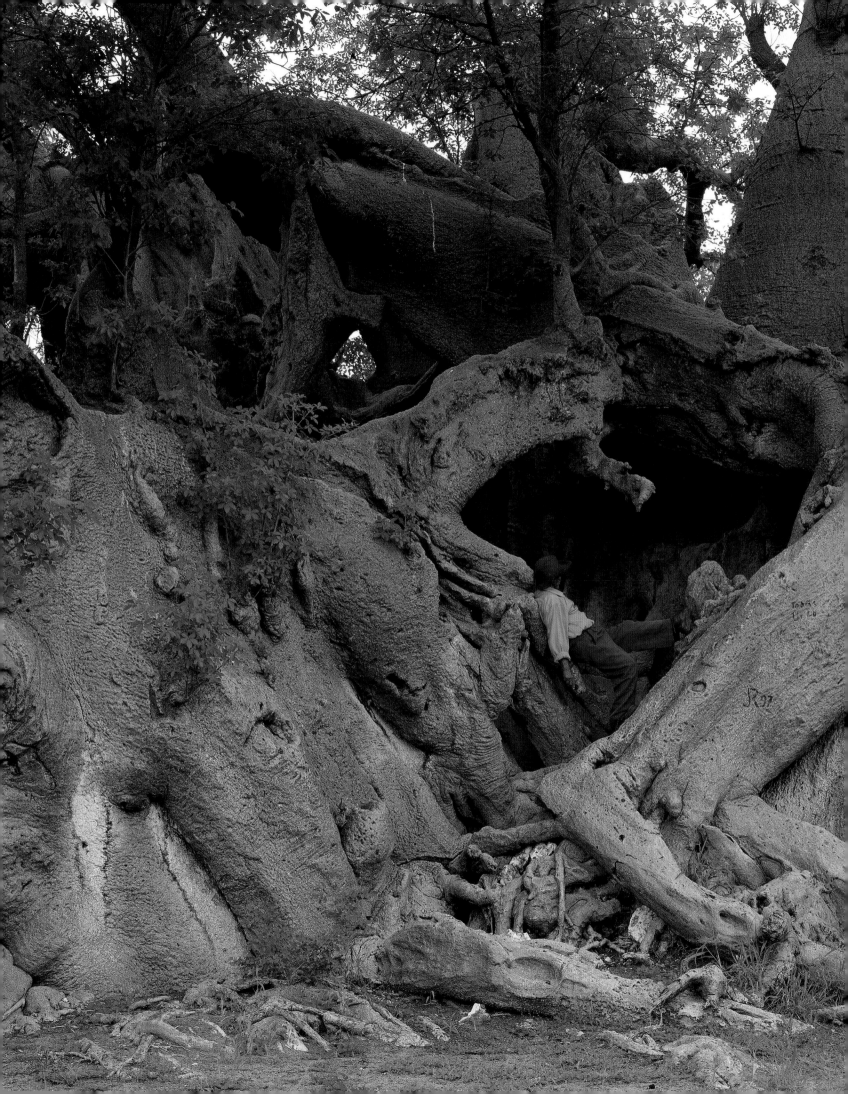

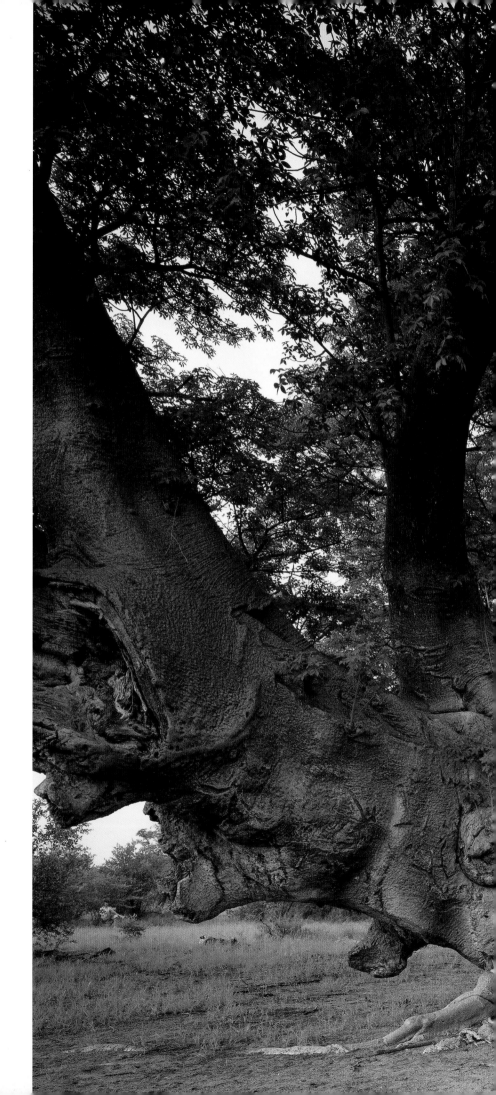

documented cases of genocide by a colonial power at the end of the Scramble for Africa. Three quarters of the Herrero, men, women and children, are thought to have perished in this war, mostly of thirst and starvation, after the wells had been sealed against them and they had been driven out into the waterless Omaheke desert.

I was glad that our Brobdignag Giantess had been able to save a few lives. We spent a happy evening exploring the recesses of the tree, and I photographed our talented and long-suffering artist, Lindy Dufferin, drawing the portrait of one of our Bushmen sitting under the armpit of his ancestral giant. But were they arms or legs, these mighty limbs that splayed out from the ground at either side of the great cavern? I think, on second thoughts, they are legs. And this raises a somewhat embarrassing question. What is this strange pose that the giantess has adopted? If you look at her through half-closed eyes, it is almost as if she was … er, um … exposing herself. Perhaps you know those Celtic fertility figures sculpted as corbels under the roofs of Romanesque churches, the famous (or infamous) Sheela-na-gigs. Well, is this Namibian giantess a Sheela-in-the-bush? And how better to celebrate the fecundity of nature's biggest baobab?

Next day we flew back to the Limpopo in a Wagnerian thunderstorm, a suitable prelude to a week in a landscape tormented by elephants.

The Holbaum, also known as the Brobdignag Giantess, with trunks splayed out on either side. Were they arms or legs?

36

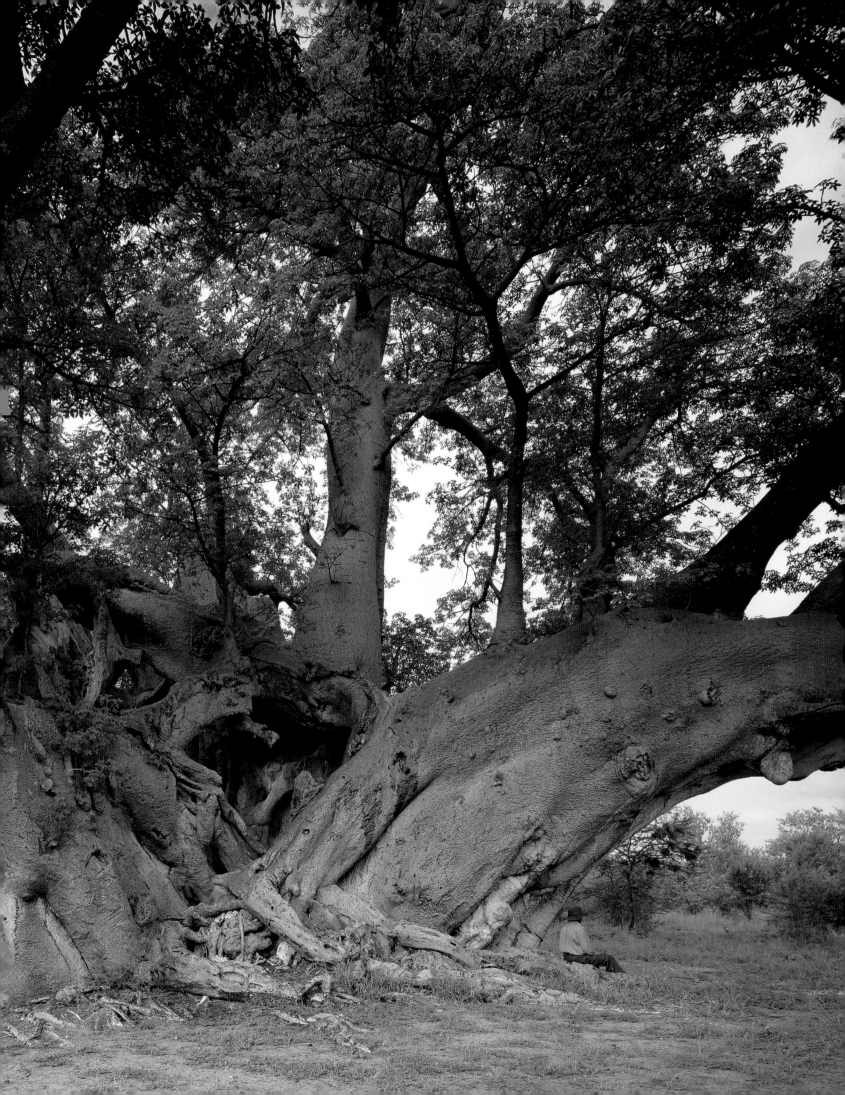

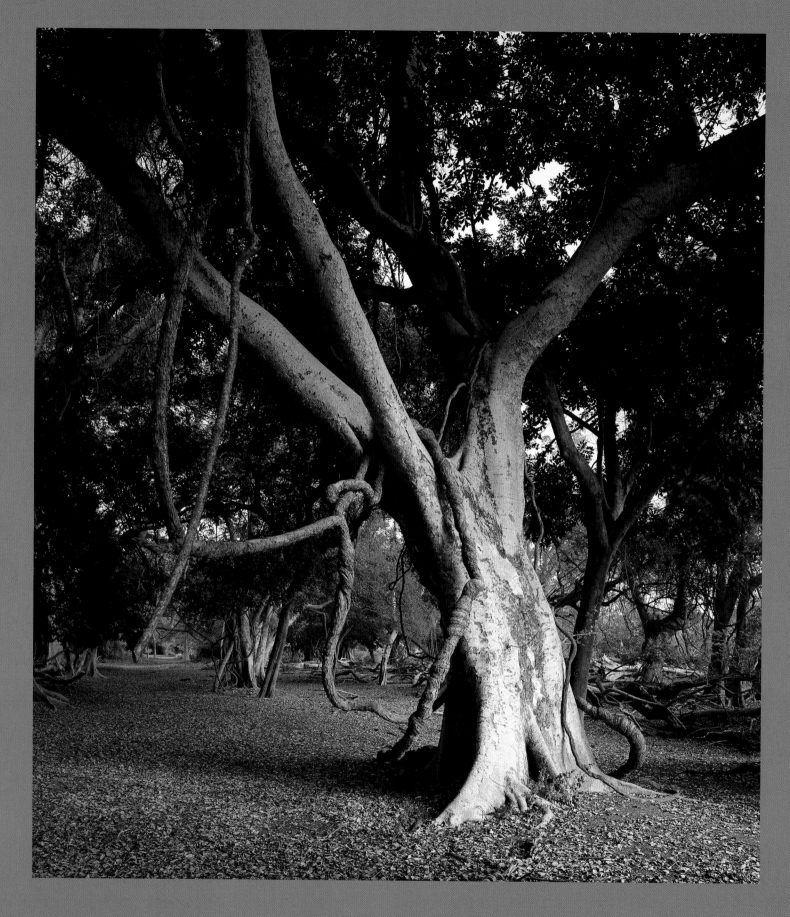

Among Serpents

A Tree for Paradise

IF I WAS AN ELEPHANT I would feel a grudging admiration for the sycamore fig (*Ficus sycomorus*). It's one of the few species (apart from the mighty baobab) that can rival it in size and magnificence. There the giant fig stands, 100 feet high and 100 feet wide, straddling the green and greasy banks of the River Limpopo, with its roots like steel hawsers, a challenge to all-comers. And try as it will, no elephant can knock it flat.

For five days in February 2007, I stayed as a pampered guest at Megwe, one of the game camps on the Botswana side, that is the north side, of the Limpopo. It's squashed into the north-east corner of the Charter Reserve, a slice of stony upland and sandy flood plain, where the Sashe River runs into the Limpopo. This was a slice finessed like a card trick by Cecil Rhodes in the 1890s from King Khama's Bechuanaland; Rhodes and his Chartered Company were hungry for land on which to build the railway to Rhodesia and the north. Today three African countries — South Africa, Botswana and Zimbabwe — shake hands at the sandy confluence where the two rivers meet.

Like much of the wild lowveld, it's a magical place, vibrating with birds and animals: eagles, kites, squirrels, buck, lions, elephants. From Megwe's elegant stoep (or verandah) you watch the mysterious ebb and flow of the elephant's world. 'Good heavens,' you say, 'real elephants.' Yes, just over there by the bore-hole, a hundred yards away, dozens of them, mothers with families, flooding silently into that grove of apple-leaf trees, like players coming on stage at an open-air theatre. 'Why, if we got too close, they might — you know — they might…' 'Yes', comes the sombre reply from our generous hosts, John and Sara Dewar. 'The elephants kill four or five people every year in this reserve. Mostly unfortunate refugees from Zimbabwe trying to slip across the border at night. But our gardener was killed tragically last month when walking home from a party.'

It concentrates the mind, the thought you might

be trampled to death at any moment. In fact, game watching from an open game car is remarkably safe and easy. We saw rhino and leopard as well as elephants, and we were hunting trees not animals.

Once upon a time the trees along the north bank of the Limpopo were some of the finest in Africa. Now much of the place looks like a battlefield. Elephants are destroying most of the smaller species of tree. Everywhere you see mangled corpses: leadwoods, shepherd's trees, sesame bushes, fever trees knocked flat in a moment. (See page 71 for more about their fate.) Sadly, there are just too many elephants in this crowded corner of Africa, too many for their own good, and too many for the good of other animals and plants. Culling was suspended in 1995 for what seemed an excellent reason: the cruelty of even the most humane way of killing these enormous creatures. Bore-holes were drilled that allowed elephants better to survive the drought years. In twelve years the numbers of elephants have risen by a third. The result: nature's applecart upset and a man-made catastrophe for the environment.

However the giant sycamore fig has no anxieties on that score. Our hosts, John and Sara, took us down to the Sashe to see their favourite trees. 'Oh, my God!', said Lindy, the intrepid artist, hunting for her sketchbook. I set up my Linhof on its gaunt tripod and settled the blanket over my head to view the tree on the ground glass screen. The shade temperature was above 100°F, well above blood heat, and the steel frame of the camera was hot to touch. By comparison the great tree, reflected upside down on the ground glass under my blanket, looked serene. It was much the largest sycamore fig I had ever encountered. And it was *painterly* in the way that makes this species so delightful: the smooth pink bark starts yellow, the leaves are large and reflect the sun like mirrors, the roots are like serpents. Nearby was an even more beautiful but smaller tree, one of whose branches

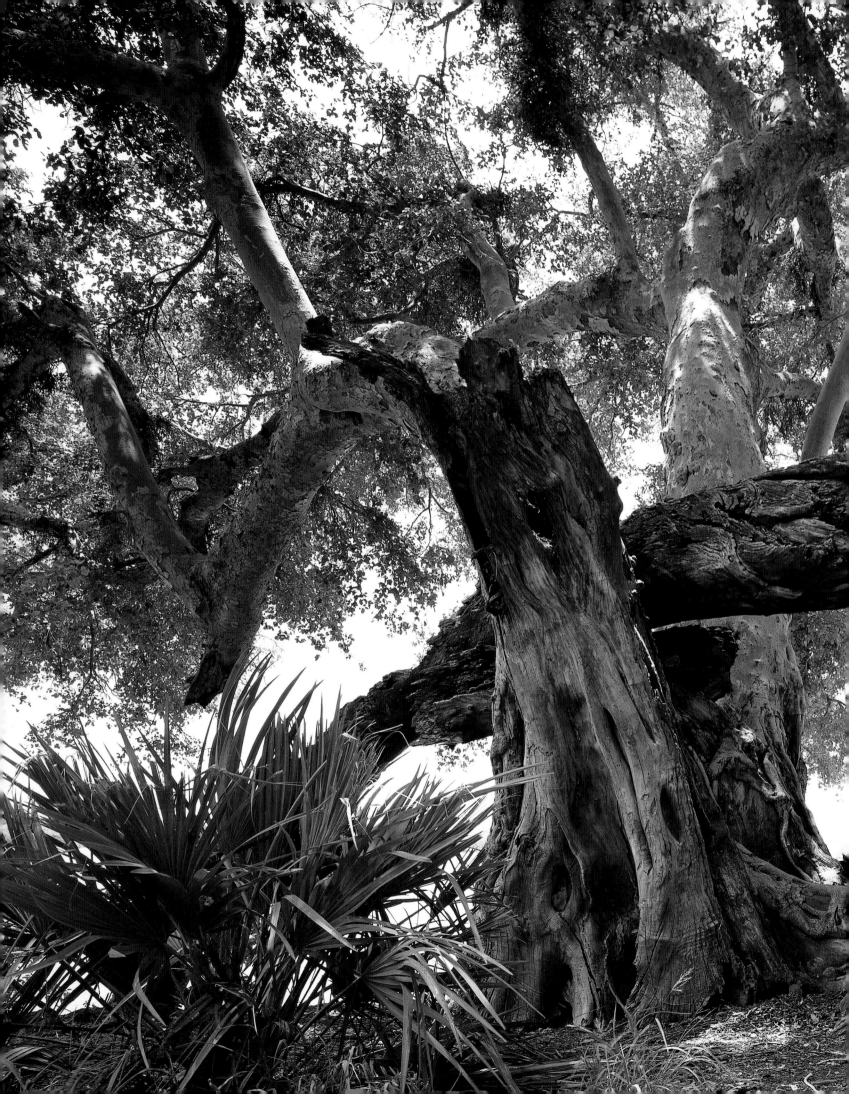

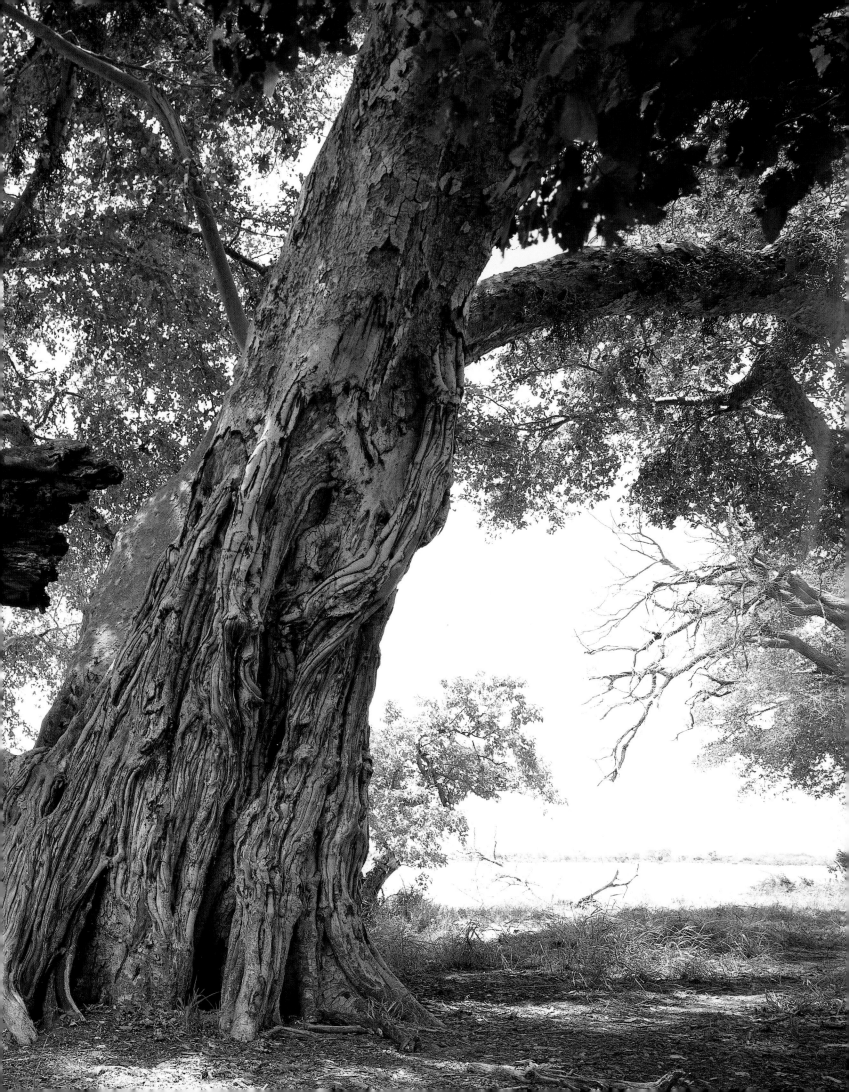

had been smashed by a storm — or an elephant. Both trees had been gnawed by browsing animals, by kudu or zebra or rhino perhaps. But, compared to the battlefield beyond the river, this was paradise. (And talking of paradise, this is the same species of giant fig as the one which grows in the Holy Land, the tall tree up which Zaccheus the publican climbed, determined to see Jesus pass through Jerico on his way to Jerusalem. The tree also supplied the wood for Egyptian mummy-cases, in which Pharoahs lay waiting their turn to be received in the Other World.)

Both trees were teeming with the clusters of inch-long fruit which I am told are like oysters and champagne for the Green Pigeon and the Brown-headed Parrot. They are also dried like sultanas by Tonga women. If you planted a sycamore fig in your garden it would be a garden in itself.

Previous pages and right:
Sycamore figs on the banks of the Sashe river in the Charter Reserve in south-east Botswana. A match for the elephants.

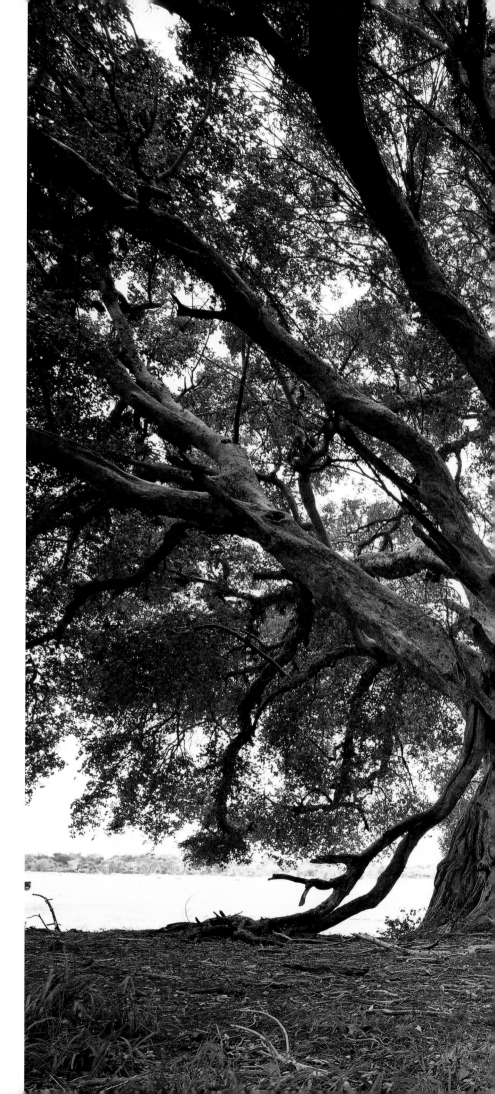

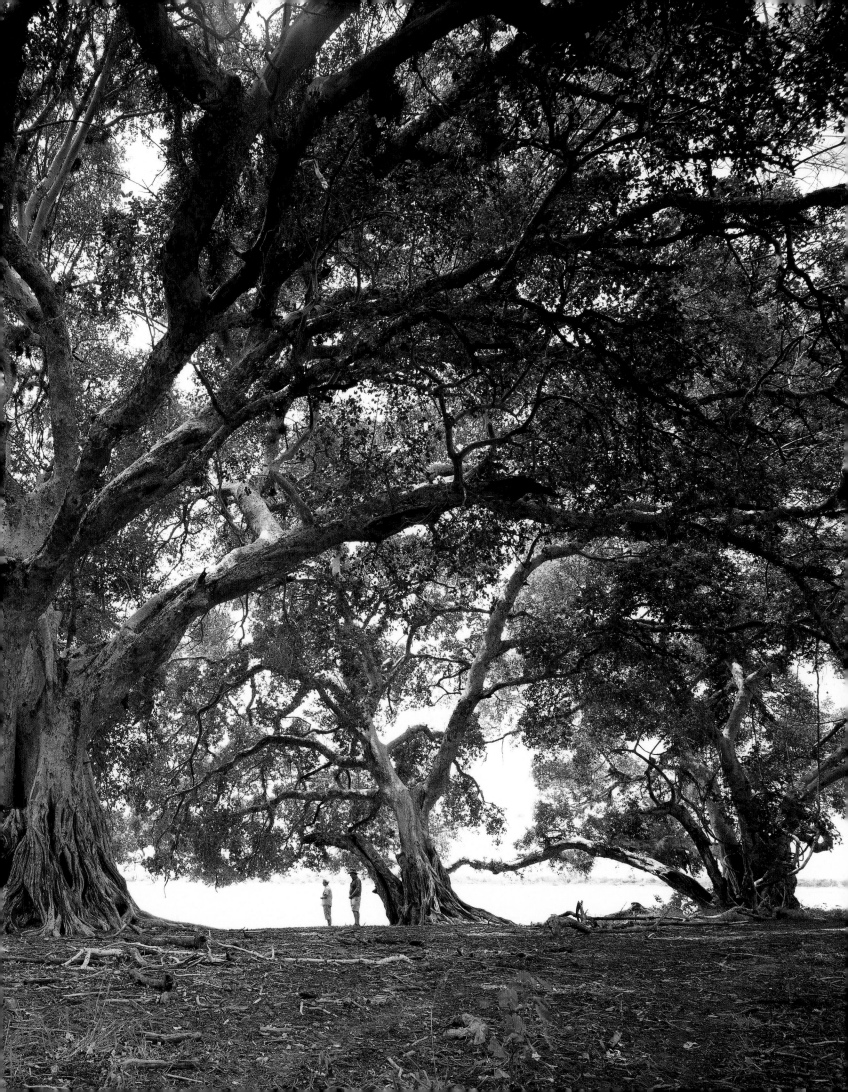

Mashatus and Matumis

THERE ARE TWO other species of lowveld giant self-confident enough to stand firm against even the hungriest elephant. Considering their magnificent appearance, both are surprisingly little-known. It might be because their botanical names are rather a mouthful. The first is *Xanthocercis zambesiaca* — the name means literally the 'the yellow redbud from the Zambezi'. It is known as mashatu in Botswana and as the nyala tree in South Africa. The second is *Breonadia salicina,* known as the matumi. Both are evergreens, both have a taste for sandy river banks and both are protected trees in South Africa, which means that you could be fined for cutting down even a youngster. Otherwise the two giants could hardly be more different.

Below: *A mashatu (nyala tree) close to the Limpopo river in the Charter Reserve.* Right: *The champion matumi in the Amorentia estate near Tzaneen in Limpopo Province.*

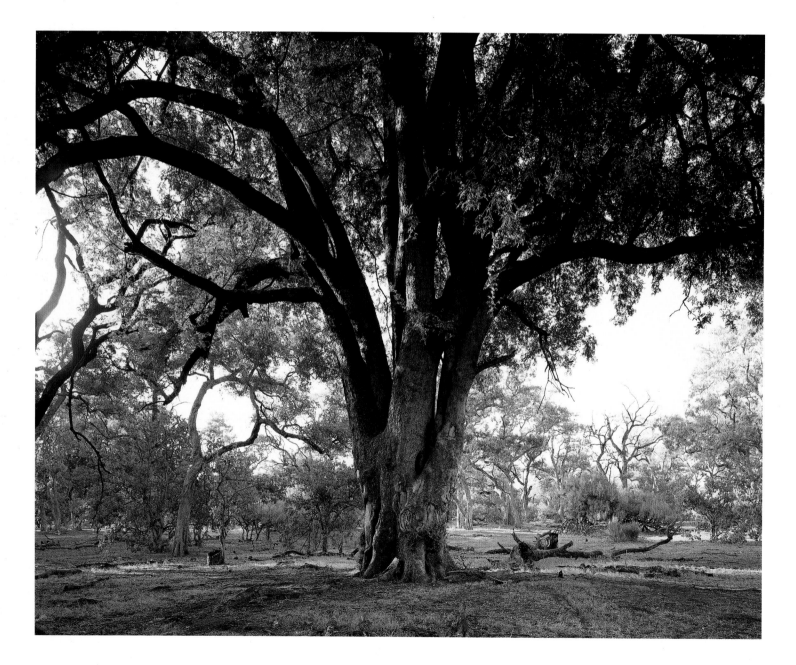

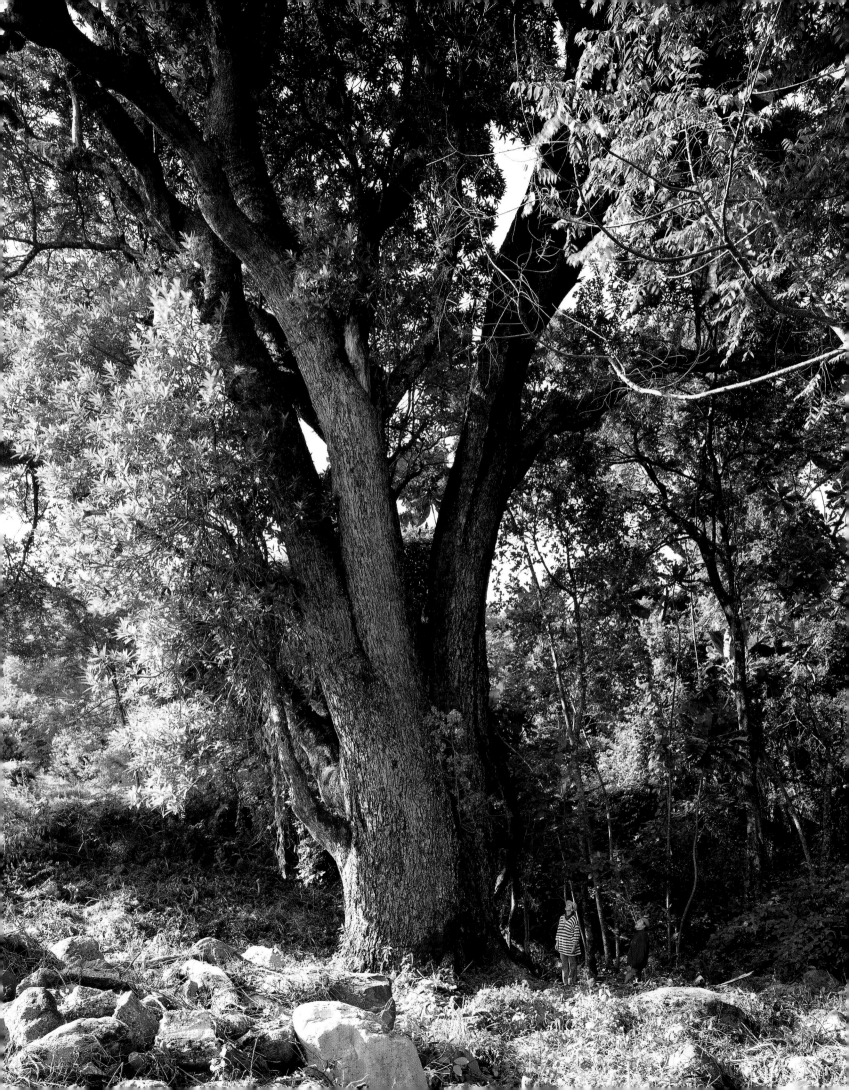

Along the Limpopo and Sashe rivers, in the hot, dry climate of eastern Botswana, I saw dozens of huge, ancient mashatu astride the river banks, their dark green domes sometimes coalescing to give the effect of a planted avenue. When you approach them, they present a more scruffy appearance. In fact, I rarely saw a tree content to throw up a single massive trunk. The reason, I suspect, is that the mashatu has a passionate longing for anthills — and the ants that enrich the soil reciprocate the passion. As the grey or brown ant-hill grows larger and richer the tree produces an ever larger and darker thicket of competing trunks. Many of them get broken by browsing animals like impala, zebra and nyala (hence the name, nyala tree). Birds and animals, especially pigeons, monkeys and baboons, also stuff themselves on the brown fruit. This is about an inch long and plum-shaped, with a single, shiny black seed embedded in a sticky paste. It would be exciting to be there in the autumn when the brown fruit is ripe and rains down on the nyala, much of it carelessly dislodged by the pigeons and baboons in the canopy above. I am told that this fruit is remarkably tasty and you can it make it into an excellent porridge if times are hard. But you must first bury the fruit to give it time to mature.

By contrast the matumi prefers a hot, wet climate and boldly throws up a single huge trunk like a column. I saw the two biggest yet discovered in South Africa. They are pampered residents on the lush Amorentia estate near Tzaneen, famous for its groves of oranges, lemons and avocados. My hosts had generously sent a team to clear the ferns and thorns from the feet of these noble beasts. But obviously they could not clear away the 60 foot high *Anthocleista grandiflora* (Forest fever tree) which had upstaged the smaller matumi. No matter. The two giants faced my camera without blinking and the oblique evening sun did not fail to smile on us. The champion itself is so elegantly proportioned that you would never guess that its size — 120 feet high and 30 feet in girth — would match a factory chimney's.

At Woodbush Forest, in a sumptuous kloof, we saw a third giant, a forest cabbage tree (*Cussonia spaerocephala*). This, too, had grown to champion size — over 25 feet in girth — as it revels in a hot, wet climate.

To return to the matumi, under the name of African or Transvaal teak, the wood was once prized by builders and cabinet-makers. It's very hard and durable like true Asiatic teak, but has a distinct oily smell of its own. Termites, I am told, run away in terror when they smell it. The colour varies from yellow to brown, and polish will bring to light the most elegant flame-like markings. A century ago, great matumis strode through the rain-soaked forests of Natal. Now even small ones are rare. But it's still quite common in tropical Africa. Up there, in Malawi, people prize it above all for making dug-out canoes, as the wood is thought to be crocodile-proof.

When I next paddle through the swamps of the Okavango, in north-west Botswana, my crocodile-proof canoe will be cut from the trunk of a giant matumi, and the polish will sparkle like the figure on the back of a Chippendale chair.

A giant Forest fever tree in a kloof at Woodbush Forest near Tzaneen.

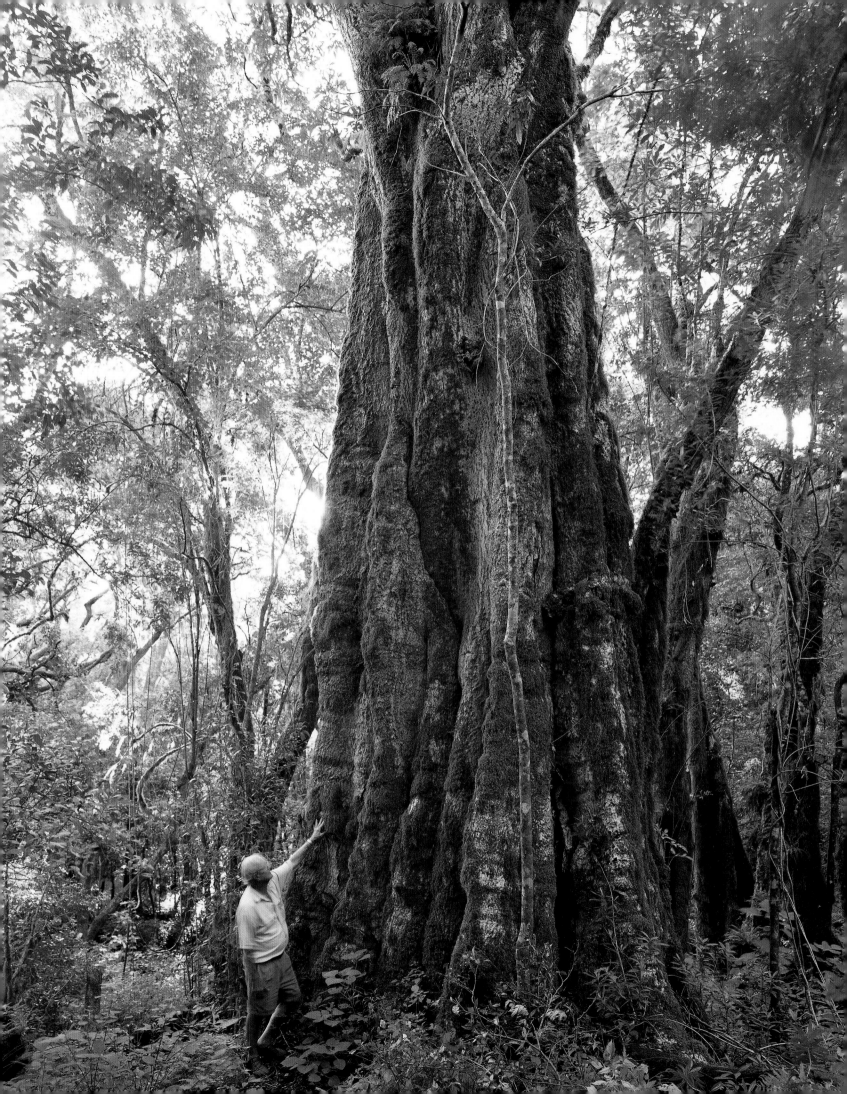

The Lion's Tree

FACE A LION, run from an elephant. The old adage came back to me as I stared, eyeball to eyeball, into the unblinking eyes of a recumbent lion. Well, I had certainly run from an elephant in the Okavango — fortunately for me (see page 60), but I wasn't quite sure how to handle this lion. Was it like facing a hijacker? I mean, must I remain calm and dignified? Or try to look bored. Yes, I would try to look bored. I don't think I made a good job of it. It was the lion that looked supremely bored with me.

A hundred yards behind us on a grassy knoll, its trunk smooth and pinkish yellow in the sunset, stood a celebrated, lone sycamore fig. This huge tree was the magnet that had brought us 1000 miles north, to the great flood plain of the Kafue in northern Zambia. It was July 2005, and the grass was bleached brown; it was the height of winter. This is the time when, if you're lucky, Zambia is relatively cool and dry. Prospero had flown us there in Papa Juliet Tango, landing on an almost invisible airstrip hacked out of the bush by licenced big game hunters. (They looked like mercenaries, as they were armed to the teeth, and wore dirty camouflaged denims, but I'm sure they were excellent fellows.) We ourselves were staying in a game camp 30 miles beyond their licenced hunting ground and it was boiling over with game. 'I say,' said one of our party, the first evening, 'this place is rotten with

lions. Watch out when you go to the loo.'

Round the camp fire that evening our hosts told us the jolly story of the Italian tourists who wanted to see lions at a kill. At that time — it was a few years back — the tents were pitched on the grassy knoll beside the lone sycamore fig. When it was dark they set off in the game car towards the place where the kill, an unfortunate zebra, had been spotted. I can picture the Italians sharply dressed in their Armani safari suits. On the way they noticed a pride of twenty-one lions close to their track. A mile beyond, the game car bogged down in a ditch. The car had to be abandoned, and the Italians were told they would have to return on foot. But they took no chances. To avoid those twenty-one lions they made a detour through the wood half a mile to the right. Well, they reached the middle of the wood before they saw the green eyes of the first lion in the beam of their torch. The lion stared at them from straight ahead. The beam was turned slowly to left and right. More green eyes, a lot more. The pride had surrounded them in a half circle. The Italians were aghast. Slowly they made their retreat, walking backward. After several miles stumbling in the dark, with their Armani suits now in ribbons, they came within sight of the tents on the grassy knoll. But, *mamma mia,* what were those dancing figures silhouetted against the camp fire? The camp was

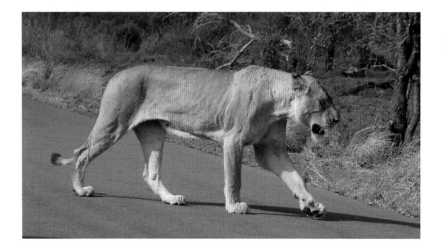

Left: *Lioness in the Kruger National Park.*
Above right: *Dawn at The Lion's Tree, a lone sycamore in the Kafue flood plain, northern Zambia.*

under siege from two more lions that were trying to steal the steaks from the *braai*. Somehow the thieves were driven off by the cooks, lunging at them in a shower of sparks.

We had no such athletic experiences ourselves. With my camera I caught the lone sycamore fig in various poetic moods: in the sumptuous glow of sunset; in the thin, misty, monochrome of dawn; in the crackling heat of midday. My admiration for the tree ripened. Lone trees are always mysterious. Why is there only one tree, is the question one always asks, and one seldom finds the answer. Here it was the grassy knoll above the flood plain that

had offered sanctuary to one great fig, when there was room for at least a grove. However, the tree in its turn had proved a kind of Noah's Ark for a host of birds and beasts. Until recently, I was told, a python had reared its family in the hollows between the roots. An eagle had built its home in the branches. And the tree was at the hub of a great army of puku, waterbuck and impala, parading in the flood plain. Which brings me back to that recumbent lion staring with that world-weary look at the fig tree and the grassy knoll.

Why was he as bored with the puku and water-buck and impala as he was bored with me? I can

offer no explanation except the obvious one.
He had dined very well earlier in the day. I could
tell by the tail. You see, our hosts had told us that
you can always tell a contented lion from a hungry
one. Just look at the tail. If the tail doesn't move,
the lion's happy. If it sweeps from side by side
like a metronome, he's about to spring.

Well, the king of the beasts suddenly stopped
looking at the lone fig tree and the grassy knoll and
looked once again straight into my eyes. His face
was curiously like a cross between that of Paul
Kruger, the bewhiskered President of the Transvaal,
and the famous oval radiator of a Bugatti. His eyes
were terrifying. I felt like a peasant scrutinized by
a medieval king. And I saw his tail beginning to
twitch. I had started to interest him.

I don't know how I got out alive.

The Lion's Tree at evening.
The lion himself, a hundred
yards away, suddenly looked
interested.

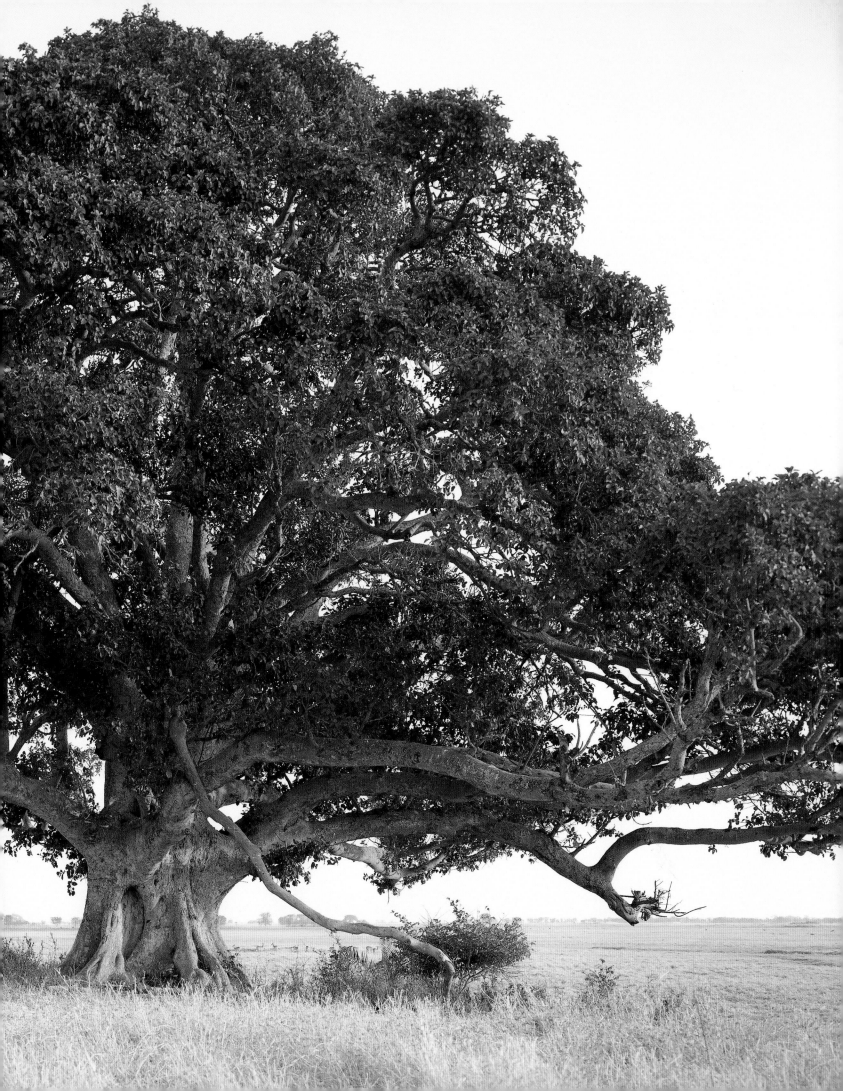

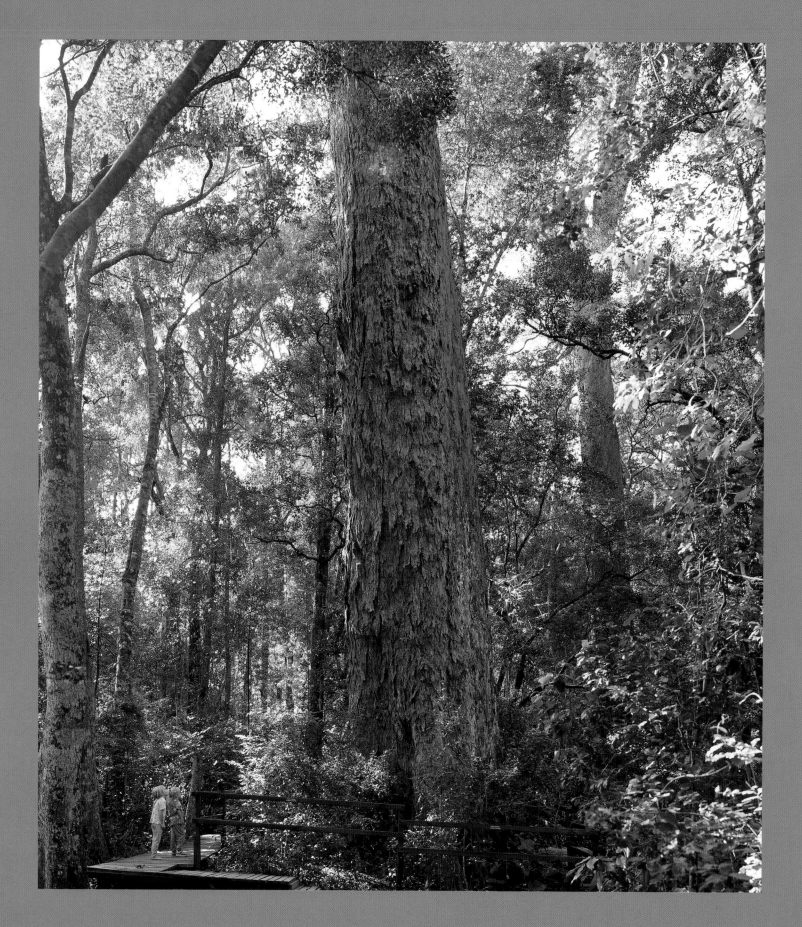

Last of the Yellowwoods

In Nature's Valley

To SEE A HUGE, ancient Outeniqua yellowwood (*Afrocarpus falcatus*) in its natural setting would make even the stoniest-hearted visitor cry: 'Wow!'

The tree rises clean out of the surrounding forest, an explosion of dark green leaves frothing with grey lichens, supported on an enormous pillar of flaking bark. The biggest trees today are 140 feet high and 20 feet round the waist. Sadly, you can now count specimens like this on the fingers of one hand.

Two centuries ago there were trees little short of 200 feet high, and this and its smaller sister species, real yellowwood, (*Afrocarpus latifolius*) were the dominant timber trees of southern Africa. However, the colonists in the Cape and Natal found the wood irresistible. The bright yellow wood was perfect for everything from roof beams to ships and wagons, from ploughs and water-wheels to chairs and cabinets. Quite suddenly the wood was found to have vanished — mined out like its counterpart in New Zealand, the totara. The government has now introduced strict controls to try to protect the survivors. But no one alive today will ever see the commercial forests of yellowwood reborn. The species grows too slowly to compete with the pushy young pines from California and Mexico (*Pinus radiata* and *Pinus patula*) and the gum trees from Australia (*Eucalyptus saligna* and its hybrids) which guarantee your money back in a decade.

It is a disaster as extreme as if all the huge, ancient oaks of Europe had been logged in the last two centuries — except for half a dozen preserved in a zoo for rare native breeds. Or as if, in the timber states of Canada and America, the loggers had stripped out the forests of Douglas fir and redwood, and replaced all but a handful of old trees with upstarts imported from overseas.

Still, I suppose that it was a miracle that *any* trees so appetizing to the loggers have survived in South Africa. A couple of years ago I went down to see the handful of 'big trees' in the forest reserves at Knysna and Tsitsikamma in the eastern Cape. No one could fail to be impressed by the zeal with which the authorities now protect these noble survivors. In fact, at Tsitsikamma rather less zeal might be found to suffice. The giant there at Storms River has had to suffer the indignity of being half throttled by a boardwalk designed for tourists. Posts have been hammered into it delicate roots

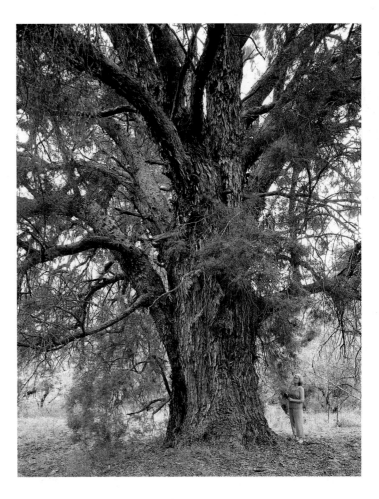

Left: *The Storms River giant at Tsitsikamma, eastern Cape — one of the few large yellowwoods to escape the loggers.*
Right: *A handsome yellow-wood in a private estate south of Port Elizabeth. Even trees of this modest size are now rare.*

and the planks pushed up far too close to its vulnerable trunk. Better to use an ordinary fence to keep back its admirers.

Perhaps I am being unfair. I will admit that I am no lover of boardwalks. I have seen them and suffered them in many parts of the world, from the giant kauri forests of New Zealand to the cypress swamps of South Carolina. I know the idea is to protect the tree roots from being trampled by tourists. But I'm sure that an outer ring of fencing would do the job better. It would also save these ancient creatures from the whiff of the theme park or the suburb. Will street lighting be the next way of improving the forest?

It was with huge relief that I found a fine old yellowwood in a corner of ancient forest at Nature's Valley, roughly half way between Knysna and Tsitsikamma. Once this forest would have echoed with the crash of falling giants, as the loggers methodically stripped the entire coastline of indigenous timber — yellowwoods and black stinkwood, ironwood, assegai and so on — for shipping to Port Elizabeth or Cape Town. But somehow one old tree escaped the axe and found sanctuary beside a small stream that flows out across a sandy beach.

Unlike the majority of us, old trees usually become more beautiful as they get older. The Queen of Nature's Valley is the best-looking ancient tree I know in South Africa. Benign neglect, the best fate an old tree can hope for, has blessed it with a jungle-growth of thorns and bushes around its feet. But how could I get to those feet in order to give scale for my photograph? There are times when a man must do what a man must do. I was, of course, quite prepared to crawl on my stomach to the tree through a snake-infested jungle. It was nothing to compare with being chased by elephants or being eyeballed by a lion. But a woman friend, braver, more athletic and more elegant than me, volunteered to crawl through the jungle in her red dress. So I had to resist the temptation to be a hero.

The giant yellowwood at Nature's Valley, near Plettenberg Bay, Eastern Cape — blessed by benign neglect.

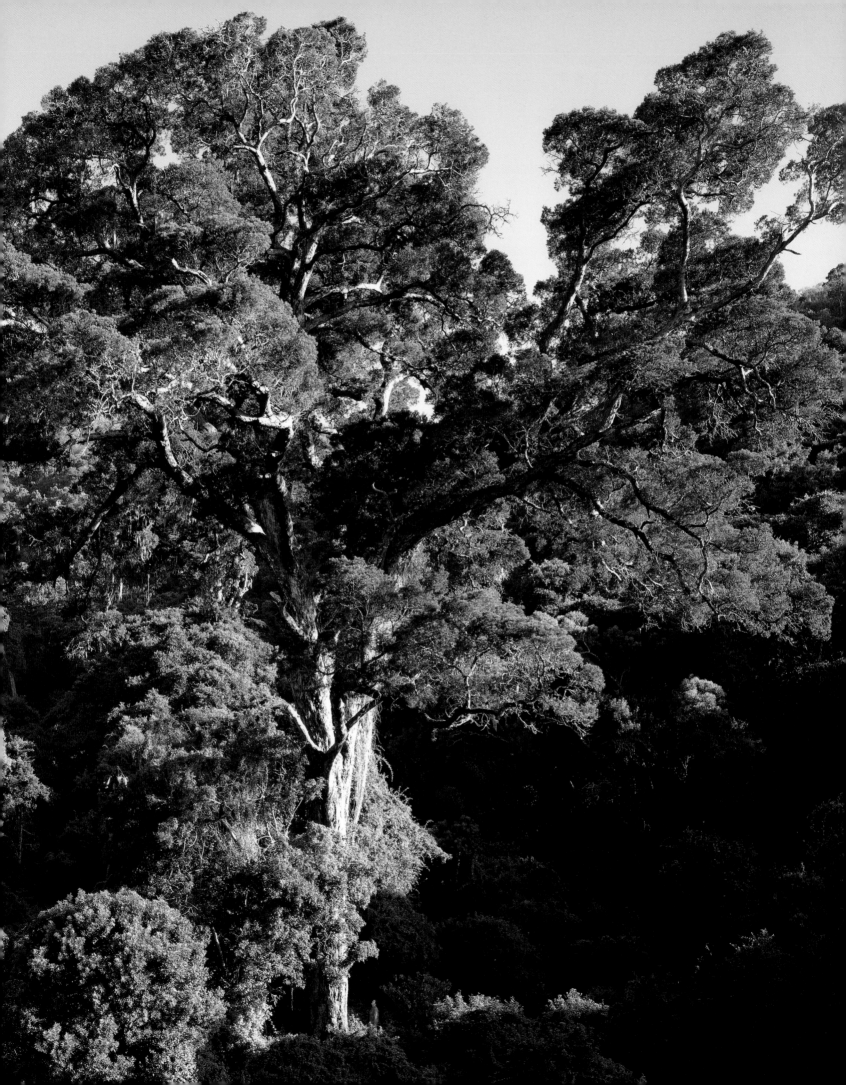

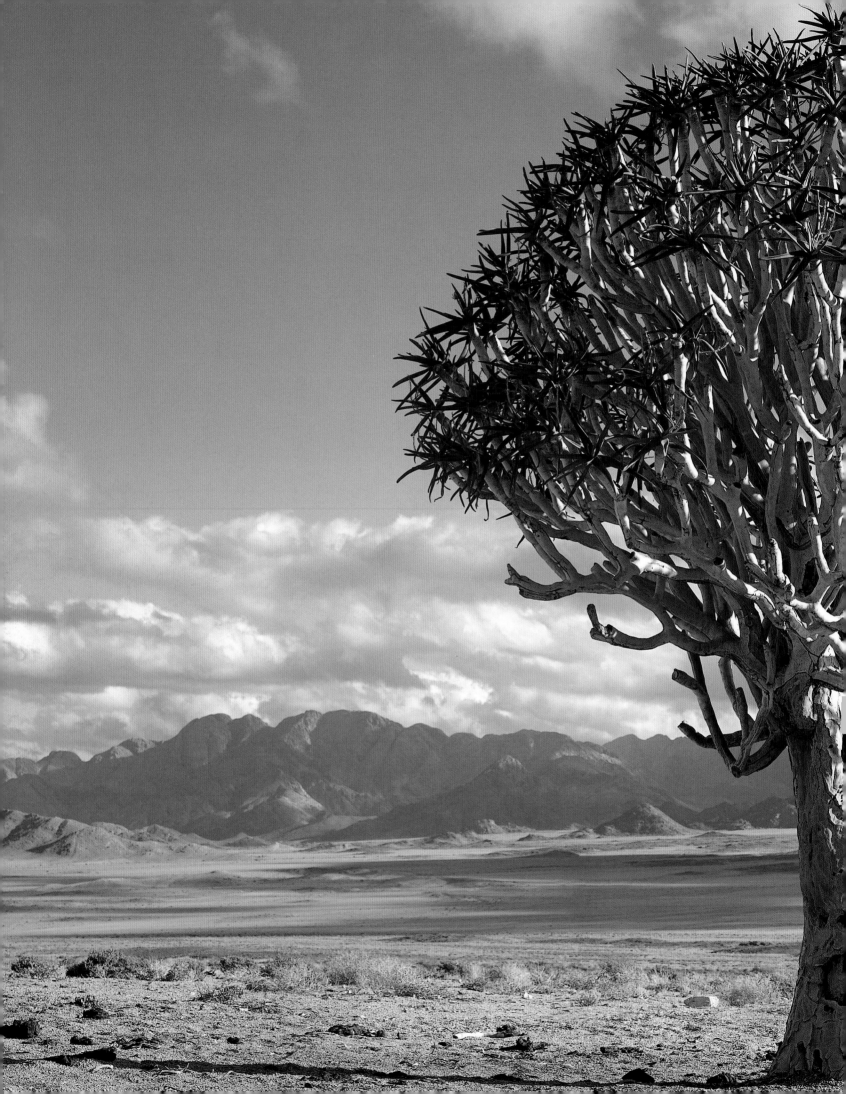

More Beasts

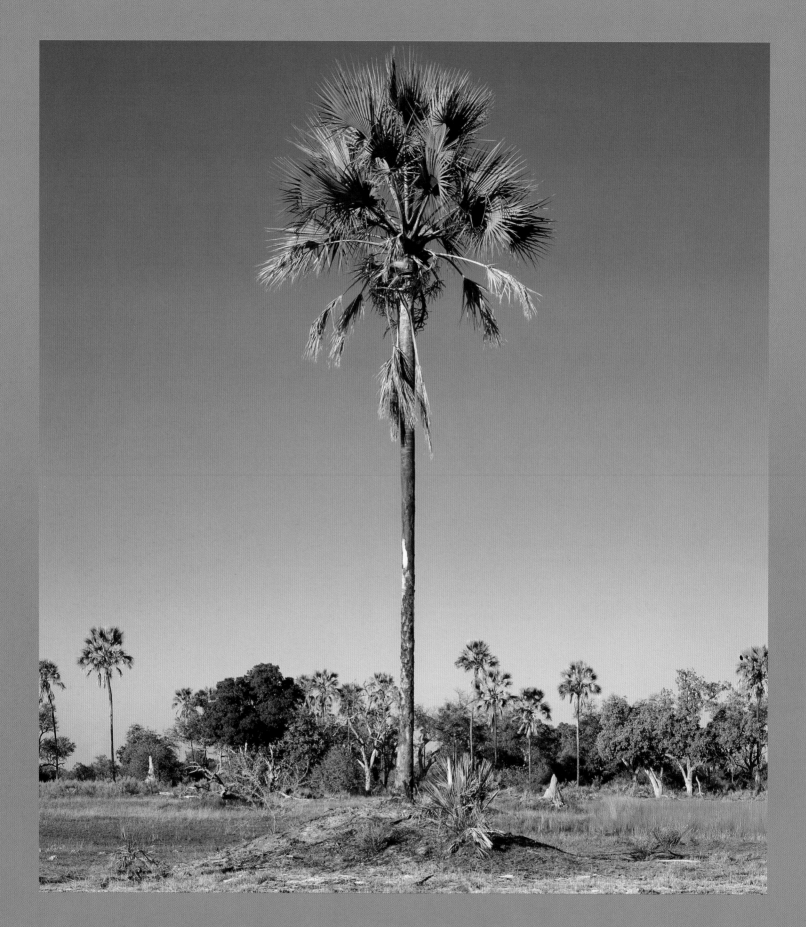

Where the Elephants Rule

Try a Glass of Palm-Wine

FROM THE SHIMMERING salt-pans of Ntetwe in Botswana it's only half an hour's flight to the steamy swamps of the Okavango.

I flew with Prospero and four other friends in Papa Juliet Tango, and in a second similar tan-and-white Beechcraft belonging to a friend, Tommy Crowe. It was July 2005 — in time to catch the Delta in flood. We landed at Maun, the nearest town, and changed planes to a high-wing monoplane belonging to the owner of Oddballs Camp where we were heading.

The Delta was spread out below the plane's wing in the shape of fan — or the frond of a fan palm — a hundred miles long. It's a primeval landscape where the wandering of the river owes nothing to man. (Think of the long-suffering Nile by comparison, a prisoner for 5,000 years in a maze of irrigation ditches.) The Delta here has, however, a split personality. For most of the year it's a wilderness of low, brown hills bisected by one large river, the Okavango. But when the flood comes down from the mountains of Angola and silently takes over the landscape, the brown hills become an archipelago of green islands. From the air we saw no sign of life except some meandering paths, worn by buck or elephant, cutting across the green islands. There was also a self-important motor boat steaming down the main channel to Maun.

Oddballs Camp, where we stayed, was built about twenty years ago by one of the pioneers of

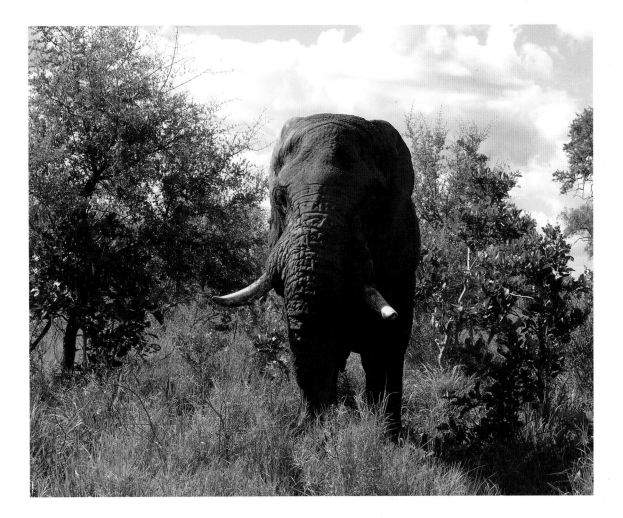

Previous pages: *Lone kokerboom (quiver tree) in the Richtersveld National Park, Western Cape.*

Left: *Grove of real fan palms at Chief's Island in the Okavango Delta.*
Right: *Bull elephant in must in the Kruger National Park.*

tourism in the Delta. It has a small, wooded island to itself, facing Chief's Island, the main island in the Delta. In fact Oddballs comes in two versions. There's the up-market camp, complete with a honeymoon suite in a tree-house at the east end of the island (this was out-of-service when we there); and the down-market camp, a place of 20 simple green tents among the palm trees, and a dozen dug-out canoes splayed out on the river bank. The tents are built on wooden platforms, to keep out intruders like hyenas and lions. There are no cars or motor-boats — not even fibreglass canoes. At Oddballs you are punted about in your dug-out canoe or *mokoro*. All this suited me perfectly. My aim was to find an exceptional specimen of the real fan palm (*Hyphaene petersiana*), which makes its home here. It's one of the most elegant and at the same time most useful palms known to man.

At dusk on the first evening we heard an eerie sound of thumping. We were told not to worry. A pair of elephants had invaded the camp and were shaking some fan palms violently from side to side, bringing down a shower of palm-nuts for the elephants' evening meal.

We set off soon after dawn, two of us and a guide in each *mokoro*. At breakfast one of our party, who happened to have worked at Oddballs himself when he was a student, told us a story about the chief guide. 'One day he took out an American couple in a *mokoro*. He stood in the back of the boat and put down his punt-pole in order to study an unusual bird through his binoculars. Suddenly an enormous crocodile rose from the water and grabbed him by the feet, and he disappeared. The American couple stared in disbelief. Then the chief guide re-appeared, said "get me a knife", before disappearing forever.'

I can't say I felt cheered by this story. Soon after we set out, a hippo rose with a bellow a couple of yards ahead of the *mokoro* where I was the front passenger. 'Oh, my God,' I heard myself say. Our guide punted us hastily back to safety. Although hippos do sometimes attack people, they normally keep to the main channel during daylight and can easily be avoided. I suppose our hippo, lying submerged in our path, was either deaf or absent-minded.

We found a fine fan palm among a colony of ant hills on the sandy shore of Chief's Island. This was a typical site, I was told. Like the mashatu I saw by the banks of the Limpopo, the fan palm adores ant hills, because the ants enrich the soil with nutrients. This specimen was unusually tall — perhaps 70 feet high — and its huge leaves flashed in the sun like propellers. I noticed that half-eaten nuts littered the ground under the tree. 'Elephants are messy feeders,' said our black guide, Jack, disapprovingly. 'So are baboons.' I gathered that the local villagers treated the fruit pulp as a delicacy — it tasted rather like gingerbread — and I heard that the flower bud was finer than asparagus. Best of all, the sap of the fan palm makes a delicious wine. They tap the tree, and the sap runs out by the gallon. Then you mix it with sugar and leave it a few days to ferment. 'Man, that stuff could drive even an elephant crazy.' (The operation is also lethal to the tree.) Other products of the fan palm include basketware made from the leaves. This is ornamented with handsome zig-zag patterns and is so closely woven that I believe you can use the baskets as beer bottles.

On our way back to camp I landed at the east end of the island to photograph a second fan palm. The tripod was soon set up in the high grass, and I was stooping over my camera bag when there was a thunderous roar. A bull elephant appeared out of a small wood about eight or ten yards away, and charged straight for us.

Fortunately I was too surprised to be frightened. My companions pushed me violently to the ground — rather the way that Secret Service agents would push an American president to the ground to save him from assassination. The next moment I found myself scrambling up a staircase which spiralled up into the palm trees. By an odd chance the elephant must have established his territory in the up-market camp. Soon we stood 40 feet up on the balcony of the honeymoon suite, as we watched the angry beast retreat the way it had come.

I don't know why it had taken against us. Perhaps it felt threatened — a compliment to us, I suppose. Or perhaps it had merely drunk too much palm wine.

Real fan palms in an oasis in northern Namibia.

Livingstone's Sausages

When God made the sausage tree (*Kigelia africana*) he must have felt it needed no other purpose than to amuse. It's the most comic of species. From the lumpish canopy hangs down a crop of amazing green sausages more than two feet long and weighing up to 25 pounds. But far from being useful to man or beast, these absurd fruits are toxic to both. All one can say is that the wood doesn't split and so makes a good stout *mokoro*.

I had flown to Zambia with a party of daredevil friends eager to go white-water rafting at Victoria Falls, rightly regarded as a wonder of the world. For myself, I wanted to stand on the left bank of the Zambezi where David Livingstone stood in 1855, and later wrote in his account the famous sentence describing the view of the falls: 'It had never been seen before by European eyes; but scenes so lovely must have been gazed upon by angels in their flight.' Livingstone had camped in this paradise overlooking the falls, pitching his tent under a huge sausage tree.

Well, where was that sausage tree now? My friends went off cheerfully to descend the falls in inflatable rafts (I mean, the rapids *below* the falls, but the rapids, they were delighted to find, were big enough to flip over their raft). I struggled through dense bush looking for the sausage tree. My search was in vain, although I saw a baobab with a sign saying 'Livingstone's Baobab.' It seemed small beer after some of the giant baobabs I had seen in Botswana and Namibia. And I doubted whether this was really the tree Livingstone described at Victoria Falls. 'There, towering over all, stands the great burly baobab, each of whose enormous arms would form the trunk of a large tree.' However, I hear that this modest-sized baobab was once unusually tall but lost its head in a storm.

Could Livingstone's sausage tree be on the other bank of the river, that is, on what is now the Zimbabwean side? Foreign tourists are not too common in this troubled republic, but I found a

warm welcome when I walked across the elegant bridge which faces the Falls. The Falls Hotel provides delicious sausages for breakfast. But, alas, not a whiff of the tree.

We made a final attempt to trace the tree when we took a canoe to Livingtone's Island, which he describes at some length in his book, *Missionary Labours*. Livingstone must have had a cool head, as the island is perched on the very lip of the precipice in the middle of the Falls. I found the

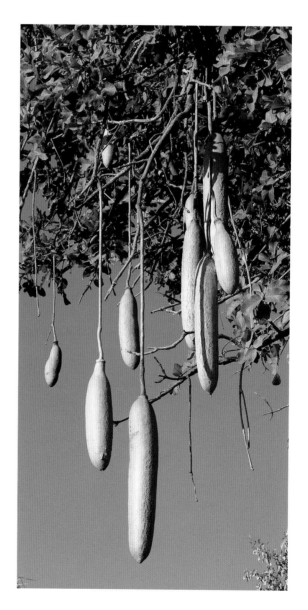

Above and left: *Sausage tree e in the Kafue flood plain, northern Zambia. Not a good place to pitch your tent.*

journey somewhat alarming. But the canoe trip was nothing compared to the surreal swim to which our guides invited us. At low water, as it was then, you can swim to the very edge of the abyss as though bent on self-destruction. Was I a man or a mouse? I had left my bathing costume back at the camp. Otherwise I would of course have been the first to risk my life plunging into the roaring water.

There are days when the tree-hunter brings nothing back to the pot. Livingstone planted a hundred peach and apricot stones on the island which now bears his name. Somewhat sheepishly, he also carved his name on a tree — perhaps a sausage tree — with the date 1855. ('This was the only instance in which I indulged in this piece of

vanity.') But we could find no trace of either the trees or his signature. A terrifying night ride down the Zambezi in a small canoe, slaloming in the rapids, to avoid hippos and crocodiles, brought the tree-hunt to its conclusion. And Ole Man Zambezi, like Paul Robeson's Mississipi, didn't say nothing, he kept on rolling, without a sausage in sight.

It was days later that I found a pleasantly ridiculous specimen near the River Kafue and photographed it. The tree is like a drawing by Edward Lear. The sausages were champions: nearly 20 pounds in weight, I guessed, and nearly three feet long. If one of them happened to fall on one's head it would have been no laughing matter. Unlike Livingtone, we took no chances. We pitched our tent well away from the tree.

The Anabooms of the Chongwe

FROM VICTORIA FALLS we flew in our Beechcraft formation to a small camp in the bush, where the River Chongwe flows into the lower Zambezi. I had come to see the spectacular groves of ana trees. It was not a dull flight.

Our pilots took us low over Lake Kariba, the man-made lake and hydro-electric scheme created in the 1960s by damming the Zambezi. Tens of thousands of trees were drowned as the waters rose, including some large and beautiful baobabs. It was well known that some of these trees were regarded by the local people as the home of their ancestral spirits. So the authorities decided that, before the waters reached the baobabs, someone should ritually break off a branch from each tree and thus conduct the ancestral spirit to a new home in a baobab left above the water-line. The plan was carried out with due ceremony. But the engineers in charge of the project had a less spiritual concern. They forecast, that if the baobabs were simply left to drown, their corpses would eventually clog up the turbines. So millions of pounds were spent trying to exterminate the baobabs — both with bulldozers and high explosives — before it was too late. The job was only half complete when the dam filled up. But the engineers had miscalculated. The remaining baobabs didn't clog the turbines. So full of air is the wood of this remarkable tree that each drowned baobab rose to the surface like a cork and could be safely towed to the shore.

We flew low over the shore and we could see some large baobabs which had, presumably, recently made room for ancestral spirits. They looked very happy. Then we skimmed the surface of the vast blue lake itself, and vultures flew over us like pistol shots. 'Safer to go low', said our pilot, and who knows, he may have been right. As it was we flew over the lake *below* tree height — the trees being the tops of forests of dead trees (not baobabs) projecting from the water.

The camp at the Chongwe proved as welcoming as we had anticipated. The tents were pitched a few yards from the river bank, and a family of rhinos gambolled in the shallows. Crocodiles slithered down the river banks as we went fishing for tiger fish in a small red boat with an outboard. The camp was open to elephants at any hour of day or night. (In fact, my neighbour at lunch, a boy of 15 who had just arrived from England, said he had been surprised to find an elephant's trunk exploring the open-air bathroom when he was in the middle of taking a shower.)

Best of all are the ana trees or anabooms (*Faidherbia albida*). This species is the largest, fastest- growing and often best-looking of all the far-flung family of acacias. In good alluvial soils it can throw up a spire 100 feet high, and grow as fast as the finest poplars in Europe — more than 6 feet a year. The trunks are yellow or silver and the leaves a silvery-blue. Here at the Chongwe, their luxuriant winter foliage was pruned and twisted into strange shapes by the local elephants. But they had survived attacks that had eliminated most of their rivals. In fact the elephants seemed to have played the same violent role in dealing with the anabooms' rivals as forest fire plays in the life of the giant redwoods of California. The trees could survive — just — and the competitors could not.

Talking of Californian redwoods, I am told there is an exceptionally tall group of anabooms about 10 miles north-west of Mokopani in Limpopo Province. Eugene Marais, the author, loved these trees and declared that they were actually taller than the redwoods of California. The authorities were impressed, and the trees were officially designated a national monument. Experts recently examined the trees and took accurate measurements. Authors can be forgiven a little hyperbole, and their claims should be taken with a pinch of salt, besides, Marais was not only famous as a writer; he was famous as a heroin addict. The measurements showed that the trees were just short of 80 feet high — a quarter of the height of the tallest redwood in California. I am delighted to say the trees are still national monuments.

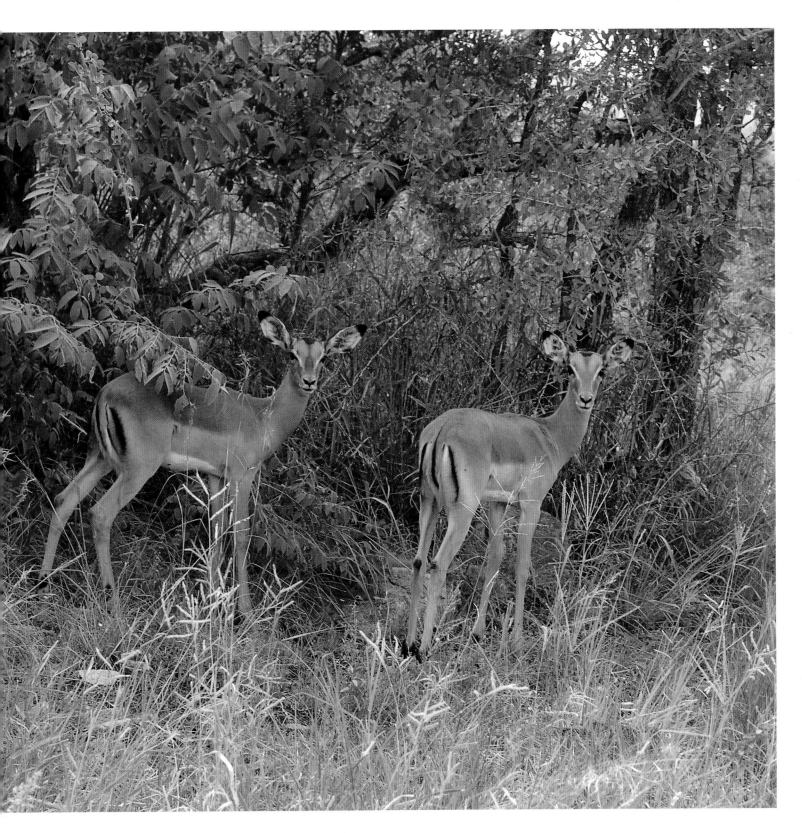

Grove of anabooms beside the Chongwe River, Zambia. Paradoxically, the foliage is at its most luxuriant in winter when other trees are leafless. But here the anabooms have been pruned by elephants.

Just the Tree for a Necklace

THE FLOWERS of the pod mahogany (*Afzelia quanzensis*) have a touch of magic by all accounts. In spring the green buds open one at a time to produce four green, boat-shaped sepals. Out of the sepals comes a single flaring, reddish petal and an explosion of yellow stamens. The flowers vibrate with bees and other insects beguiled by the smell. I missed the flowers, alas. It was autumn when I went down to Tembe Elephant Park, on the border of Mozambique, to explore the forests of pod mahogany. But the ripe pods are worth a king's ransom.

Imagine a jeweller's case, lined with white silk, holding half a dozen jet-black jewels topped with scarlet. This is what you find, more or less, when you break open the eight-inch long, brown, curved, woody pod of a pod mahogany. To a botanist they are beans — shiny, black, oblong beans with a red aril, arranged in a white pith. To the Zulus this has always seemed the most poetic of trees. It's the *mkehli*, meaning 'the betrothed'. The shiny black beans topped with the red aril represent the Zulu maiden wearing the romantic red-ochre head-dress in the weeks before her wedding.

The timber, too, has its romantic uses. The heartwood is exceptionally hard and the tree can laugh off an attack by termites. So the pod mahogany is the chosen material in Zimbabwe for drums and in KwaZulu-Natal for ornamental carvings. Unfortunately the tree is becoming rare in southern Africa, and we saw only one or two of any size. The first settlers stripped it from the forests to build their ox-wagons, bridges and their railways; the wood is perfect for railway sleepers.

Tembe is full, but not too full, of elephants. So the pod mahogany trees were well respected. Elephants and baboons munch the pods, but they had kindly left plenty for us. I took back a basketful. You can buy a necklace or a charm bracelet made from the black-and-scarlet beans — the curio shops are full of them, but I'm sure they cast a stronger spell if you make your own. And the beans, like so many African seeds, roots and bark, have a medical as well as a magical purpose. Have you developed an unpleasant tropical sore? Well, grind up that black-and-scarlet bean and mix it with python fat. Then rub it on the affected place. In KwaZulu they say it never fails.

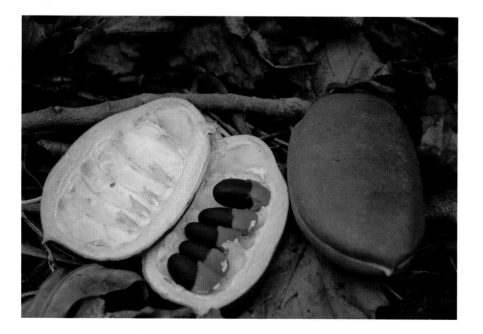

Above: *Young pod mahogany tree in Tembe Elephant Park, KwaZulu-Natal.*
Left: *The pod is like a jewel case inside.*

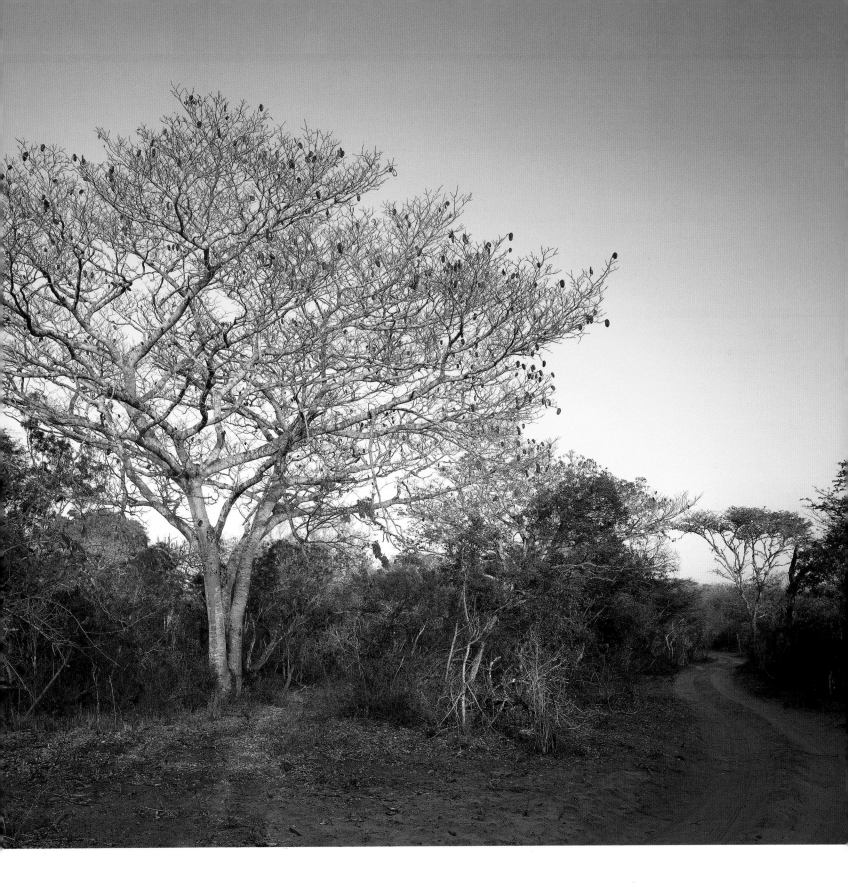

Fever and Weavers

IN KIPLING'S TIME, as his Elephant Child discovered, the great, grey-green, greasy Limpopo was 'all set about with fever trees'. And Kipling would be relieved to hear that it's still like that today. In fact the brilliant yellow bark of the fever tree catches the eye all over the north-eastern lowveld, especially along the banks of the great rivers and in the flood plains. As a tree enthusiast, I often confess myself stumped by some species of thorn-tree — for this huge genus of acacias is, in every sense, thorny. I breathe a sigh of relief when I encounter a fever tree (*Acacia xanthophloea*). The powdery, yellow-green bark makes the tree unmistakeable. And I don't mean simply the trunk. The whole tree, from the bole to the twigs in the canopy, is painted this eerie, jaundiced colour.

In Afrikaans it's the 'koorsboom', which is the same as fever tree in English. And the name fits perfectly. Of course the tree is not guilty of spreading malaria — as was once believed. (I have heard the story that people, when passing a fever tree, used to hold their noses.) Ever since the 1890s it has been recognized that the anopheles mosquito, not the tree, carries the malaria parasite and is thus the most successful of all man's enemies. But the tree much prefers malaria country: low-lying creeks and swamps. That and its eerie colour have given it this sinister name.

I know two game reserves notable for their fever trees — although I'm sure there are thousands of other noble specimens up in the wilder parts of the lowveld.

The first is the Gettys', the private reserve at Phinda, which includes about ten miles of river bank and flood plain. It's a magical place, a natural sanctuary for every kind of animal, including giraffes, white rhinos and lions. Unfortunately, too many elephants have recently been introduced into this game reserve — too many, as the fever trees would see it. The elephants are refugees from the surplus in the Kruger National Park to the east. Many of the best fever trees have been knocked flat by these newcomers in the last few years, as the elephants are impatient to browse on the delicate green leaves of the canopy and the yellow trunks are too frail to resist. After a search, Hendrik, my guide, succeeded in finding me a fine specimen crowded with the nests of weaver birds and of a solitary eagle.

The second is the Ndumu Game Reserve which straddles a flood plain on the border with Mozambique. Beside a small lake, there's a forest which is alive with magnificent fever trees. It's also alive with magnificent crocodiles. Apparently, as soon as the sun rises in winter, they leave the lake and sun-bathe on the muddy banks. I decided to try my luck there in July, the middle of winter. My guide was Elsa Pooley, the distinguished naturalist, whose late husband, Tony, was a world-renowned authority on crocodiles. To photograph the finest fever trees I needed the goodwill — the permission, so to speak — of those magnificent crocodiles. 'And why not?', said Elsa as we drove in a borrowed game car down the track alongside the blue waters of the lake. 'In winter, you see, crocodiles are quite harmless. The air is too cold for them to work up an appetite.'

There are times when the amateur must respectfully set aside the advice of the expert. I did not approach within a hundred yards of the crocodiles. I took my photographs from the security of the game car. Elsa may well have been right. But the proof of that pudding would be in the eating.

Below: *Fever trees at Ndumu Reserve, KwaZulu-Natal, and 'harmless' crocodiles.*
Below right: *A fever tree at Phinda Game Reserve, home to weaver birds and an eagle.*

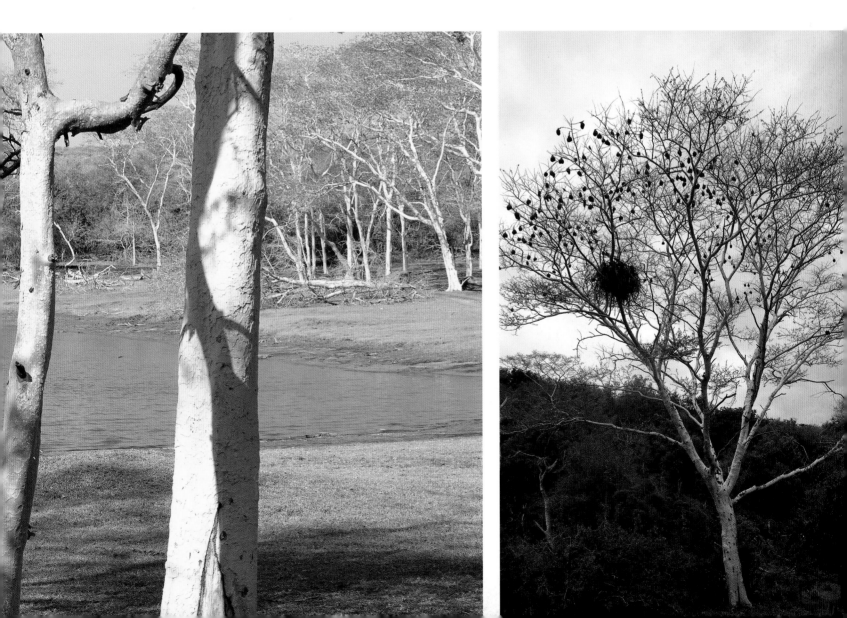

A Whiff of Squashed Sesame

NO TWO BOTANISTS will ever agree where to draw the line dividing a bush from a tree. So I am not surprised that some botanists pay the Limpopo sesame bush (*Sesamothamnus lugardii*) the compliment of calling it a tree. And why not? It can grow up to 15 feet high with a belly as swollen as a miniature baobab's. In February 2007, I found a whole grove of them growing within sight of the shepherd's trees in the sandy bushveld on the Botswana side of the Limpopo. Many of them had been upended by elephants and they had the whiff of squashed sesame — or what I took to be that. The one I have chosen is one of the most tree-like and least damaged.

The sesame family, Pedaliaceae, is small and mysterious. These spiky trees are only distant relations of the sweet-smelling sesame herb made famous by the story in the Arabian Nights when Ali Baba learns the secret password of the Forty Thieves: 'Open Sesame!' There are three species in southern Africa and the Limpopo or Transvaal sesame is the best known. Some writers have called them grotesque. I would certainly admit they are bizarre, like most succulents. From the swollen belly rise a number of spiny trunks and branches which taper so rapidly that they look more like

roots. In fact, like the baobab, you could call this the 'upside down tree'. But in every other respect the sesame bush could hardly be less like the baobab. The bark is grey or yellow with black markings. The leaves are tiny and grow out of the axils of the branches — that is, from the angle where the spines project from the branches. Most striking, the flowers appear before the leaves — and their elegance is overwhelming in such a strange, spiky creature. We saw the last of them lying discarded in the sand. They are white inside, pinky-white outside and they smell delicious.

Who was the Lugard who gave his name to this particular species? I believe that botanists cannot agree which of two English brothers were being honoured when a German botanical explorer, the celebrated Friedrich Welwitsch, named the sesame bush. Was it the polished imperial statesman, Lord Lugard, the man who in 1892, with little to help him except his Maxim gun, saved Uganda from the French? Or was it his obscure younger brother, Major Edward Lugard, who went lion-hunting in the Kalahari desert in the 1890s? It would be much more fitting if it was Major Edward. He hunted plants as well as lions. He was also like the sesame bush: a strange, spiky creature himself.

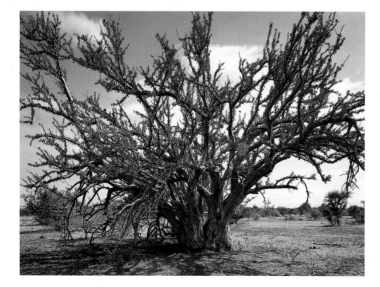 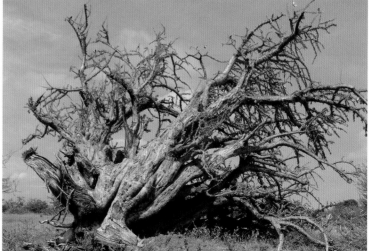

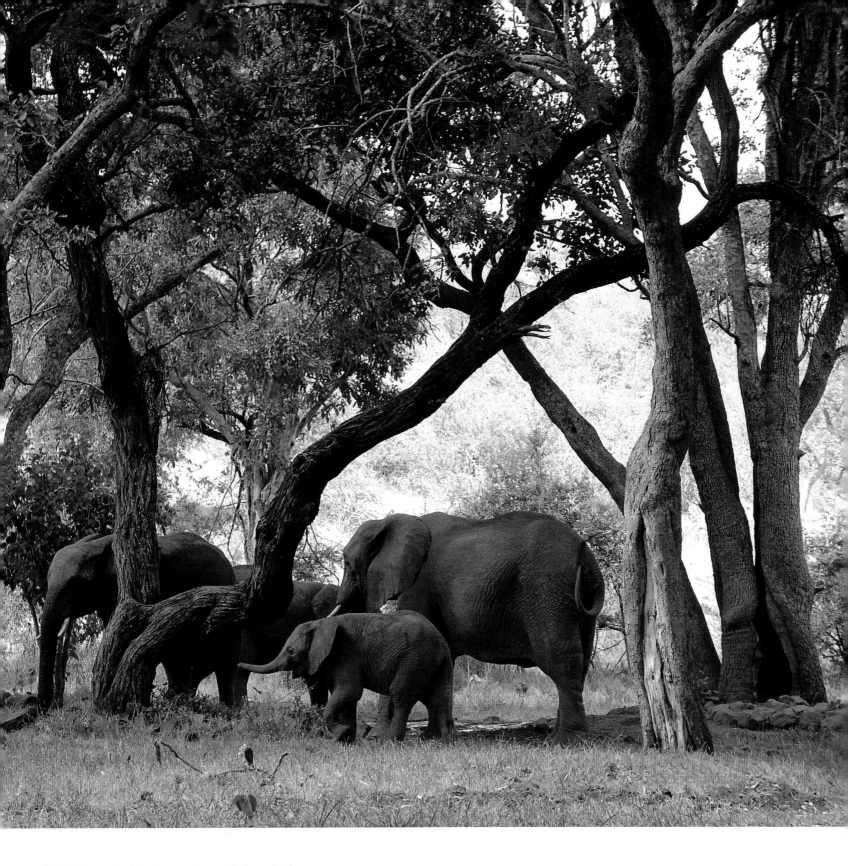

Far left: *Sesame bush in the Charter reserve, Botswana.* Left: *A bush knocked over by an elephant.*

Above: *Elephants drinking from the bore hole at Megwe Camp in the Charter Reserve, Botswana. Not as cuddly as they look.*

The Tree with a White Behind

I HAD LONG WANTED to photograph a large, white shepherd's tree. Its chalky whiteness has always fascinated people. Afrikaners use the earthy name of 'witgat', meaning 'white behind'. Botanists know it primly as *Boscia albitrunca*, the *Boscia* with a white trunk, and the name given it by the artist and naturalist, William Burchell. The trees wander across a wide arc of Namibia, Botswana and the arid north and western districts of South Africa. But good specimens always eluded me until, in February 2007, I found a whole flock of shepherd's trees down in the hot, sandy bushveld beside the Limpopo.

Miraculously, the elephants that had upended most of the other small trees had left the shepherd's tree unharmed. It made good sense, as the trees provide elephants with excellent fodder from their olive-green, leathery leaves. Many other animals will also browse on the leaves and gnaw the trunk in time of drought — especially game animals, monkeys, goats, donkeys and horses. (Although sheep, strange to say, are not much involved with the shepherd's tree. I suppose the trunks are too tall for the tree to offer sheep much except shade.)

For farmers the tree has always been a godsend in difficult times, providing extra fodder for their cows, although the leaves can taint the milk. During the second part of the Boer War, in 1900–1902, when the Boers on commando were fighting a guerrilla war against the British, the Boers ran out of supplies of coffee. The roots of the shepherd's tree, roasted and ground, made an excellent substitute —'witgatkoffie' ('white-bum coffee'). The roots, dried, ground and sifted, can also be used to make a kind of porridge or a kind of syrup. And, when pulverized, the roots, according to some authorities, have the miraculous effect of preventing milk from going sour and butter from going rancid. Its flower buds, when pickled in vinegar, are said to taste better than European capers.

What are the drawbacks? None, as far as I'm aware. This tree is a paragon. I would certainly take it to my desert island if I was only allowed to take one tree. In spring the neat, round, evergreen canopy bursts into a crop of small yellow-green flowers with a heavy, sweet scent. Butterflies — the Brown-veined White and the Queen Purple-tip — find them irresistible.

Well, perhaps there is one drawback after all. The shepherd's tree looks remarkably like its close relation the stink shepherd's tree or 'stinkwitgat' (*Boscia foetida*), which lives in the same hot, dry bushveld. We saw plenty of these spiky, grey-trunked creatures down by the Limpopo and it would have been easy to confuse them with a real shepherd's tree whose white trunk had been gnawed by an elephant. Imagine taking the wrong tree to one's desert island! Fortunately they were out of flower when we passed that way. But I believe they are aptly named and their yellow-green flowers stink to high heaven.

Shepherd's tree in the Charter Reserve. Its companion stinks to high heaven.

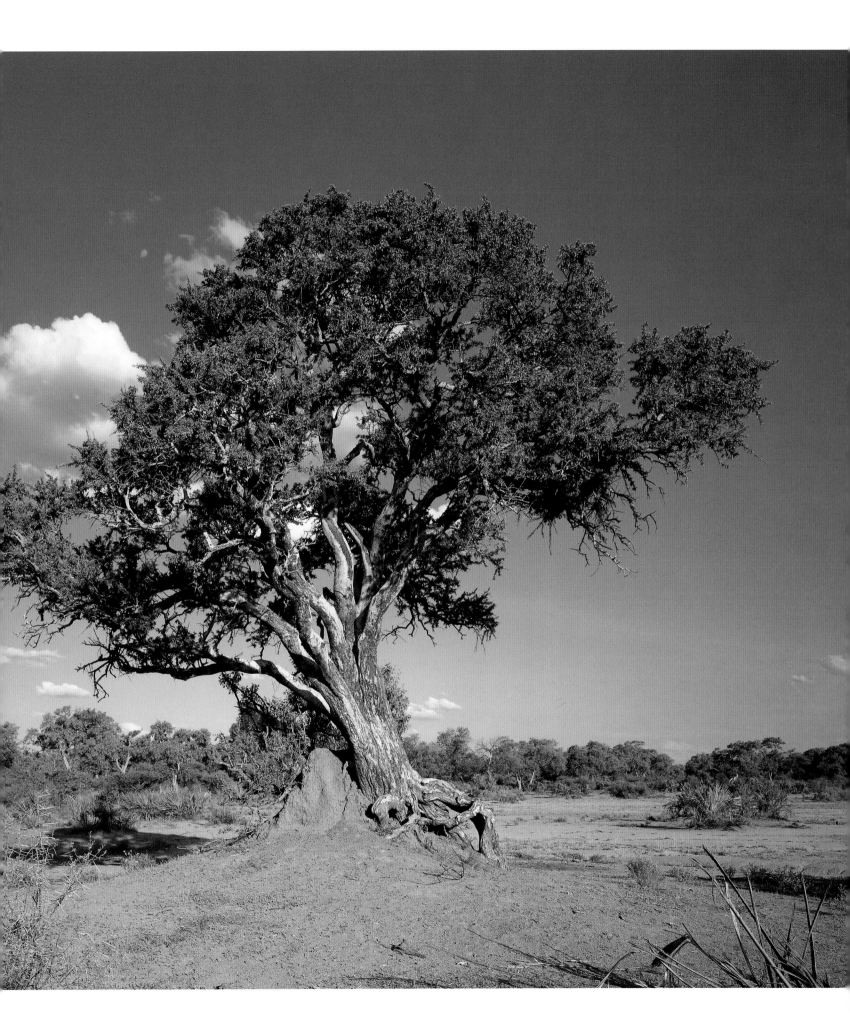

'I Greet Thee, O My Father'

When I first came out to South Africa nearly 40 years ago, I had never heard of leadwood, alive or dead. Then I saw the elegant, twisting pillars on the stoep of a friend's house. They were made of leadwood so hard that they could almost have been made of stone. (Later I heard that the Venda name for it means 'stone tree'.) We have our own equivalent in Europe — the sombre common yew — which looks noble when it's dead. In fact yew wood is so hard and heavy and durable that a dead tree can stand up in the woods for fifty years without much sign of decay. But the leadwood (*Combretum imberbe*) makes an even more elegant corpse. Count Dracula would have felt at home with this tree. In fact you could almost say that the leadwood only comes alive when it's dead.

In January 2007, I photographed one of the biggest living leadwoods recorded in the Kruger National Park. It dominates a small grassy clearing in the bush, just across a bridge, where the camp authorities allow trippers to make a *braai*, and have a bash in the bush. I'm sure people sing incongruously jolly songs under that tree. And I bet the tree is not amused. It's a morose looking creature with small green leaves and a double trunk. Not very impressive, to be honest. Think of some of the other happy trees in this national park, especially the great sycamore figs and the mashatu along the river banks. The best you can say about a living leadwood is that its whitish-grey bark is its most elegant feature. It cracks into

small squares or oblongs, rather like the bark of the common European oak.

Down in the flood plain of the Limpopo, on the Botswana side, I hunted down another even bigger living leadwood. This is in the Charter reserve where elephants have recently wreaked havoc on most of the trees. The leadwood has roots like steel and this giant specimen shows no sign of elephant damage. Yet this tree, too, was curiously unimpressive. To an eye accustomed to the big beasts in the forests of Europe — the ancient oaks at Bialowieza in Poland or the towering beech in the forests around Brussels — a leadwood hunt is something of an anti-climax.

Left: *Two dead leadwoods in the Charter Reserve, perhaps killed by elephants.*
Right: *One of the champion leadwoods of the Kruger National Park.*

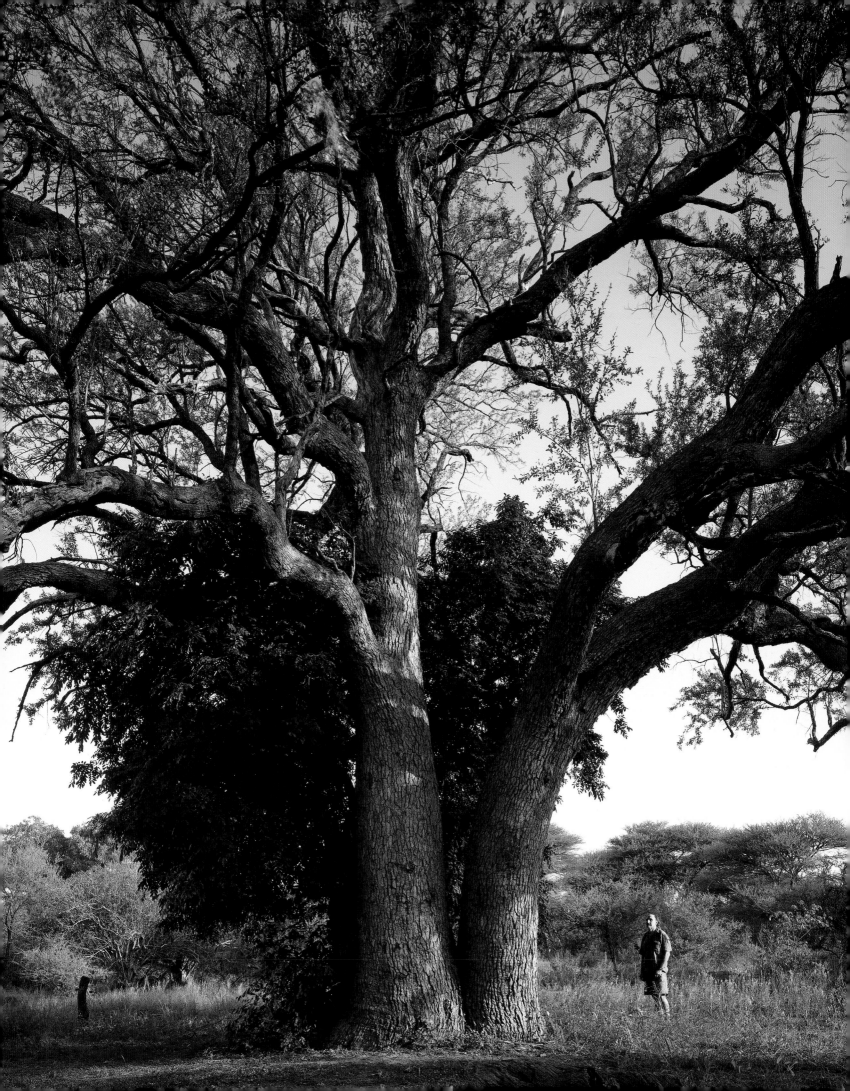

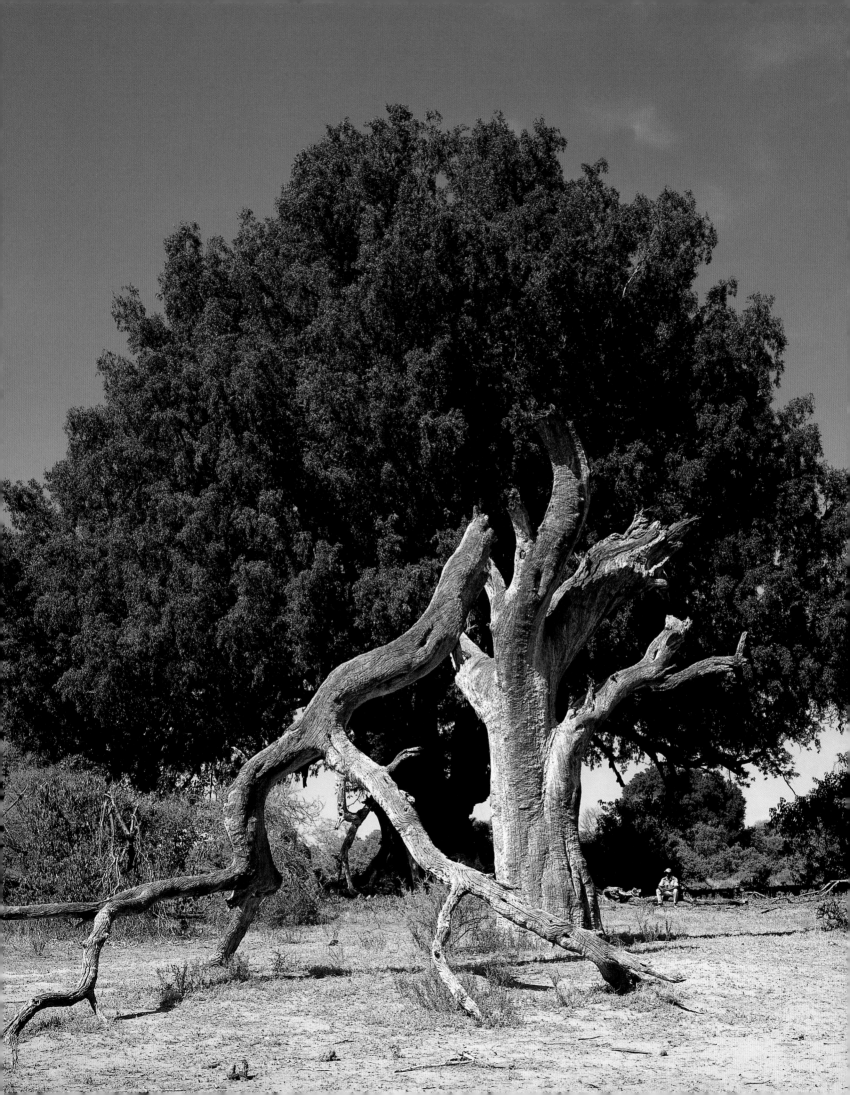

Only a mile from this spot I found what I was looking for, one of the most handsome leadwoods you could imagine. Its grey trunk soared to the heavens, set against the huge bulk of a mashatu on the river bank behind it. One of its branches had been torn off, perhaps by a storm. The branch still rested beside the trunk although it might have fallen long before, for the handsome creature had been dead for many decades.

Appropriately, in the north of Namibia the Ovambo and Herrero people treat the leadwood with the respect due to a dead ancestor. They believe that the stump of a dead tree, still visible in southern Ovamboland, is the remains of the ancestral tree from which the whole of creation — sheep, cattle, lions, elephants, and humans — actually descended. So every Herrero and Ovambo who passes a leadwood, dead or alive, duly addresses it with the words: 'I greet thee, O my father. Grant me a prosperous journey.'

Left: *Dead leadwood in the Charter Reserve. Count Dracula would have felt at home.*
Right: *Detail of a dead leadwood in the Okavango Delta.*

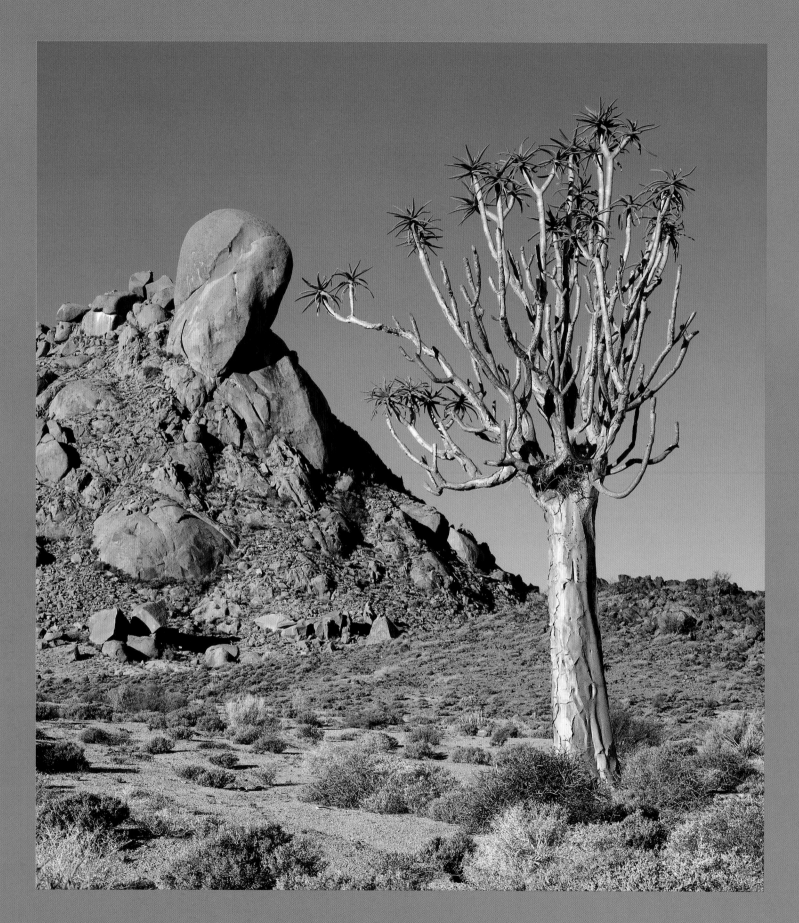

Nomads

Vanishing Kokerbooms

FOR A FEW WEEKS in winter the yellow flowers of the kokerboom (*Aloe dichotoma*) enrich the wastes of the north-west Cape and Namibia. They smell like honey and are soon a honeypot for mousebirds and sunbirds and bees, all feeding on their nectar. Baboons and monkeys — and children — are less considerate. They eat the flowers whole.

The kokerboom is the most spectacular of the 130 or so aloe species that flourish in southern Africa, mainly in the areas plagued by drought. Most of them are only elegant shrubs, whose flowers range from scarlet to orange, from pink to yellow. Kokerboom means 'quiver tree'. The name was given to it by Dutch immigrants who noticed that the Bushman and Hottentots used hollow branches as quivers for their arrows. In fact, the tree is a monocot like a palm and belongs, incongruously, to the 3,000-odd species of the far-flung lily family, the liliaceae. So its wood is not solid, but a pithy material as light as balsa wood or papier mache. You can pick up a whole tree, once it's dead, a tree with a girth of three or four feet, and sling it theatrically over your shoulder, swollen trunk, massive branches and all. I have tried this trick myself.

The tree does indeed look like a stage prop, an inflatable rubber tree, with bright blue ends to the branches, and yellow, flaking bark that seems to be losing its paint. Inevitably it has been beset by admirers. In the small towns near the Orange River you can see many a kokerboom exile — a handsome tree ripped up from the veld and still unreconciled to life in the suburbs.

Fortunately I was able to track the spoor of the kokerboom to both of the fiery deserts where it's most at home. The place to see kokerbooms at their most dramatic is the nature reserve in the Richtersveld, a theatrical promontory of South Africa projecting into Namibia. To the north it's enclosed by a loop made by the Orange River before it dives into the icy water of the south Atlantic. The scenery is extravagant: Namibia on one side of the river, terrace after terrace of stony mountains; and in the Richtersveld, a landscape of desolate plains and monstrous granite boulders precariously perched on hill-tops and hill-sides. The most monstrous of all is Die Toon ('the toe', though I can think of a ruder name) where we pitched our camp.

The second place to see them is in southern Namibia, near the small town of Keetmanshoop. For many years tourists have flocked to see this extraordinary forest: 200 or more kokerbooms jostling for space in a stony plateau of scarlet rocks and green sage bushes. I arrived there in January — high summer and too late, alas, for the yellow flowers. My companions included Beezy Bailey, brother of Prospero, and a most accomplished artist. Beezy launched himself boldly at the kokerbooms, working in the sun which could have roasted a pig on the car bonnet. He captured three magical trees for his canvas. I waited for the cool of evening and was rewarded with an operatic thunderstorm — drenching me a few moments after I'd snatched the crucial photographs.

In the Richtersveld, the oldest kokerbooms might be a century old and, more than most old creatures, they face the photographer with a look of exhaustion. Sadly, they are dying out, and dying out fast, here in the driest part of the Northern Cape. We saw numerous dead trees, some of which could only have collapsed a year or two ago. We saw no young trees ready to succeed them. What's the explanation for this grim state of affairs? Global warming according to one of the experts who's been coming to the Richtersveld for more than thirty years. He believes that the rainfall, always marginal, has finally shifted against the kokerboom. I hope he proves wrong. But in case he's right, don't lose a moment in planning your trip to Die Toon.

Lone kokerboom at the entrance to the valley of Die Toon ('The Toe') in the Richtersveld National Park, Northern Cape.

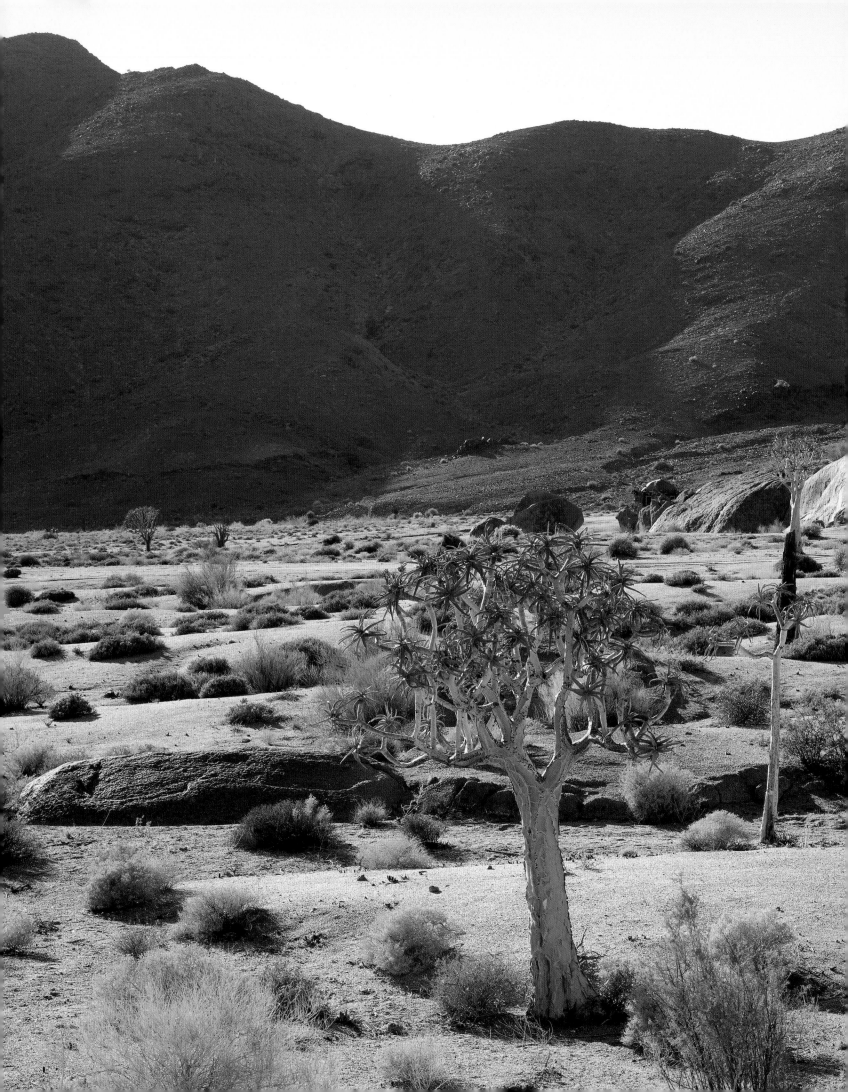

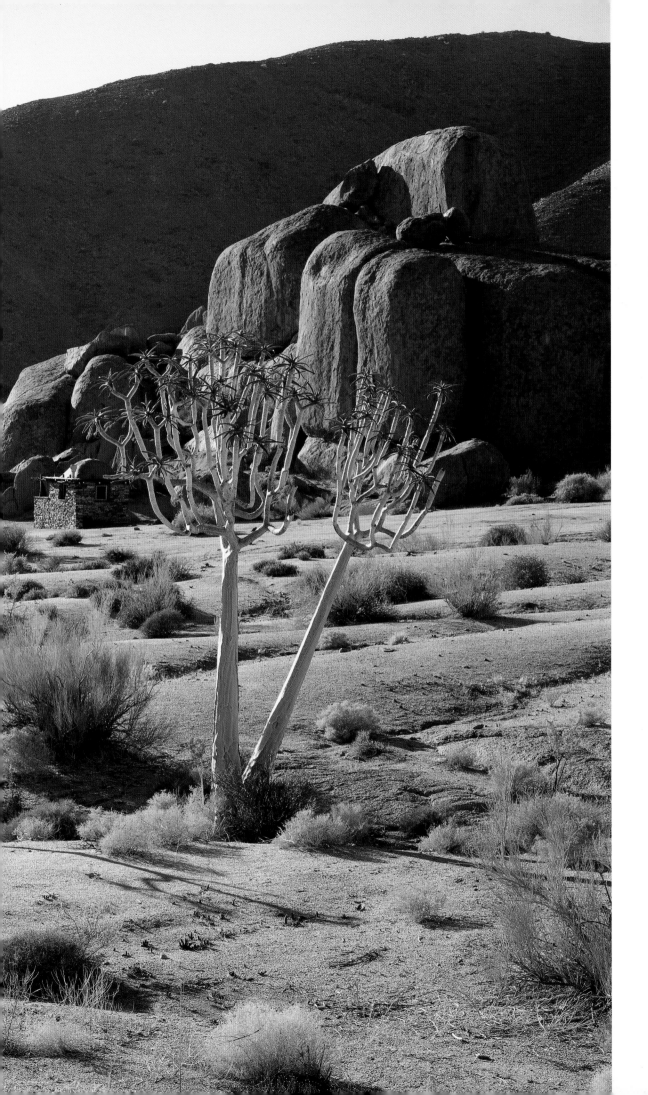

Kokerbooms among the granite boulders of Die Toon. The trees are dying off, and global warming seems to be the cause.

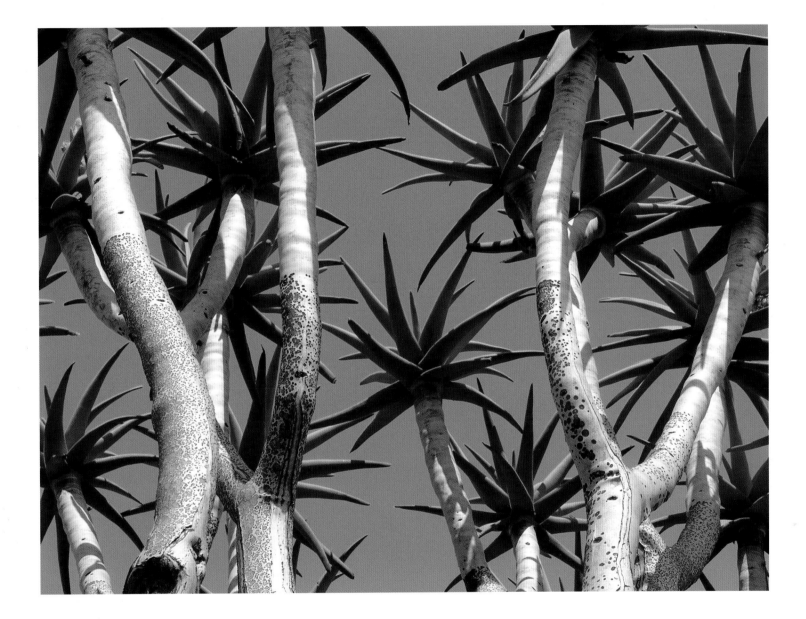

*Details of the kokerboom
forest near Keetmanshoop in
southern Namibia. The tree
resembles a stage prop.*
Left: *Flaking bark.*
Above: *Leaves.*

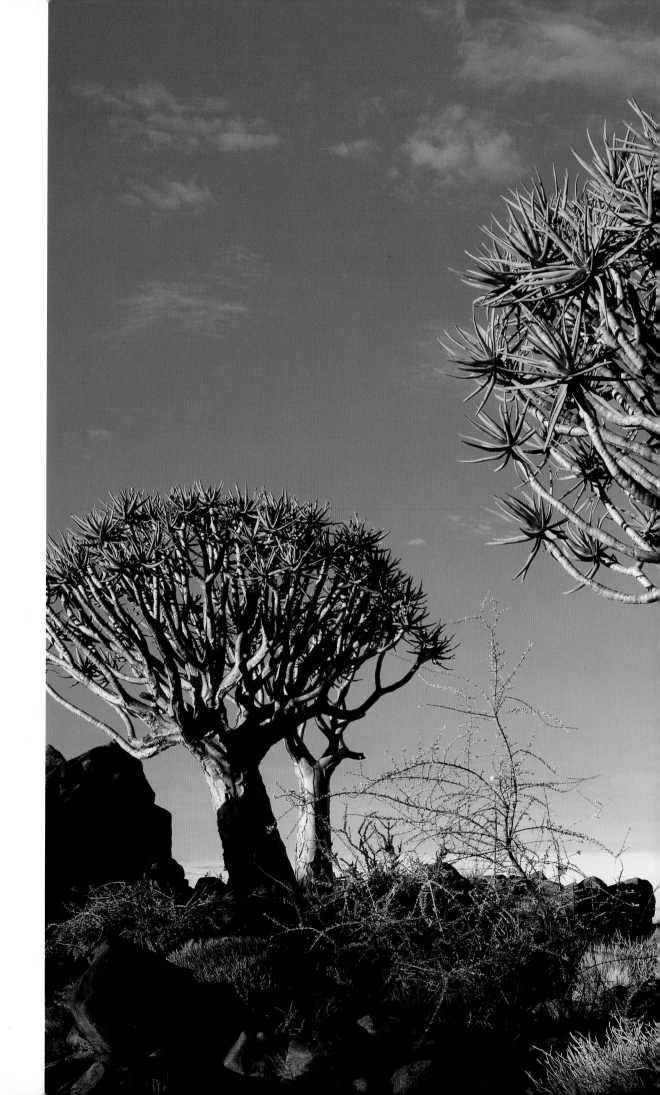

Sunset at the kokerboom forest.

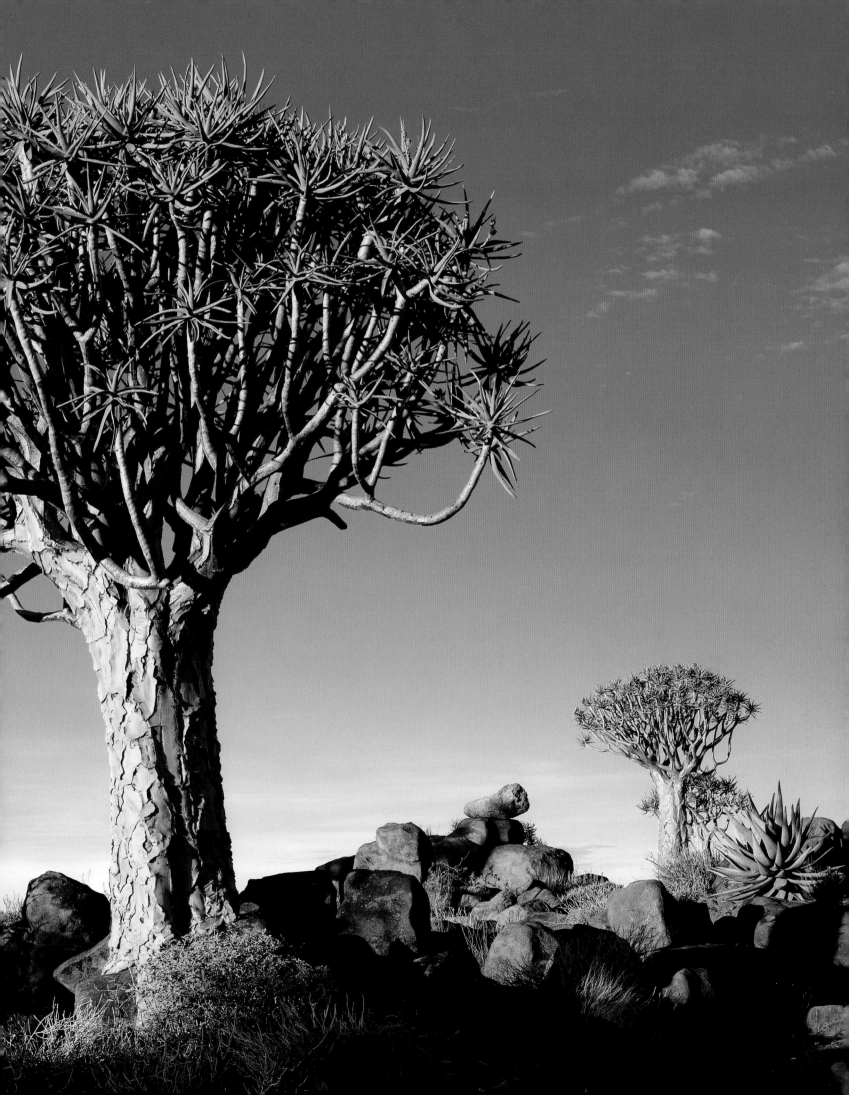

The Tree that Grows Fat in the Desert

BY CONTRAST with the anaboom which prefers a relaxed life on a river bank, its fellow member of the Acacia family, the camelthorn (*Acacia erioloba*), luxuriates in the desert. I saw and photographed one of the finest, growing on the lip of an old volcano in one of the hottest and driest parts of Namibia. Look at the bright green foliage, dense enough to shade the traveller, or a herd of buck, on the hottest day. And look at the highly nutritious seed pods that delight the hearts of elephants. How does it grow fat in the wilderness? The camelthorn's secret is that its roots can penetrate to extraordinary depths in the sand. A well-digger once reported striking camelthorn roots at over 150 feet down, where the tree had detected a spring. Of course even a camelthorn can die of thirst if the rains fail — as fail they have, for a succession of years in the last decade.

The tree is a protected species in Namibia and you pass handsome specimens in the wildest country. To cut one down here would break a taboo as well as the law. In South Africa, too, it is now protected. One hundred and seventy years ago Robert Moffat, the missionary, reported 'the remains of ancient forests of the camelthorn'. But the forests soon vanished. Both Africans and Europeans found the timber suited them perfectly. For Africans it made spoons and knife handles, and also an excellent firewood. For Europeans it was the raw material for the new industries. The heartwood is so hard that an axe will strike sparks from it; in the early days of diamond mining, engineers used it to make bearings for machinery shafts as well as pit props and wagons. The newcomers cut down tens of thousands of camelthorns for firewood. Today there are very few fine specimens left near Kimberley or any part of the north-west Cape, where it was once common. One of the most magnificent grew in a suburban garden in Kimberley, close to the diamond diggings at the Big Hole. According to tradition it was under this tree that Cecil Rhodes sorted his first parcel of diamonds in the early 1870s. But the tree was cut down a century later to make room for a block of flats.

Another pair of famous (or infamous) camelthorns survived on the great north road between Potgietersrust and Nylstroom. They are national monuments and bear a plaque with the text: 'In memory of 33 Voortrekkers who were treacherously murdered by Makapan in 1854'. The party was led by Hermanus Potgieter and the children, it is believed, were dashed to death against the two camelthorns.

Strange to say, the name 'camelthorn' is actually a mistake. In 1760 Jacobus Coetse, the first citizen of Cape Colony who was officially recorded as having trekked out of the colony into the unknown land beyond the Orange River, encountered the species and christened it 'kameeldoring'. This was duly mistranslated into English. In fact, the Afrikaans word has nothing to do with camels. It means 'giraffe-thorn' and refers to the way that a giraffe has the surprising ability to browse on the leaves despite the huge white thorns which curve like the horns of a buffalo. Other animals content themselves with the thick, grey, ear-shaped seed pods which are blown down by the wind; elephants simply shake the tree to bring down the seed pods.

The tree has few vices — although of course, when attacked, it defends itself gallantly with those huge white thorns. But it does have some drawbacks. There's the bloodsucking 'soft tick' or sand tampan which buries itself in the soil beneath a fine, shady camelthorn. The tick then lies in wait for the unwary traveller, man or beast, who lies down in the shade of the tree. Fortunately the victim can escape simply by moving into the sun, as the tick can't stand heat or light.

A more serious drawback, according to the experts, is the generous way the tree provides hospitality to the tsetse fly. And how the tree was made to suffer for it. Tsetse is a lethal, bloodsucking pest. It transmits parasites which give sleeping sickness to humans and a plague, nagana, to cattle.

Lizard on the rocks in Namibia.

Its intermediate hosts are game animals — kudu, buffalo, warthog and so on — which are themselves immune from nagana. In 1962, the numbers of tsetse in Botswana suddenly increased alarmingly. It was thought that the camelthorn was partly to blame, as the shade it provided was perfect for the tsetse. So the authorities, at the cost of millions, launched a three-pronged extermination campaign. Every camelthorn in the tsetse districts was to be cut down or poisoned, every game animal to be exterminated; and the whole country was to be sprayed with dieldrin, a deadly, long-lasting insecticide. But all three methods proved ineffective. Eventually the government found a new, safer chemical, Endosulphan, which controlled the tsetse. The camelthorn and the game animals were reprieved — after tens of thousands of trees and game had been needlessly slaughtered.

A happy Camelthorn in the desert at Messum Crater, Namibia. Its Botswana counterparts were not quite so lucky.

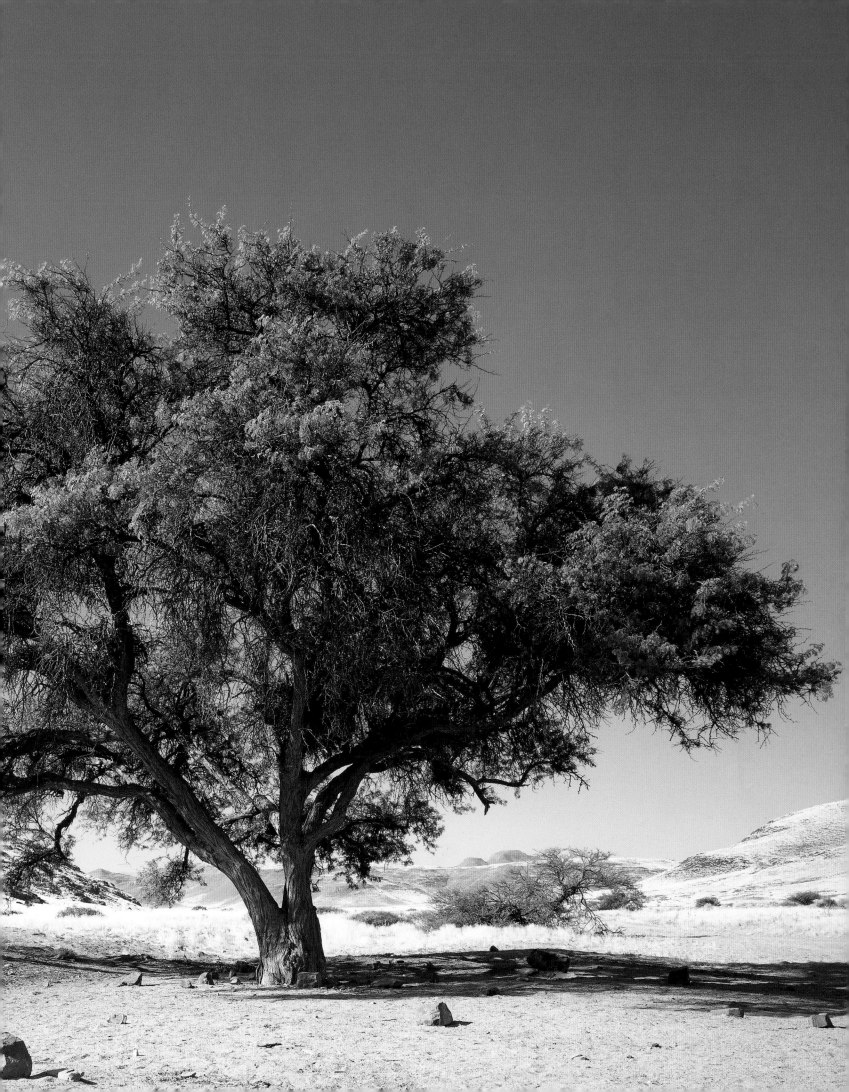

Mountaineers

Christmas among the Olives

I HAVE NEVER spent Christmas in the southern hemisphere, but I imagine that plum pudding and brandy butter would be a little heavy on the stomach when the temperature is over 100 degrees. In South Africa it's natural to celebrate it with a *braai* of grilled waterbuck or kudu. And where better to make a *braai* than on a cool mountain top?

For almost a hundred years two families from the wine-rich valley of Paarl have been celebrating Christmas by camping for a week, 2,000 feet up on the top of the local mountain. Of course the original campers are long dead, but their descendants for three or four generations have enthusiastically maintained the ritual. You can see approximately thirty of their children's names inscribed on a large rock close to the camp site, with the date when it began, '1908'. The mountain is famous for this Christmas camp. It's also famous for a circle of ancient olive trees, the jewel in its crown.

You can imagine the first generation of children struggling up the mountain in the carts and wagons. I expect they now go on mountain bikes, as there's a dirt road all the way to the top. I was driven up there myself this January, 2007, by some generous friends, including the distinguished botanist John Rourke, former director of the herbarium at Kirstenbosch. We saw the blackened embers of this year's Christmas camp fire. Of course it was the olives we had come to see, and these were no disappointment.

Inside a circle of huge granite boulders we found the circle of huge ancient olive trees. John said the trees were certainly wild — and were probably several hundred years old when the first campers struggled up the mountain. Some of them were growing out of the boulders themselves. Almost all were gnarled and twisted. How had they survived the waves of grass fires that must have swept the mountain time and again during the last centuries? 'The boulders would have saved them', said John. 'They form a natural fire barrier.' I remember reading how the oldest wild trees of many species are often found snugly tucked into kloofs (that is, canyons) where the flames can't reach them.

Left: *Ancient olive in a garden at Wellington, Western Cape.*
Right: *Rock at Paarl Mountain, Western Cape. They started camping here at Christmas 1908.*

'And the boulders have saved the false olives, too.' John's professional eye had spotted how most of the true olives (*Olea europea*, subspecies *africana*) had a younger partner beside it, an olive-like tree called *Maytenus oleoides*. 'They're younger than the real olives. I expect a bird sat in each of the old trees and spat out the seed which produced the younger one.'

To European eyes the wild olive of southern Africa looks comfortingly familiar. And so it should: it is European and indeed Asian, too. Although a true son of the veld, this amazing species has travelled half the world since it first evolved as a tree. In fact this species, *Olea europea*, has never needed to be introduced by man to exciting new soils and climates. It had travelled there by itself long before the ice ages. And today it's as native to the green shores of the Mediterranean or the stony hills of the Holy Land as it is to the green mountains of Zululand or the desolate kloofs of the Karoo.

At first South African botanists believed, with a touch of understandable national pride, that their olive was a separate African species: *Olea africana* as opposed to Europe (and Asia's) one, *Olea europea*. But this idea was eventually rejected. You could say that the 'lumpers' beat the 'splitters' — meaning that the botanists who want fewer subdivisions beat the botanists who want more subdivisions. It was shown that the two species were almost the same, hence this African olive is now only a subspecies of its European cousin. But who cares? For me the olive is the great cosmopolitan. It belongs to the world, this symbol of peace, not to any one nation or region. O how I long to have an olive tree in my chilly garden in Ireland.

Ancient olive at Paarl Mountain, saved from veld fires by a ring of huge boulders.

Sugar on the Mountain

WHEN THE FIRST proteas arrived in Europe from South Africa, at the beginning of the seventeenth century, it was not only botanists who rubbed their eyes in amazement. The brilliance of the flowers stunned the public. Then it began to emerge that the blue sugarbush (*Protea neriifolia*), described and illustrated in 1605 by the botanist Clusius in his *Exoticorum Libri Decem* (Ten Books of Exotic Plants) was only one of a huge and very ancient family of proteas. They are now known to be spread

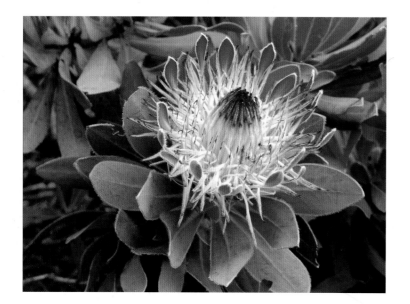

over large areas of both South Africa and Australia, with outliers in South America. The family must have started its life in 'Gondwana', the super-continent in which Africa, Australia and South America were united until about 70 million years ago. Indeed so ancient is the protea's family tree that the leathery leaves of a modern *Protea* hardly differ from those of its fossilized ancestors of 200 million BC.

Modern botanists divide the family into more than fifty genera and a thousand species — and the names and numbers change with baffling frequency. The best known are the proteas of the Cape, mostly shrubby in form, which produce dazzling flowers.

But I wanted to see a protea that is a real tree. I chose the small gnarled species that revels in the wilds of the Drakensberg Mountains, the silver sugarbush, also known as the Drakensberg protea (*Protea roupelliae*). A bonus would be to see the tree in flower. And, who knows, we might see the malachite sunbird probing for nectar with its long beak.

I set off on my hunt for a photogenic specimen guided, once again, by Elsa Pooley. Elsa has written the standard work on the trees of the region, and all doors flew open (I mean, all her friends' doors — not the car's doors) as we drove up from Durban. We stayed in great luxury, but the silver sugarbush eluded us. Then we spotted a handsome specimen at Giant's Castle reserve in the foothills of 'the Berg', as the locals call the Drakensberg. It was not actually in flower, for we had come in mid-July, which was either too late or too early for the flowering of most sugarbushes. But the setting was everything I had been led to expect.

Giant's Castle is one of the 11,000 foot high buttresses of the range, and is often snow-covered in winter. Even in the foothills there is an alpine wind in winter, but the silver sugarbush seems relatively impervious to cold or heat. In fact those leathery leaves, 200 million years old according to the fossil record, are designed for both extremes. A few degrees of night frost doesn't worry it. And when a winter fire sweeps across the bleached, brown grass of the mountainside, sugarbushes are ready to celebrate. The fire is their friend in two different ways. First, it destroys their competitors, while their gnarled black trunks and tough grey-green leaves can survive — or at worst they can throw up a new stem and new leaves from

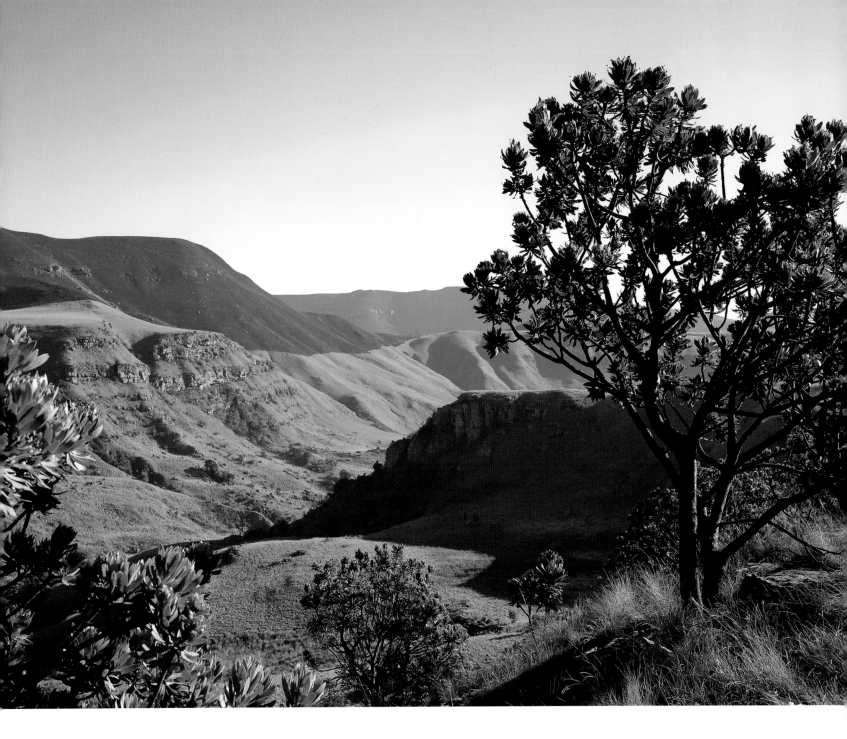

Above: *Silver sugarbush
in the foothills of the
Drakensberg Mountains
in KwaZuluNatal.*
Inset left: *Details of the
flower at Kirstenbosch
National Botanic garden near
Cape Town.*

the old roots. Second, it helps them to continue their ancient line. Their hairy nutlets explode in the heat of the flames and catapult the seeds to fresh ground.

I drove back to Durban, sorry only to have missed the tree's flowering. This January, 2007, I was fortunate enough to see the species in flower at Kirstenbosch, the treasure-house of indigenous plants under the shadow of Table Mountain. As is the case with all proteas, its actual *flowers*, in the botanical sense of the term, are not interesting at all. They are small and nondescript and almost invisible. What one sees are the stunning flower-heads, composed largely of bracts like petals. The outer

bracts of the silver sugarbush are brownish, the inner bracts deep pink edged with silvery hairs.

The only thing now missing was the probing beak of the malachite sunbird. I'm sure they are common at Kirstenbosch. But this was not the moment for bird-watching. I was chased from the flower of the silver sugarbush by winged hooligans — a swarm of malevolent wasps.

A Thorn in the Garden of Eden

MY FRIEND PROSPERO had talked a lot about the Lesheba Wilderness and it was all praise. The name 'wilderness' hardly described it. This was a garden of Eden 3,000 feet up in the Soutpansberg. All the trees were green and healthy for there were no elephants here to tear them out of the ground. There were silverleafs and Cape ash and waterberries, with the odd strangler to add drama to the landscape.

Among these happy trees there frisked great herds of contented animals: impala, waterbuck, kudu, wildebeest, giraffe, rhino. (These were white rhino — the good-humoured kind.) But how was I to get the key to the gates of this paradise? Show them a suitable credit card, I was told, and a hut in the Venda village would be mine.

So in late January 2007, in the height of summer, I escaped the heat of the Limpopo lowveld and drove to Lesheba, a green valley in the mountains high above the plain. My quarry was a lone thorn tree dominating the valley. Prospero had spotted it

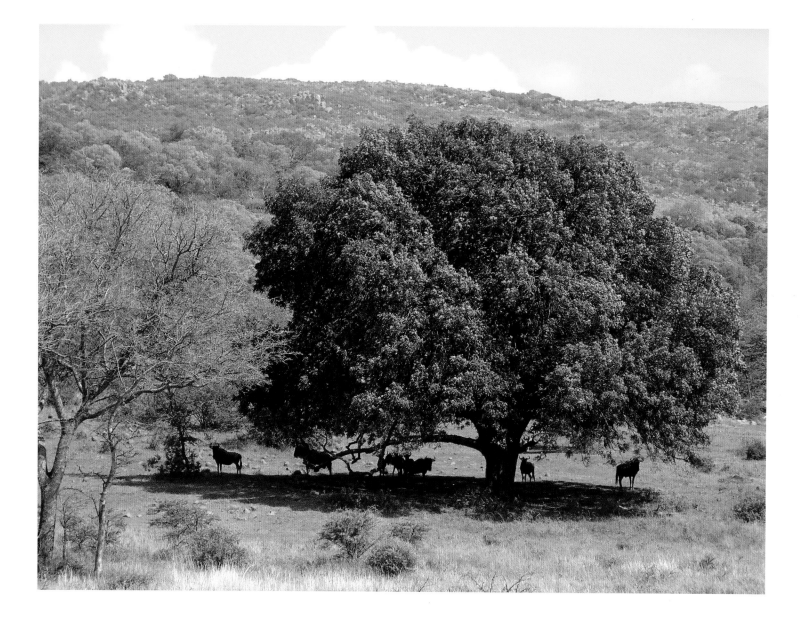

when flying past in Papa Juliet Tango. He was not sure of the species but was certain I would find the tree remarkable. It might even rank as a wow-tree.

I stayed four nights in the Venda village — a delightful experience. The owners of this game farm commissioned a celebrated Venda sculptor, Norina Mabasa, to design a village combining the luxury of modern chalets with the forms of a traditional Venda village. She enriched the huts with portrait sculptures cast in the external walls and doorways.

At dawn on the second day I was taken by Peter Straughan, the son-in-law of the owners, John and Gill Rosmarin, to see the the lone thorn and a wow-tree it was. Paperback thorns (*Acacia sieberiana* var. *woodii*) are not generally so large, and the setting was extraordinary. All around the tree, in the early morning sunlight, stood the promised animals:

wildebeest, impala, giraffe and the good-humoured white rhino with its calf.

Sometimes you can stumble into paradise, then lose it again. I had forgotten my camera. When I came back the lone thorn was alone in the valley.

Lesheba 'Wilderness':
a garden of Eden 2,000 feet
up in the Soutpansberg,
Limpopo Province.
Left: *Wildebeest in the shade*
of a Cape ash.
Right: *Giraffes against a*
background of silverleafs.

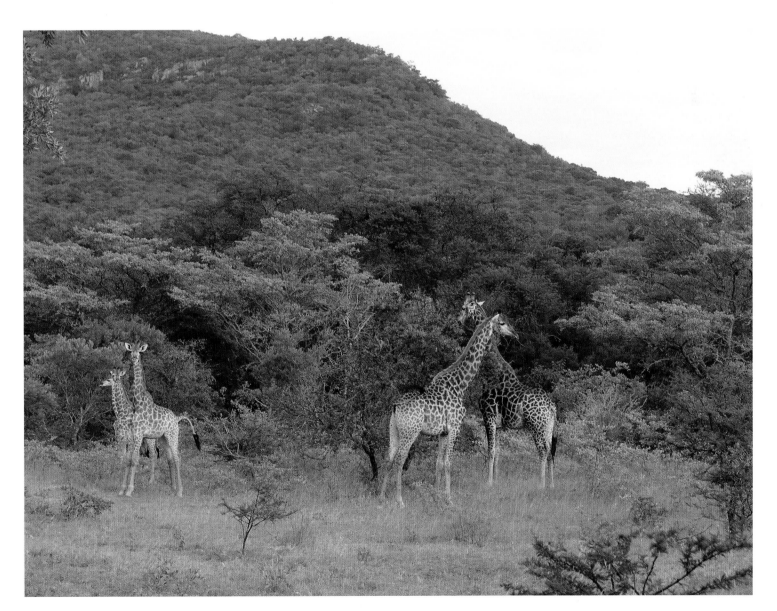

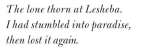

The lone thorn at Lesheba.
I had stumbled into paradise,
then lost it again.

Rock Stars

Cabbage Trees and Coral Trees

ROCKS ARE the chosen home for two of the most beguiling south African trees: the common coral tree (*Erythrina lysistemon*) and the highveld cabbage tree (*Cussonia paniculata*). Rocks give them protection from cattle and game and veld fires. They also provide a warm nest for a young tree trying to make its way in the icy world of the Drakensberg.

The flowers of the highveld cabbage tree are dull, but the rest of it — bark and leaves — are magnificent. One winter day I was taken by Elsa Pooley to see some of her favourite cabbage trees high in the foothills of the Drakensberg. At first I was disappointed. I was hoping for a cornice of snow on the Amphitheatre, the 11,000 foot high escarpment in the background. But a warm wind blew from the Indian Ocean, and you hardly needed a coat. We photographed three fine specimens among the scrub and rocks. I admired the corrugated, corky, brown bark — a second line of defence against grass fires — and the huge, leaves.

The common coral tree is the more ambitious in its range. You can find them down in the steamy bushveld as far north as the border with Mozambique — and up the coast into tropical Africa. The flowers are a revelation. Suddenly, in the middle of winter, without a leaf on its branches, this ordinary-looking tree bursts into an explosion of blooms. Long, curved, scarlet petals unfurl from the ends of the young stems. They are followed in early summer by slender, black pods, tight-waisted between each seed.

For various reasons you will often find an old tree marking the site of an African village. (Hence the original Afrikaans name, 'kaffirboom', now considered offensive to Africans.) Few small trees could claim more varied medicinal uses: crushed leaves for sores, burnt bark for open wounds, strips of bark with herbs for an easy childbirth, decoctions of roots for sprains. The tree was also regarded as a token of good fortune. Lucky charms were made from the shiny red seeds; when a man died, a coral tree would be planted on his grave.

I don't know whether the coral tree flowering in my photograph marks the site of some long-vanished Zulu village. But the tree must have been admired — and protected — for generations. It stands near the centre of a grassy field in the rolling hills of KwaZulu-Natal. I was taken there one winter's day by Elsa Pooley and Geoff Nichols, both distinguished naturalists. A second coral tree, perhaps the offspring of the first, was flowering in the rocky dell below us. Together the two trees dominated the winter landscape where Zulu farmers were burning the old grass to force it into early growth.

Coming from Europe I can understand why the Zulus attributed magical powers to the coral tree. For us the trees that brought good luck and averted evil were holly and rowan, both with scarlet berries.

Left and inset: Cabbage tree in the foothills of the Drakensberg in Natal.

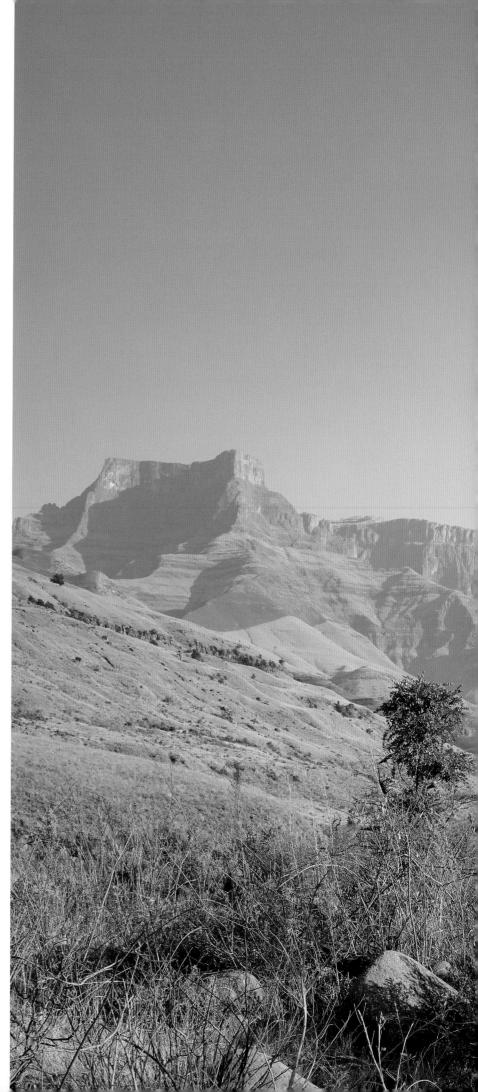

But neither tree could flower on bare branches in the middle of winter. For that delightful trick we Europeans have to plunder the temperate flora of China and Japan. My garden in Ireland is too cold for even a coral tree from the Drakensberg. But in late winter my pink magnolias from China, with flowers the size of dinner plates, burst magically into bloom.

My thoughts returned to the cabbage tree. This certainly deserves better than to be called after a cabbage. The leaves are far too exotic: an eerie blue-green, shredded like filigree, and whirling round in spirals at the ends of branches. They also have the distinction of being used, in traditional medicine, to treat the first stages of mental illness.

If I ever begin to fear for my own sanity, I must remember to go to the highveld to pick a cabbage leaf, and then all will be well.

Cabbage tree with a back-drop — the Amphitheatre in the Drakensberg.

Right: *Coral tree in Zulu-
land, protected by local
Zulus for generations.*
Below: *Detail of flowers.*

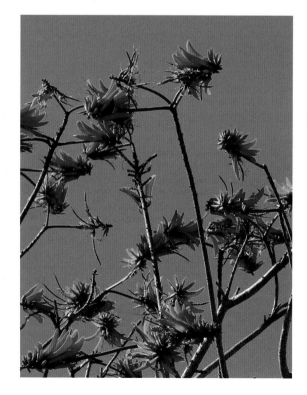

Peace Under a Milkwood

DRIVING NORTH from Durban you come to the river Thukela (formerly Tugela) which marks the nineteenth-century border between the old colony of Natal and the independent kingdom of the Zulus. It was here, on the river bank close to the main road, that a huge fig tree once stood, known as the 'Ultimatum tree', famous (or infamous) for its links with the Zulu War of 1879. Two years earlier, the British government had annexed the Boer republic of the Transvaal. To appease the Boers, the British decided to provoke a war with the Boers' traditional enemy, the Zulus. So here, at the Ultimatum tree, the British High Commissioner, Sir Bartle Frere, threw down the gauntlet to King Cetshwayo and his people. Fight or surrender were the British terms, and the Zulus of course decided to fight. Six months later, after one crushing victory over the British — at Isandlwana — the Zulus were crushed in their turn at Ulundi and Cetshwayo was driven into exile.

Today the Ultimatum tree is not even a tree stump by the roadside. What remained of it was washed away during the floods of the 1987. But further east, near Eshowe, there's an historic tree with happier associations. It's a very tall, elegant fluted milkwood (*Chrysophyllum viridifolium*), known as the tree beside the Bishop's Seat. You can find it in the Dhlinza Forest reserve, an island of tall trees and giant strangler figs rescued from the rolling fields of maize and sugar cane. The Bishop in question was Dr. Carter, the Bishop of Zululand who helped to evangelize the Zulus at the turn of the century. It was here, in the peace of the forest, that he would sit and compose his sermons, admiring, no doubt, all the works of God's creation including the fluted milkwood. Beside him, they say, on this small circle of stones, sat a group of Zulu disciples.

Bishop Carter was fortunate that his attachment to the Zulus didn't alienate his white supporters. This was the fate of his colleague, the Bishop of Natal, Dr. John Colenso. Politically, Colenso was regarded by most white colonists as a trouble-maker. He had taken a distinctly pro-African stance in the wars with Africans. Worse, from the point of view of his detractors, Colenso announced an important shift in his theological views as a result of Bible studies with his Zulu students. The Zulus just couldn't understand the account of creation in the Book of Genesis. It was obvious to them that it had taken longer than six days to create the world. It took longer than that to build a hut. And the Bishop agreed.

In the resulting hullabaloo, attempts were made to drive Colenso from his bishopric. He was tried by an ecclesiastical court in Cape Town, found guilty of heresy and excommunicated. He appealed to the Privy Council in London — successfully. So his white congregation abandoned him and a breakaway bishopric was formed. Colenso died a broken man after denouncing the British invasion of Zululand. But his liberal ideas very slowly took root.

How lucky for Bishop Carter that he could admire the evolution of the fluted milkwood with no fear of being called a heretic.

The fluted milkwood at Dhlinza Forest in Zululand —a tree much admired by Dr. Carter, Bishop of Zululand in the 1890s. His Zulu disciples sat on the stones beside him.

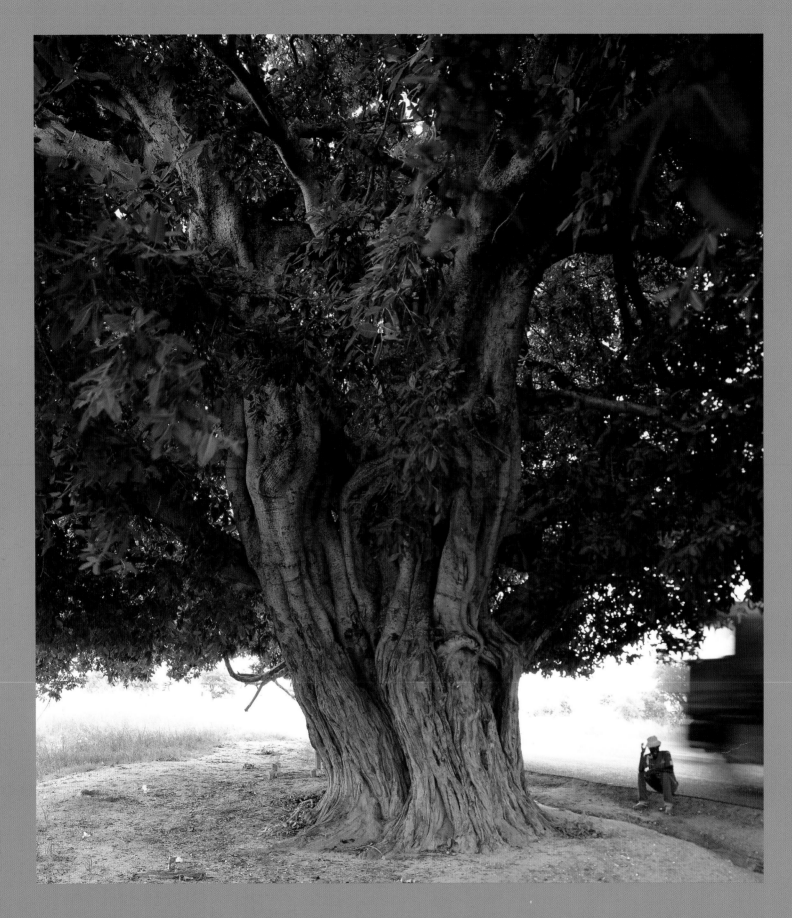

City and Suburban

Waiting for the Bus

THE RED-LEAVED rock fig is usually a small straggling creature of the hillside, despite its high-sounding Latin name, *Ficus ingens*, which means 'giant fig'. However, giants do turn up occasionally in unlikely places.

In 1829, Robert Moffat, Livingstone's father-in-law and a fellow missionary-explorer, was entertained to a meal of locusts high up in a giant fig near the site of the modern town of Rustenburg. The fig was so enormous that there was room for seventeen African huts perched in the branches. You might have thought this merely a tall story. But in 1967 a specimen of *Ficus ingens* believed to be Moffat's actual tree was tracked down by an industrious botanist. Seven of its huge branches had collapsed and taken root on their own initiative, and the spread of the tree was now 120 feet. I have told the story in *Remarkable Trees of the World*. Today that tree is battered but unbowed.

Three hundred miles to the east, at Acornhoek, Limpopo Province, I was shown another enterprising giant. It looms over the main road, fanned by passing cars and lorries, and provides a friendly roof to local shoppers waiting for the bus. I tried to measure the spread of its branches, but was driven back by the boisterous traffic. At a guess, I would say the spread of the tree is little short of that of Moffat's tree — though there would hardly be room for seventeen huts in its branches. Further north, just off a busy road, I was shown a third specimen. It was the youngest and healthiest of the three: a Gothic giant, fluted and ribbed and vaulted more elegantly than many chapels.

I should like to re-visit this red-leaved rock fig early next spring. The common name refers to the spectacular flush of young leaves. But 'red-leaved' rather understates things. Wine-red would be better — the cheerful glow of someone on two bottles a day.

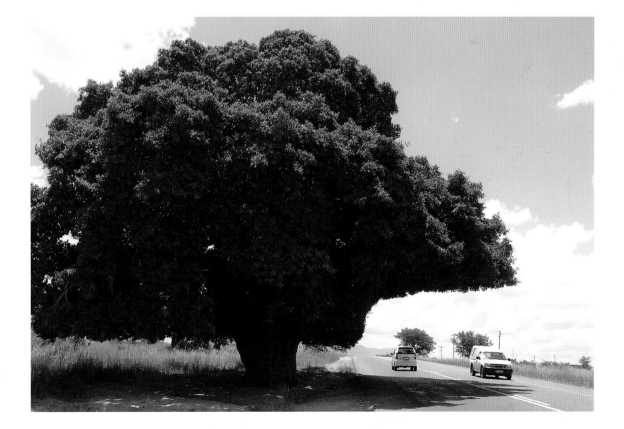

Left and right: *The red-leaved rock fig used as a bus stop in Acornhoek, Limpopo Province.*

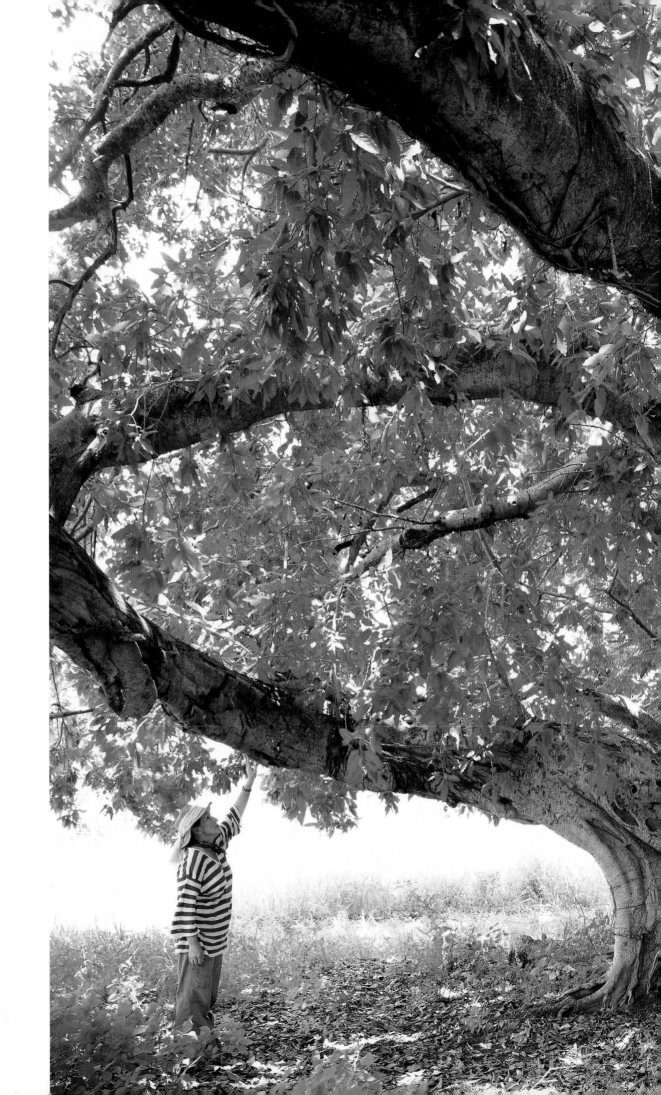

Red-leaved rock fig at
Ofcolaco, Limpopo
Province.

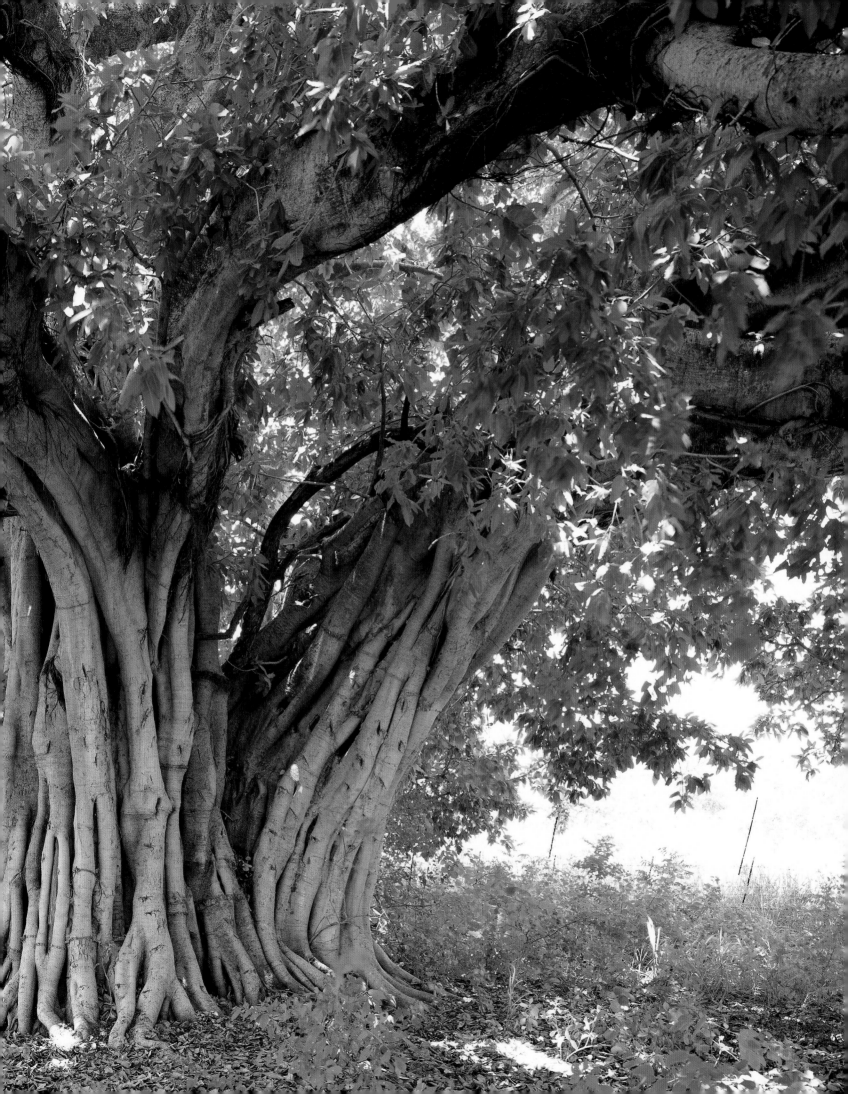

Silver Under the Table Cloth

SOME SOUTH AFRICAN trees, like the highveld cabbage tree, have corky trunks designed to protect them from fire — or at least mitigate its effects. But fire seems to present no fears for the glittering silver tree, *Leucadendron argenteum*, the prodigy of Table Mountain. Its cones are designed to explode with heat when the flames reach them, and the seeds parachute away to safety. The tree dies, but is re-born almost at once. Within eight years, a full-sized silver tree, 25 feet tall, can be back at home on the mountainside where its parents grew.

I climbed up the path on Signal Hill, in the pine-clad suburbs of Cape Town, one summer evening in January 2006. Ahead of us on the brown, sun-dried hillside, groves of silver trees reflected the dying sun like mirrors. Above us the Cape sou'-easter laid the famous white 'table-cloth' on Table Mountain. It was the scene of a landscape at peace with itself — and the great city below. I photographed several silver trees, astonished by the discovery that it's the silvery hairs on their leaves that reflect the light with such dazzling power.

Three days later I returned to Signal Hill to find Cape Town in confusion and Table Mountain on fire. A British tourist had thrown a cigarette from his car. It was as though he had thrown it into a can of petrol. Within minutes the flames surged across the hillside, sweeping up towards the skyline and down to the nearest suburbs. The authorities, using helicopters, concentrated on saving people and property. The trees were left to burn. But it was not so easy to separate them. The flames seemed to be heading straight for the sumptuous house at Kloofnek Road where I was staying. My hosts, Beezy and Nicci Bailey, doused everything with water from the swimming pool. There was an alarming moment at about 8 p.m. At that point the

Silver trees in the suburbs of Cape Town, in the shadow of Table Mountain.

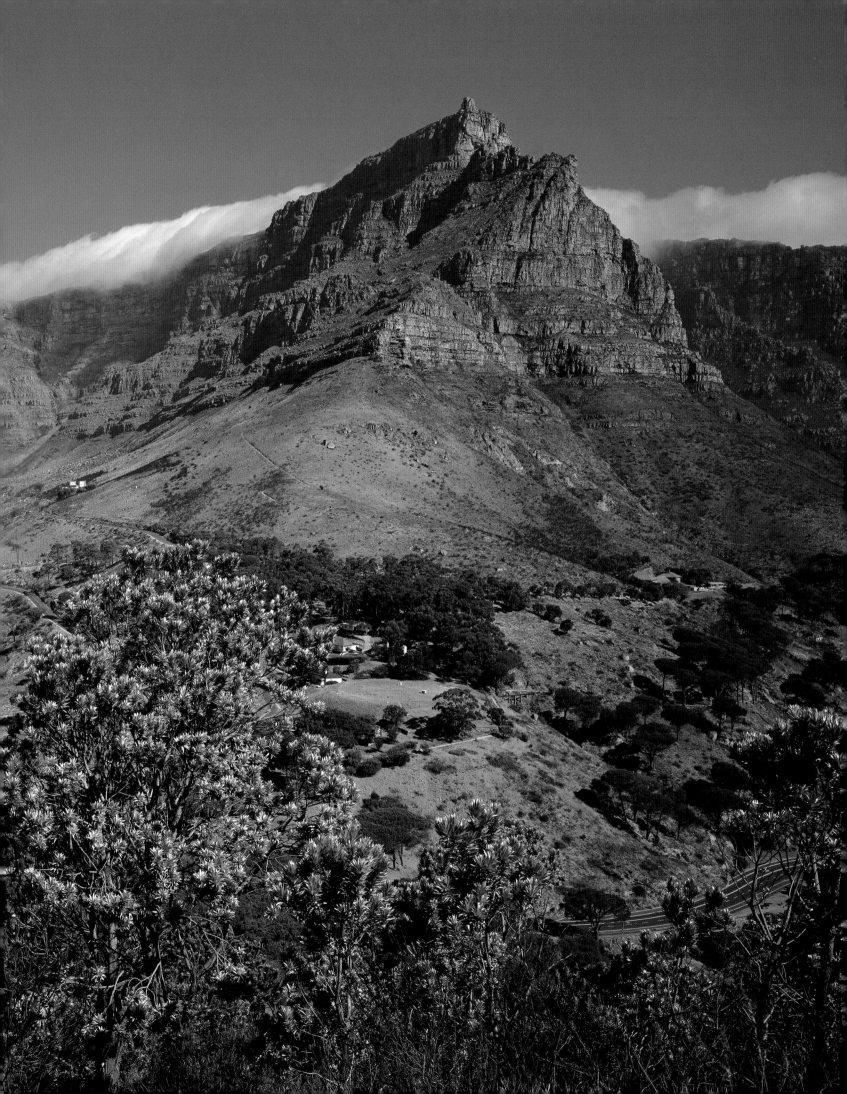

flames leap-frogged the house, the garden and Kloofnek Road, and descended into a wood of umbrella pines beyond them. We saw (and heard) those unfortunate pine trees exploding like fireworks, and most were dead by morning.

Exactly a year later, I walked back up Signal Hill to see what had survived. Above us, the 'table-cloth' was as neatly laid by the Cape sou'-easter as before. The silver trees that I had photographed were blackened corpses — like the umbrella pines over the road. But, unlike the pines, they had turned the fire to their advantage. The hillside was full of young silvery seedlings. Within a few years there would be more silver trees there than before. Then there would be peace on the mountain — until the next tourist threw a cigarette from his car.

Below: *Young silver tree before the fire of January 2006.*
Right: *Umbrella pines exploding like fireworks opposite the house in Cape Town where I was staying.*

Aloes in the Rough

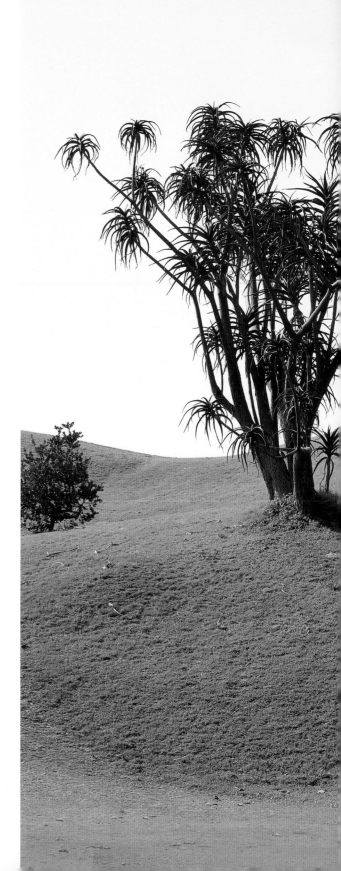

Of all the 130-odd aloes which are found in southern Africa, only three species make a fair-sized tree: the kokerboom (*Aloe dichotoma*), Pillans' aloe (*Aloe pillansii*) and the tree aloe (*Aloe barberiae*). As you would expect from its common name, the tree aloe is the tallest and largest of the three.

It grows up to 60 feet high and 9 feet in girth, decorated with rosettes of dark green, fleshy leaves at the ends of branches, and it carries a mass of pink flower spikes in winter — a spectacular tree if you can find it. Although it ranges from East London north to Mozambique, the great trees seem elusive enough. My guide was Elsa Pooley, the field botanist who knows the flora of Natal as well as anyone. We hunted high and low in KwaZulu-Natal for a fine specimen and were defeated. Then we retreated to Durban Country Club to lick our wounds. And lo and behold! There on the rolling hills by the third green we saw the specimens you see in my photograph.

Later, in the nearby suburbs, I saw other handsome examples in captivity. The tree aloe is easy to tame or to breed. It will strike from cuttings taken from the stem, and grows rapidly if the climate is warm. (A frosty night could polish it off.) The species was not identified by a European till as late as 1873 — two centuries after the famous kokerboom. Thomas Baines, the artist and explorer, found a striking new 'arborescent aloe' in some rugged hills near Greytown, Natal. He reported his discovery to Dr. (later Sir Joseph) Hooker, the head of Kew Gardens and the guru of British and foreign botanists. And Hooker was happy to name the new species of tree, after its discoverer, *Aloe bainesii*. There matters rested for more than a century.

But botanical glory is harder to win — and to keep — than a Nobel prize. Someone discovered that a South African plant collector called Mary Barber had sent a very similar specimen to Kew at exactly the same time. Hooker's deputy and son-in-law, Sir William Thiselton-Dyer, had called it *Aloe barberiae* in her honour, and published this name a few months before Hooker published *Aloe bainesii*. Baines had made the tree famous under his own name. But botanists have no time for sentiment. Under the rules of botanical nomenclature, the first published name wins. Baines was stripped of his honour, and his name excised from the botanical books. Poor Baines. He died a couple of years after writing to Hooker. So he never knew that he was to win so much botanical glory before losing it again.

Pair of tree aloes on the golf course at Durban Country Club. Thomas Baines' loss was Mary Barber's gain.

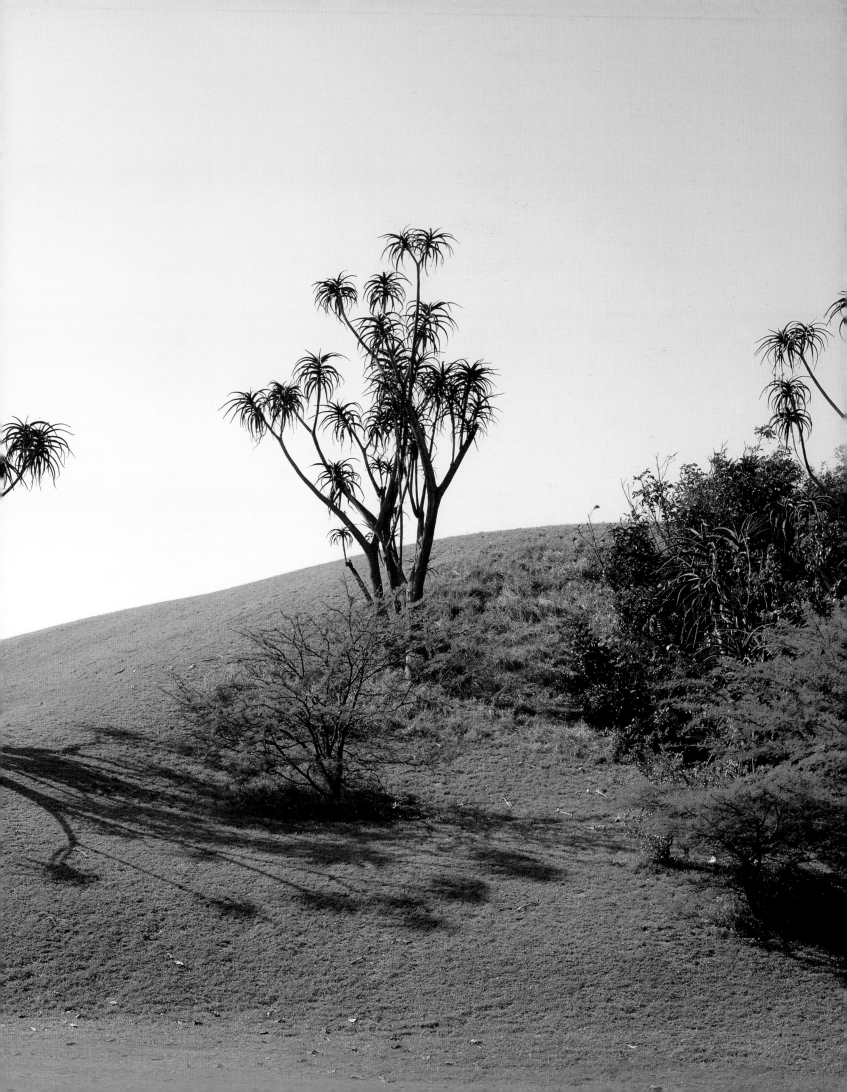

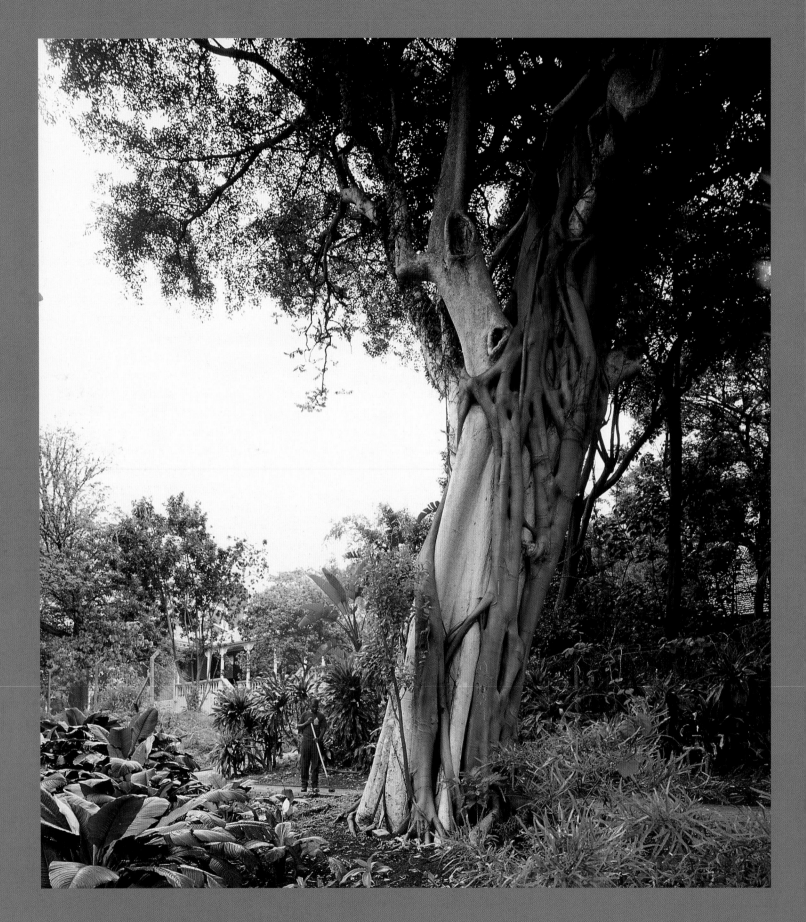

Stranglers and Suicides

Unfortunate Hosts

DURBAN BOTANIC GARDEN has always given a warm welcome to introduced species (as I shall explain in the next chapter). But occasionally it allows one of these exotic immigrants to be polished off by a native.

I was standing in the upper section of the garden with Elsa Pooley, my guide and mentor who does not conceal her impatience with 'aliens'. 'Good heavens,' I said, 'that African flame tree looks rather strange.' 'So would you be,' Elsa replied grimly, 'if you were being strangled by a Natal fig.'

Fortunately, the African flame tree (*Spathodea campanulata*), famous for its luxurious scarlet flowers, is one of the commonest trees in the streets and gardens of Durban. It was introduced many years ago from somewhere in tropical Africa; it's the same species as the Nandi flame tree in Kenya, and it has a wide range in west and central Africa.

Its attacker, the Natal fig (*Ficus natalensis*) is not a sensible tree for anyone's garden. True, it's an excellent wind-break: the dark green, shiny leaves, and the branches crowded with yellow figs, would keep out a hurricane. And the fruit provides a feast for monkeys and baboons. But the tree is by nature aggressive — a native invader. Its roots head straight for walls and drain pipes. Don't trust it an inch. It will repay your hospitality by knocking your house down.

In the wild, the Natal fig is one of a group of figs that are inured, so to speak, to crime. They start their life as stranglers. A bird drops a seed high in the fork of a friendly tree. The seed becomes an epiphyte, depending on what food it can scrounge up in its fork. In due course it cautiously drops an aerial root to the ground — and then another. From the roots grow new trunks and branches which gradually enclose the unsuspecting host, squeezing the life out of it. The process can take a century, and the strangler ends by posing as just another tree in the forest. But look carefully at its fluted trunk. Inside the strangler is the hollow left by the rotted corpse of its victim.

Down in Entumeni forest near Eshowe in KwaZulu-Natal I was taken by Elsa to see a huge common wild fig (*Ficus burkei*) that had strangled a large tree years before. The hollow left inside by this victim must have been at least ten feet in circumference. And what was astonishing was that the external lattice work of the strangler's trunks had left a series of small windows into the interior. I took a photograph early in the morning and a shaft of winter sunlight pierced the tree.

Nearby, in Dhlinza forest reserve, there's an even more menacing example of the common wild fig. It rises out of the forest like a tower of steel lattice-work 60 feet tall and nearly as broad. Its victim must have been quite small and must have died a century ago. I photographed this Dracula of the forest from the safety of the tree tops: the authorities have built a spectacular aerial boardwalk. Elsa stood bravely below, a diminutive figure in red — and Elsa is five foot ten and a half inches tall in her bare feet.

Natal fig polishing off an African flame tree in Durban Botanic Garden.

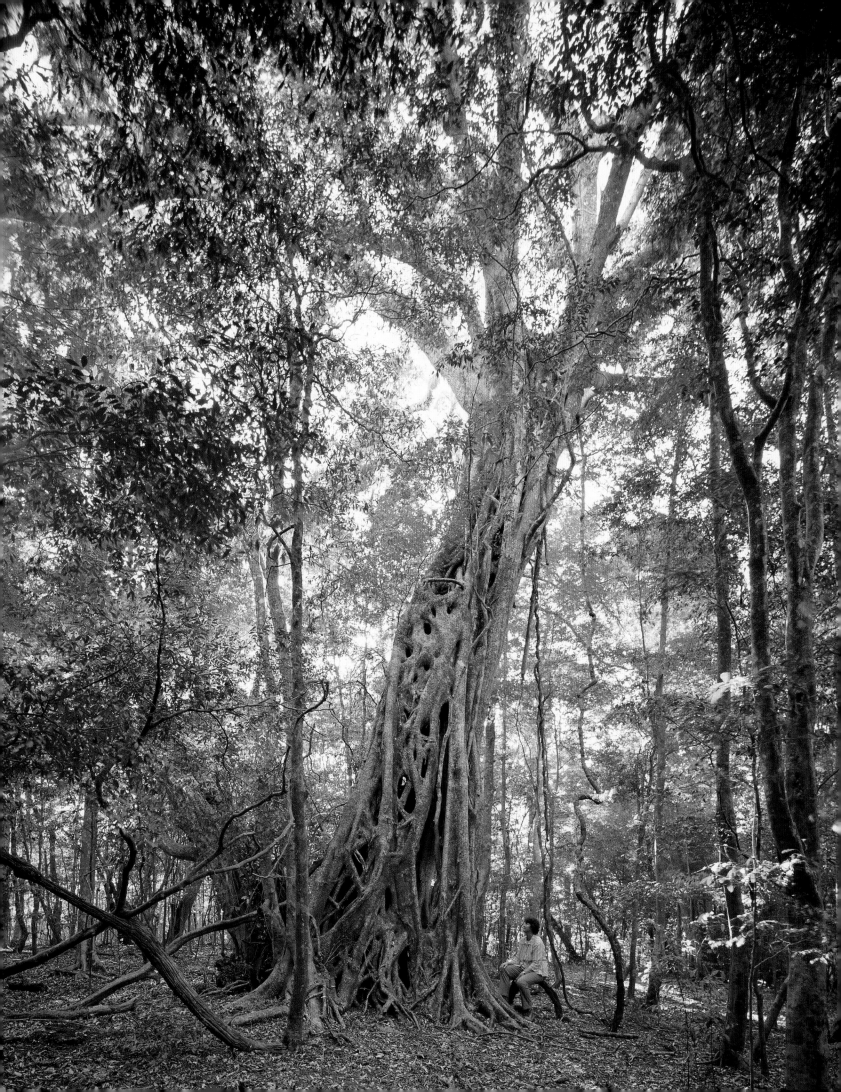

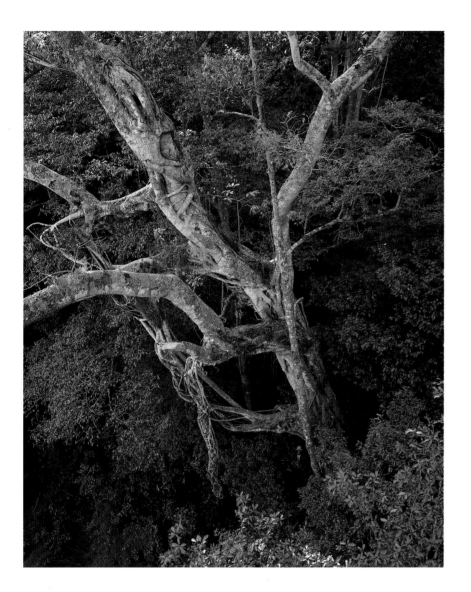

Left: *A Common wild fig after strangling its host at Entumeni Forest near Eshowe in KwaZulu-Natal. Shafts of sunshine pierce the latticework around the hollow which was once the host.*

Above: *Another strangler, photographed from 50 feet up at Dhlinza Forest Reserve, KwaZulu-Natal.*

Apocalypse at Kosi Bay

THERE ARE FEW palm trees more theatrical than the Kosi palm (*Raphia australis*). It rises out of the swampland around Kosi Bay in north-east KwaZulu-Natal and southern Mozambique, a single stem which can be up to 80 feet tall, crowned with a whorl of immense feather-shaped leaves. The leaves can be over 30 feet long, which makes them among the largest leaves in the world.

Its life is short and its end spectacular. After about thirty years a huge inflorescence, in the form of a brown plume ten feet long, shoots out of the crown. The upper part of this plume consists of male flowers, the lower part of female. After fertilisation the plume develops elegant brown fruits the size of a goose egg but resplendent with shining, chestnut-coloured scales. Inside each of these fruits is a single ivory-coloured seed. (One species of vulture, called the Palm Nut Vulture, find these fruits so delicious, that it never wanders beyond the range of the Kosi palm.) Once the fruits are ripe the great tree commits suicide: that is, it dies, then crashes to the ground, scattering the elegant brown fruits far and wide.

I was fortunate to be taken to Kosi Bay by Elsa Pooley. As I explained earlier, Elsa has no fear of crocodiles. So we set off in a small fibreglass boat to photograph a group of large Kosi palms from the water. I can't say I was looking forward to an encounter with a large crocodile, but that experience was denied us. It was the boat behind ours that was followed by one of these officious beasts. We landed safely and transferred to a car with four-wheel drive. A short drive brought us to second group of Kosi palms forming a natural colonnade beside the water. Inside this colonnade, there was tracery like a rose window and a dim religious light as if this was the nave of a Gothic church. What an apocalyptic experience, I thought, to be there when one of the great trees decides it's time is up and brings down the whole church, columns, rose window and all, crashing into the crocodile-infested waters.

Right: *Kosi palms, the pride of Kosi Bay in northern KwaZulu-Natal.*
Left: *Its elegant fruits, each containing a single ivory seed. As soon as the fruits ripen, the trees commit suicide and crash to the ground.*

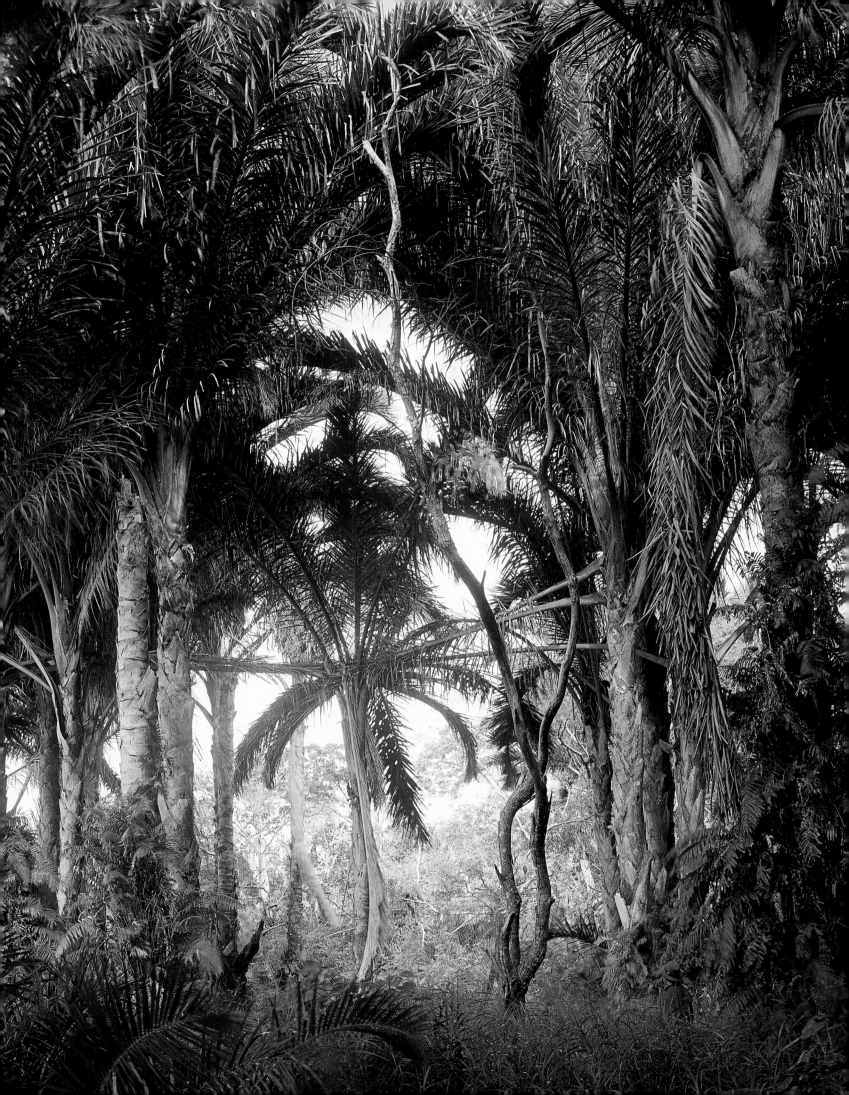

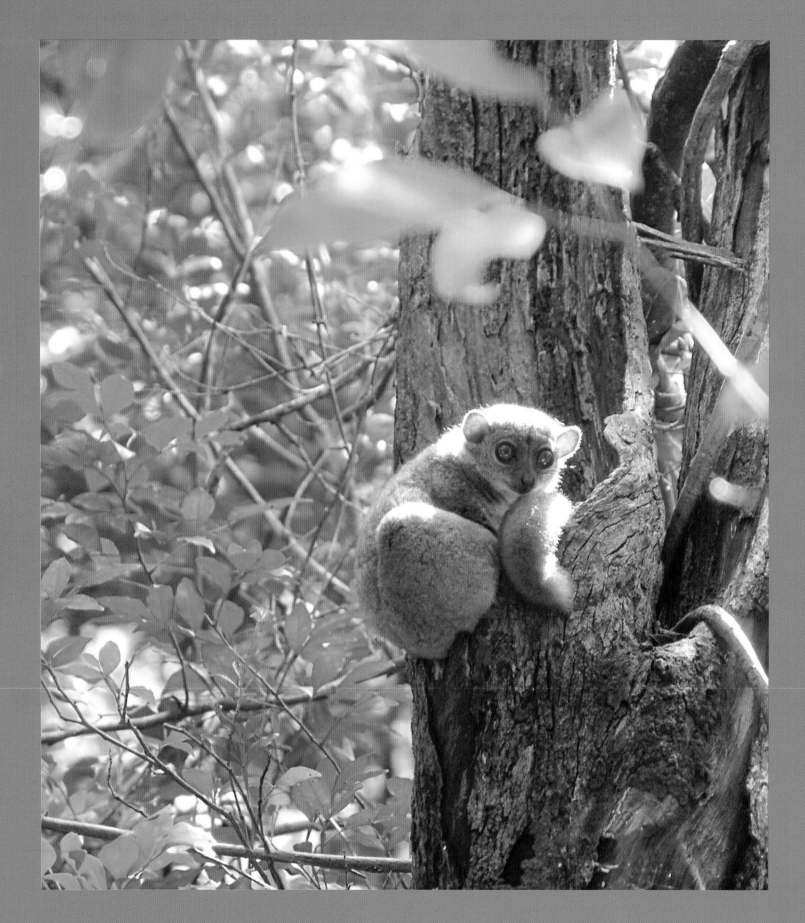

The Sport of Lemurs

In the Spiny Forest

THE SPINY FOREST of southern and south-western Madagascar is more famous for lemurs than for trees. I can see why. Half the world's species of lemurs are found in that huge, mysterious island 200 miles from the coast of Africa. None are found in Africa. Ringtails, sifakas, brown lemurs and so on — if they did not exist some artist would have invented them. But the trees in which the lemurs make their home are often as surreal as the lemur.

I flew down from the capital, Tana, 350 miles to Taolagnaro (Fort Dauphin) on the south-east tip of the island. The winds that carry rain from the Indian Ocean lose heart at Taolagnaro; west of this point the country becomes drier and you begin to see forests of *Didiereaceae*, the bizarre thorn trees only found in Madagascar. There are species of both *Didierea* and *Alluaudia* which look like creatures from hell. Their arms spiral up to the sky, covered in long grey thorns. In the rainy season (which it was) their arms slowly turn a garish green as each stem grows a spiral of minute green leaves. By contrast, you see small examples of *Pachypodium* with elegant white flowers incongrously sprouting from their spiny crowns.

I drove to the spiny forest at the Berenty Reserve, 50 miles to the west, equally remarkable for trees and for lemurs. It's an astonishing place. For seventy years the lemurs have been protected here by an admirable French family called de Heaulme. The ringtails — with grey-brown bodies, striped black-and-white tails, and brilliant brown eyes — now swagger about the place as though they own it. In the case of the male ringtails, this is a pathetic bluff. Unlike other male primates, male lemurs (for reasons that still baffle the world of science) are submissive to the females. The female ringtails, though smaller and weaker, are the masters, and only allow the males to mate with them for one week in the whole year. The female sifakas are equally hard on their males. Both males and females spend most of their lives up

Left: *Northern sportive lemur peering from its home in a hollow tree at Ankarana Special Reserve.*
Right: *Octopus tree at Berenty Reserve.*

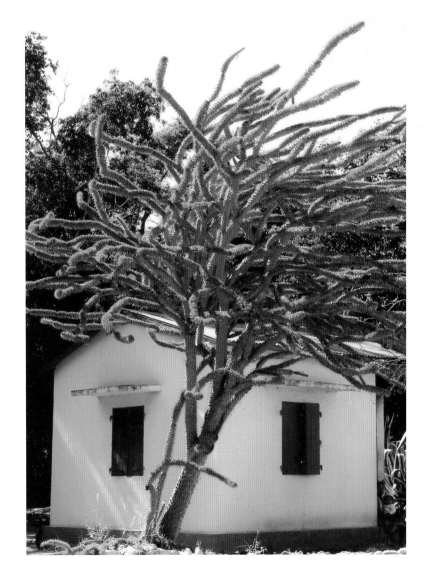

in the trees, where you see glimpses of their fluffy white fur and black faces. When they come down from the trees they present a comic spectacle. Their legs are too long for their arms, and they advance in a series of jumps with both legs together, like competitors in a sack race.

Early on the second morning I set up my camera on its tripod to photograph a dramatic tableau of native trees, planted (I suspect) by the enterprising de Heaulme family. In the foreground was a huge woody *Euphorbia*, its peeling red bark catching the early sunshine. It was set in a small grove of *Didierea trollii*, the menacing octopus tree. There were also some *Alluaudia procera* with writhing green stems. As I was about to release the shutter of my camera, I saw a sight I had not dared to hope for. In a series of ludicrous jumps a sifaka was approaching me. The next moment it had sprung lightly onto the right hand branch of the *Euphorbia* from where it boldly looked me in the eye. I'm sure it did that for every tourist. But who could fail to bless the name of the creators of Berenty, the de Heaulme family?

A few days later found me searching for fine examples of *Pachypodium geayi,* largest of the succulent trees of the arid south-west — apart from the mighty baobabs. I hired guides and a car in Toliara (Tulear) and drove for ten hours to the spiny forest reserve at Beza Mahafaly. For the last few hours it would have been better to get out and walk. Twice we had to dig the car out of the sand. When we arrived I showed the kindly director (who let me sleep in his guest room) a photograph of the mighty *Pachypodium* known to be the jewel in the crown of the spiny forest at Beza Mahafaly. 'Oh, yes', he said, 'I know it well. It's a fine tree — 200 miles from here — a day and a half to the east. Your photograph is wrongly captioned'.

There are times when the body is weak but the spirit is willing. This time, I must confess, both were weak. Three more days of those appalling roads! And did the tree still exist? We set off sadly

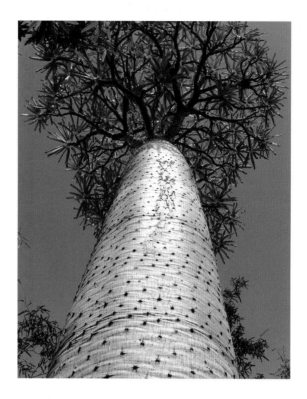

Left and right: Pachypodium geayi *on a limy hillock 100 miles south-east of Toliara.*

for the ten hour drive back to Toliara.

But fortune favours the weak as well as the brave. Six hours later I saw a strange pair of trees beckoning from a limy hill to the left of the road — twin white rockets rising from the bush. *Pachypodiums?* Yes, *Pachypodiums*. And before you could say Beza Mahafaly they were mine.

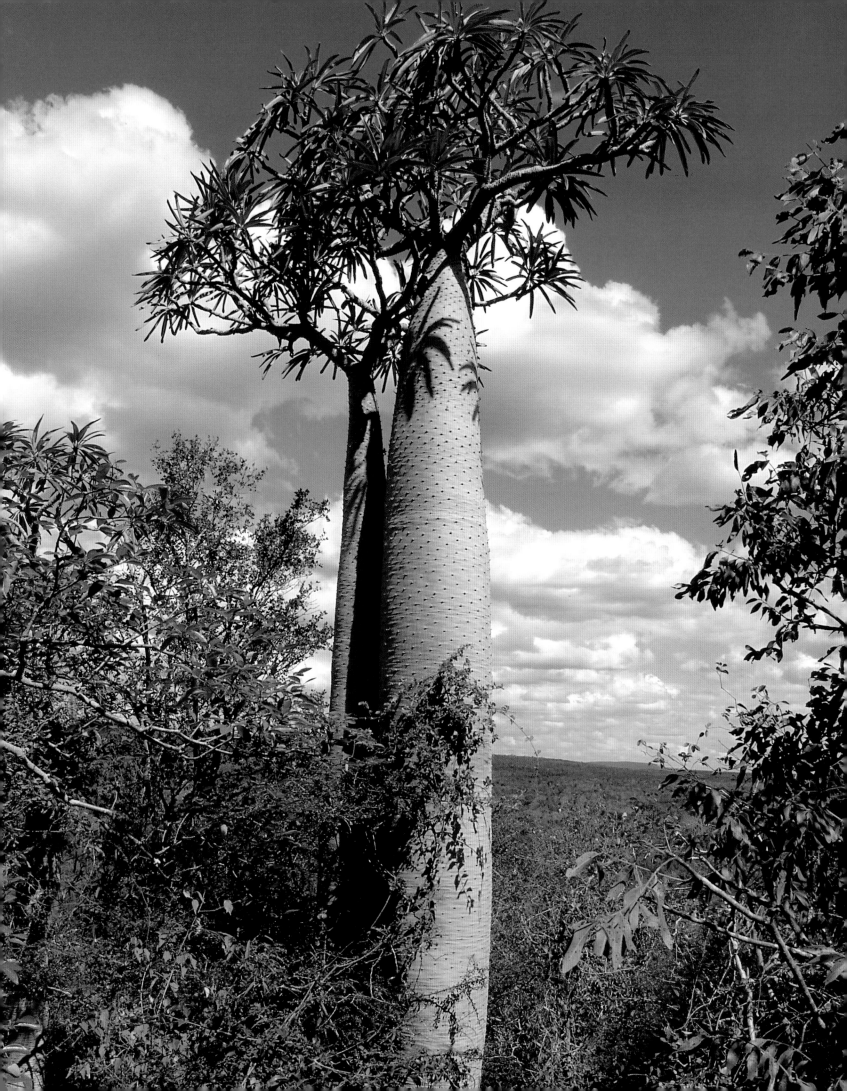

*A sifaka lemur in a grove of
Euphorbia and Octopus trees
at Berenty Reserve.*

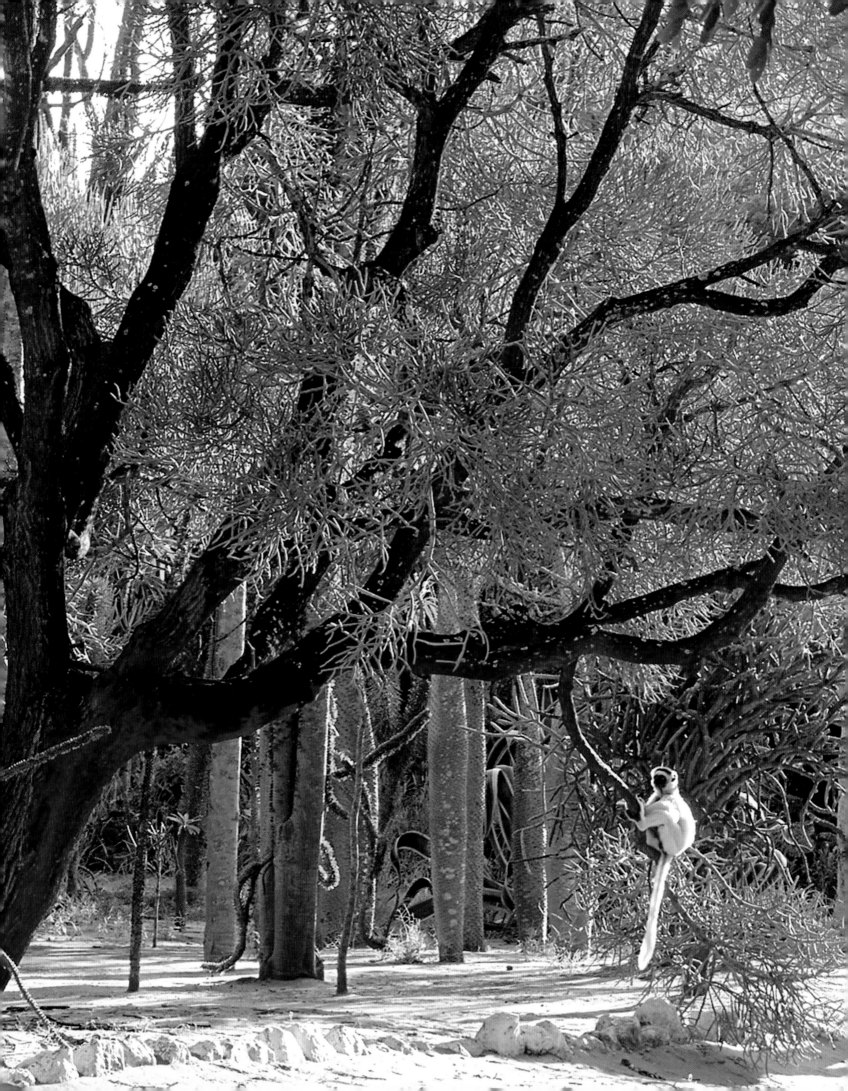

PART III

Guests

In Sanctuary

A Stripling of Three Hundred

IN 1707, Willem van der Stel, the Governor of the Cape of Good Hope, was sacked by his employers, the Dutch East India Company. As I have described in my book *Remarkable Trees of the World*, he was sacked because he had made powerful enemies among the 'free burghers', the Dutch and Huguenot emigrants to South Africa. They denounced him for what would now be called 'sleaze'. He had tried to corner the market in meat and wine by awarding his own agents the lucrative government contracts for these essential commodities.

Although he was recalled in disgrace, his legacy lived on. Wheat, barley, vines, olives: he had shown how to grow them all efficiently and profitably at the Cape. His trees, too, were magnificent. Of course his commercial oak woods have long come to maturity. Some, no doubt, were transformed into the blackened lintels and beams of Cape Dutch houses still in use today. But it's his house and estate at Vergelegen, and his ornamental plantations there, that have kept his memory green. Most of these trees are exotic introductions from abroad — trees that in other parts of South Africa have become the victims of their own success. They are denounced, and destroyed, for threatening native trees and plants. But at Vergelegen, and other estates and gardens, private and public, these guest trees are in sanctuary.

Vergelegen is only half an hour's drive from Cape Town and managed in sumptuous style by the great mining company Anglo-American, which has generously thrown it open to the public. I drove down in January 2007 intending to pay my respects, once again, to the extraordinary line of 300-year-old camphor trees. And so I did. But hidden behind the avenue was an ancient oak tree that I had missed in previous visits.

It hovered behind the gigantic arcade of camphors like a wizened old retainer. There are many old oaks in the Cape region but this was much the oldest I had seen, or so it appeared. It's the kind of oak that the English have tried to claim by calling it the 'English oak' and the Germans have tried the same trick by calling it the 'German oak'. In reality it's a great deal more: the common oak of Europe (*Quercus robur*) that ranges from western Ireland to the mountains of Asia minor. And sometimes the word 'common' hardly describes it. In its homelands in Europe and Asia it can be a prodigy: of stupendous size (there's an oak in Sweden 50 feet in girth) and of stupendous age (many trees in Britain, known as 'dodders', are veterans from the middle ages).

What was extraordinary about this specimen at Vergelegen was that it looked like one of these European dodders. It's completely hollow. There's even a window high in the trunk where a branch broke off and exposed the hollow interior years ago. This is what happens to the great ruined oaks of Europe approaching their thousandth birthday. But this Vergelegen oak is only a youngster by their standards. In fact we know its age almost exactly. It dates from the decade, at the beginning of the seventeenth century, when Willem van der Stel created his palatial house and garden here. This makes it a stripling of a mere 300 years.

Why does it look a thousand years old? I think the answer lies in the perfection of the Cape climate. For most Europeans, summers can never be too long, or winters too short. But for an oak tree the Cape climate is all too much of a good thing. The tree is compelled to grow and grow, with hardly a dormant month. So it's old long before it is middle-aged — burnt out when it should be just coming into its prime.

Previous pages: *Inside the hollow oak at Vergelegen, western Cape, planted about 1700 by the Governor of the Cape, Willem van der Stel.*

Left: *The hollow oak. The Cape's climate was too much of a good thing.*

Dancing at the Cellars

WILLEM VAN DER STEL would certainly have been proud of his wizened old retainer. And proudest of all, I'm sure, of his huge, twisted 300-year-old camphor trees. These exotic giants must have been imported as seeds from Java (then under Dutch control) and lined out in the formal garden of the governor's palatial house. There are actually *two* lines of 300-year-old camphor trees, one on the east and the other on the west side of the house. There's also a wild wood of camphor trees and oak trees — designed to be what Europeans of that period called a 'wilderness'. Most of these oaks and camphors date from long after the time of the Governor and have not yet reached their prime. I expect many are self-sown from the original stock. Some will be giants in due course — or, in the case of the oaks, wizened old retainers.

If you want to see a line of camphors distinguished for beauty rather than size, then go to the Cellars Hotel at Constantia, under the shadow of Table Mountain. The Cellars Hotel belongs to the remarkable Liz McGrath, and I had the good fortune to be entertained there as her guest. Her age is naturally a secret. But she told me that she launched herself into the hotel business almost by accident at a time of life when most people are planning their retirement. She now skippers three of the most delightful hotels in South Africa. The Cellars is her flagship, a converted Dutch country house for which she has designed almost everything except its crowning glory: a magnificent line of 150-year-old camphor trees.

Two of the 300-year old camphor trees at Vergelegen —probably imported as seed from Java and now the oldest and largest in South Africa.

Originally the trees were the glory of the adjoining estate called Hohenort. Liz told me that she looked at them, over the garden wall, with hopeless longing. But fortune favours the brave. To capture the trees for the Cellars, there was only one solution. She bought Hohenort, lock, stock and barrel. Now you wander down through the Robinsonian wild garden, past the huge tree ferns, and you'll encounter a younger and more elegant version of the gigantic camphors of William van der Stel. Go in the fading light of evening, as I did, with a glass of Constantia wine in your hand. The line of camphors keeps perfect time like a line of dancers.

A line of 150-year-old camphor trees at the Cellars, Constantia, a few miles from Cape Town. At evening the trees keep perfect time.

The First Planes have Landed

SOME TIME in the seventeenth century, somewhere in Europe, a North American plane (*Platanus occidentalis*) mated with its Turkish counterpart, the oriental plane (*Platanus orientalis*). There's a story that this romantic union took place in the flowerbed in the Botanic Garden at Oxford in about 1670. But modern authorities tend to be skeptical about the story; it's more likely this canoodling, if it ever happened, took place in some shadowy grove in southern Europe. All that we know is that the tree now known as the London plane (*Platanus x hispanica*) has been cultivated in Britain since the mid-eighteenth century, and is generally reckoned to be one of the most successful hybrids of all time. To have hybrid vigour means you have the best qualities of both your father and mother — and none of the worst. The London plane grows tall and upright, like its North American parent. It also has the longevity and good health, including an ability to cope with the stress of the city life, inherited from its oriental parent. This happy combination can be found in many hybrid trees. But in the case of the London plane these virtues have given it the power to sweep the temperate world.

This avenue of London planes in the botanic garden at Pietermaritzburg, planted exactly a century ago, appears to be the first and finest example of an avenue of planes in southern Africa. Pietermaritzburg (as its name suggests) was founded by Boer voortrekkers. But in the years after 1845, when the British carved out a second colony north-east of Cape Colony, Pietermaritzburg became the administrative capital of Natal and of one of the most anglicized parts of south of Africa. Of course it never rivalled Durban in size or affluence; Durban had the best harbour between Mozambique and the Cape. But the cooler, more temperate climate of up country Natal was almost perfect for growing anything European you chose. Hence the botanic garden is a delight. European and North American trees that would despair in the tropical heat of Durban flourish in the cool winds from the Drakensberg. I spotted many rare species of oak and pine, as well as tulip trees and swamp cypresses. Some must have been introduced from Britain. One can imagine how they were balm to the souls of homesick British colonials. Here was an avenue of planes that would soon be taller than the famous trees in Berkeley Square planted in 1789. What a symbol of colonial energy and pride. And they might grow for another two centuries, and be the tallest London planes in the world!

Today, when the eyes of most South African botanists are focussed on indigenous plants, the authorities who run the National Botanic Garden at Pietermaritzburg are still happy to give sanctuary to foreign trees. They have also developed the garden to include more native plants. I congratulate them on their broad-mindedness. Pietermaritzburg performs a historic role of great importance. Long may it continue to show the world how some of the noblest European trees grow best of all in Africa.

The century-old avenue of London planes at Pietermaritzburg National Botanical Garden, Natal — probably the first and certainly the finest such avenue in South Africa.

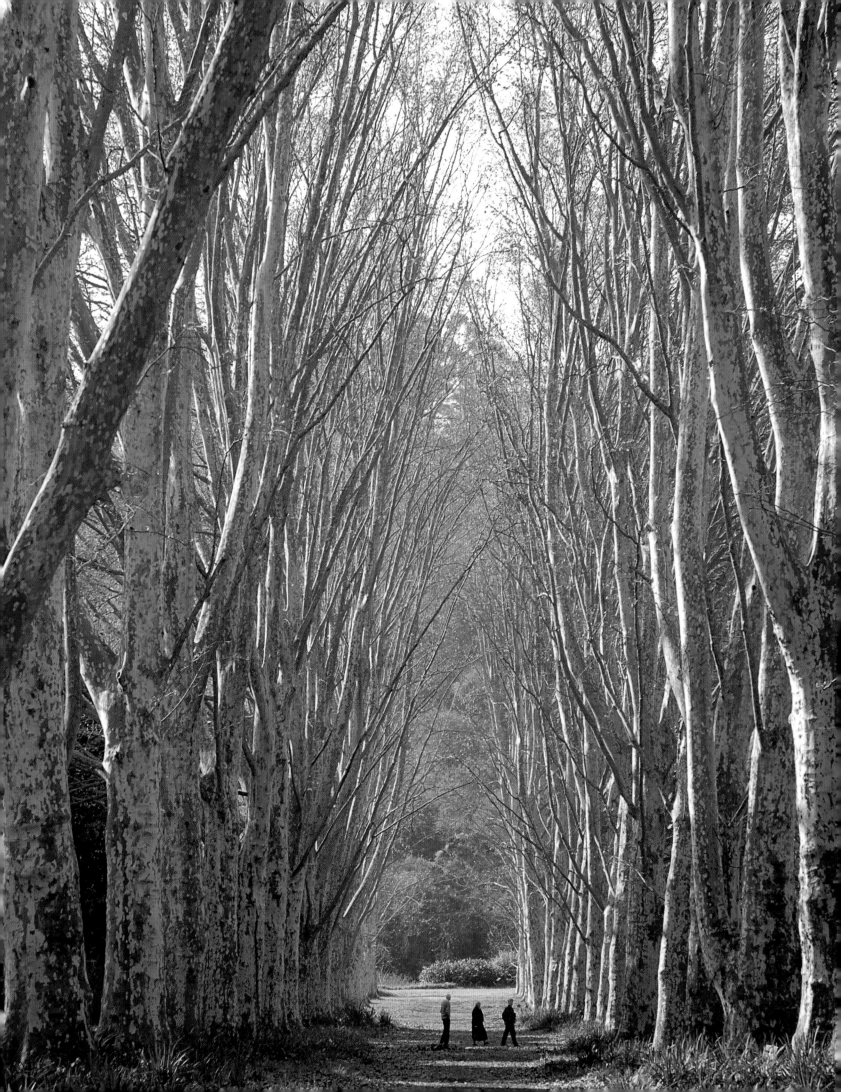

Off to the Moon

THE SUMPTUOUS botanic garden at Durban is one of my favourite botanic gardens in Africa. And when I first saw this rocket-shaped kapok tree it shot up my list of favourite trees.

Durban has a sub-tropical climate and for more than 150 years the garden has received — and distributed in its turn — a cornucopia of tropical and sub-tropical plants. It became part of the spider's web of colonial botanic gardens centred on Sir Joseph Hooker, the formidable director at London's Kew gardens. Much was expected of colonial botanic gardens at a time when botany had seized the imagination of the public throughout the English-speaking world. But the high expectations and low budgets often drove their curators to distraction. Fortunately, the Durban garden was run by a masterful curator called Medley Wood and enjoyed a golden age during his reign which lasted from 1882 to 1913. Wood combined painstaking agricultural research — transforming the colony's economy by importing new strains of sugar — with plant-hunting among the Zulus, as well as providing a pleasure ground to educate and delight the public. Today, you can see Wood's legacy in the form of a gallery of nineteenth century exotics: a huge jacaranda (1885, perhaps the first in South Africa); a mahogany (1887); a form of monkey puzzle (1888); as well as the famous cycad he discovered himself in Zululand, which bears his name, a species now extinct in the wild. (See page 189).

But the 82-foot high kapok tree or silk-cotton tree (*Ceiba pentandra*) was only planted in 1934, two decades after Medley Wood's triumphant reign had ended. By then the botanic garden had fallen on evil days, and ten acres of its site had been sold for road and residential building. It was now owned by the municipality and run as little more than a municipal park. But a few new trees were planted, including this kapok tree in the shape of a rocket. The genus is confined to South America except for this one stupendous species which is believed to be also native to tropical Africa. Specimens have grown to more than 230 feet high — which makes it Africa's tallest tree. Its enormous buttress roots, like a space rocket's fins, also make it one of Africa's oddest. And the tree has proved unusually accommodating to us all. You can use the hairs from the seed pods to make kapok for stuffing your mattress and your lifejacket. You can mill the seeds for oil; and you can use the wood to make both your matches and your canoes.

All that the species lacks is a spectacularly beautiful flower. And that deficiency is fortunately supplied by one of its near relations, the floss-silk tree, *Chorisia speciosa*. Go to the botanic garden next autumn (deservedly, the garden is now enjoying a second golden age) and you will be stunned by the pink and white flowers that bloom while the leaves fall. But beware its green trunk. The spines can bite like a sea urchin.

The kapok tree in Durban Botanic Garden planted in 1934. In tropical Africa it's the tallest indigenous tree.

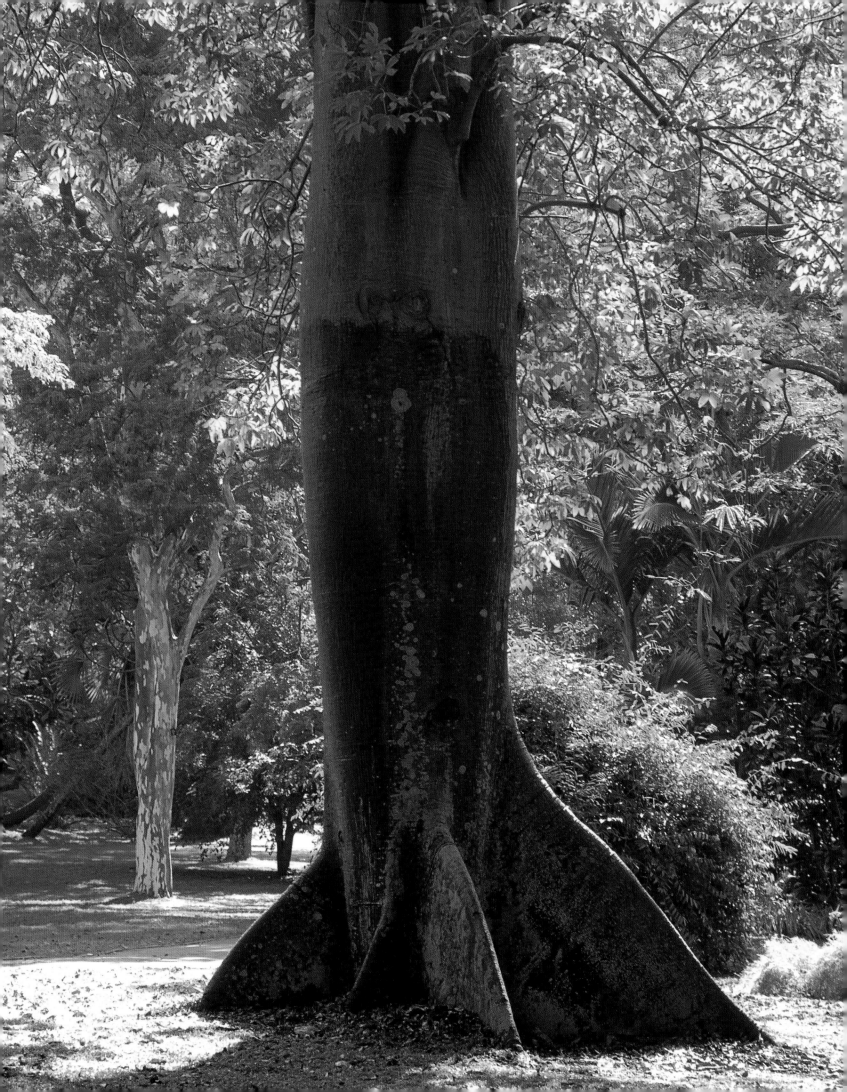

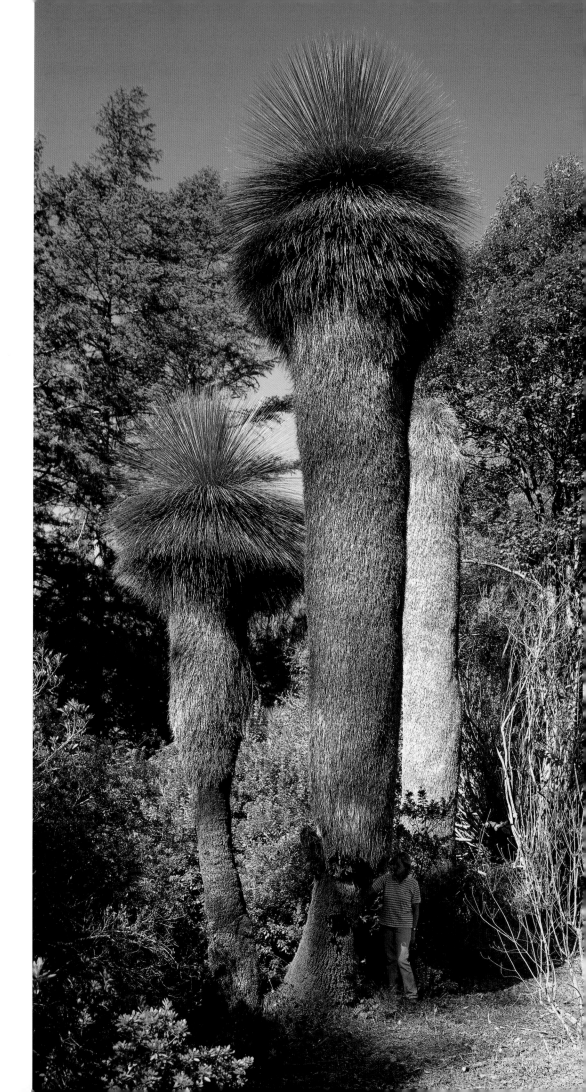

Three Australian grass trees ('black boys') at the Benvie Arboretum, KwaZulu-Natal, with Jennie Robinson whose great-grandfather created the arboretum in the 1880s.

The Salamander from Oz

THE SURREAL grass trees from Australia — trees that look like huge, elongated columns of grass — take a bush fire calmly. They are not indifferent; indeed some welcome it. Fire may be necessary if they are to flower, and some trees have to wait for more than a century before the fire comes. But the grass tree itself (*Xanthorrhoea australis, preissii* and others) is perfectly fire-proof. When a bush-fire sweeps through the dry coastal plains in south-east or south-west Australia, the flames only burn the expendable outer layer of the grass tree. Inside, the tree is happy enough, like a Victorian chimney-sweep, cheerful enough under his soot-blackened face. In fact, Australians used to call the trees 'black boys', meaning no harm. But the term is now banned in Australia, as it's thought to be insulting to the aboriginal people. The grass tree was important for them, especially for the resin, that drips onto the dead leaves, and was used to glue stone blades to the shaft of their hunting spears.

In South Africa, to call a tree 'black' offends no one (although to call it a 'native' can get you into trouble). Anyway I had no difficulties when I went to see the celebrated grass trees in the Benvie Arboretum high in the rain-soaked hills west of Pietermaritzburg.

'I'll show you our black boys,' said our obliging host, Jennie Robinson, without embarrassment. And there they were, even taller and more surreal than the ones I have seen east of Perth in Australia. The Benvie Arboretum was founded about 120 years ago by Jennie Robinson's great-grandfather, a Scottish immigrant called Geekie. Clearly he felt homesick for Scotland. Most of the trees are conifers: huge Scots pines and silver firs and Douglas firs that would look at home beside the Tay (although these trees must be half the age of large trees like that in Scotland). But Geekie also dreamt of re-creating Australia. We saw towering gum trees (*Eucalyptus regnans*) that would have drawn admiring glances in Melbourne. Best of all is this trio of grass trees.

Sadly I realised that about twenty elegant azaleas were blocking my camera's line of vision. 'If only we could cut those down,' I said, without really meaning it. 'Come back tomorrow,' said our ever-obliging host. 'I'll go and get some men and a bulldozer.' People very rarely take me seriously. But that day they did. And next day, with the azaleas' blood on my hands, I took the photograph.

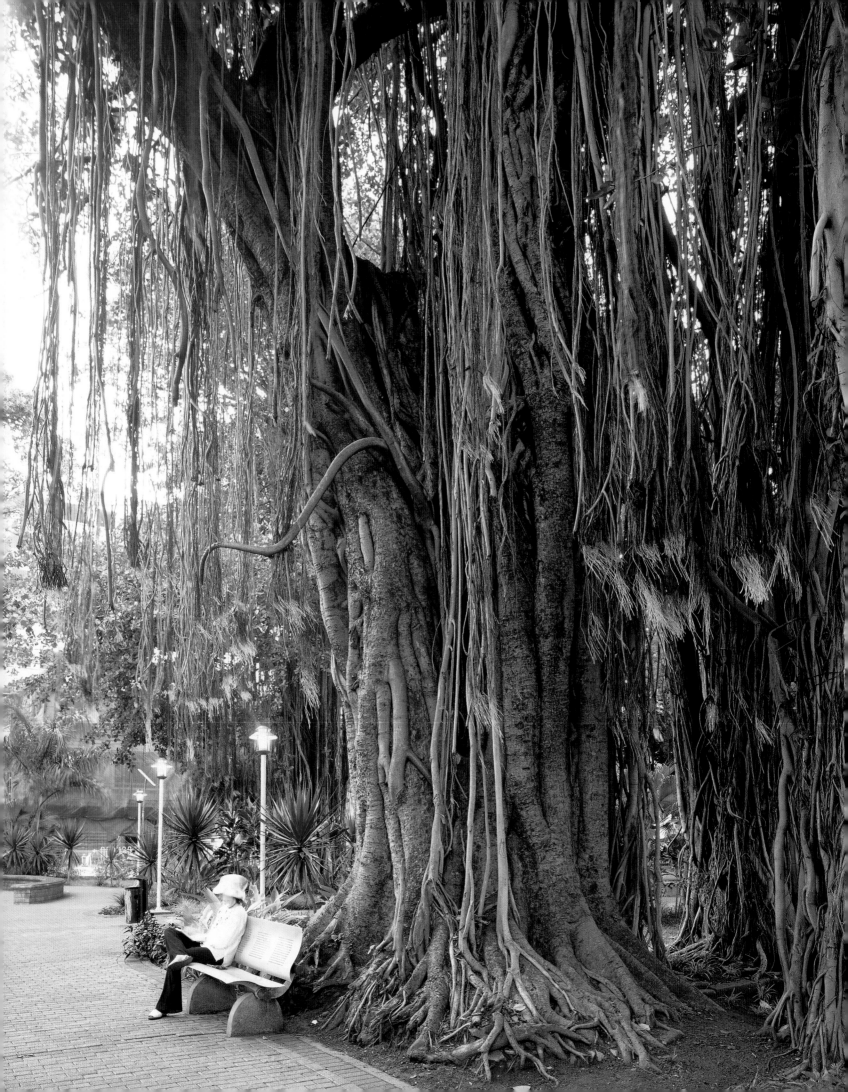

The Caress of the Banyan

Two of the most energetic trees in Durban Botanic Garden are examples of the formidable Bengal fig (*Ficus benghalensis*) a species also known as the banyan. That name is actually derived from the way Indian traders, called banians, used to set up shop under the canopies of these fig trees. The tree was a perfect tent for any number of weary travellers. Its peculiar gift is to multiply itself by means of aerial roots. The process of extension is so rapid that it is almost as if the tree was walking.

In fact ,I am sure that the director of the Durban Botanic Garden, Chris Dalzell, has to keep a careful eye on both these trees, in case they should get above themselves. The one I photographed is only about fifty years old, but is already striding along towards the main gate.

There's a cautionary tale from the history of the great banyan at Calcutta. It probably began life as an epiphyte — a bird-sown guest high up in the fork of some noble giant. Gradually, the guest extended its roots down from its perch, slowly encasing and strangling its host. This is how a strangler makes its way in the world. But the Bengal fig has wider ambitions than merely to strangle one noble old giant. Its appetite for power is Napoleonic. The great banyan at Calcutta has advanced across four acres of ground, with an army of at least 100 main trunks and 1775 proproots to support them. Give it a few more years and it will probably take over most of the city.

In Mauritius the small park in the centre of the capital is dominated by four enormous banyans. Recently I went there on holiday. As you will see from my photograph (with my daring youngest sister Rachel on the park bench) the trees have a hungry look. It certainly takes a daredevil to sit under a banyan at dusk. But was I a madman myself? I stayed there till the moon rose.

Two hungry banyans. Left: Caressing my sister Rachel in the park in the centre of Mauritius. Right: Striding along towards the main gate of Durban Botanic garden.

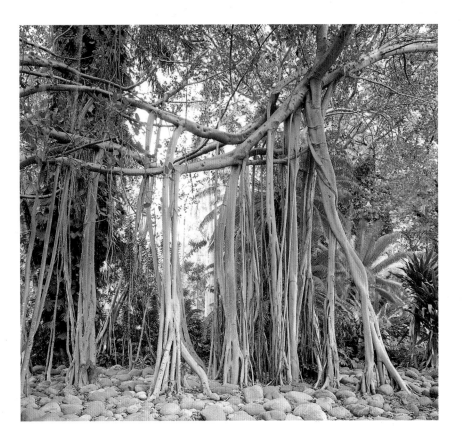

Pick Me for Your Wedding

IF YOU GO TO Arderne Gardens in Claremont, one of the leafy suburbs that lured well-off white families out of Cape Town in the mid-nineteenth century, you will find one of the largest trees in South Africa, an immense fig tree introduced from abroad, just inside the gate on the left. The tree, which has chosen the Gothic style for its trunk and branches, has long been famous for weddings. I don't think you can actually get married under its fan vaults and flying-buttresses — which is a pity. The tree is certainly bigger than many churches, and some would find it a holy enough place to make their vows. But you can certainly be photographed there. So the tree plays host to cheerful wedding parties, especially Malay wedding parties, most weekends when the weather smiles.

What kind of fig could grow to such a gigantic size in the space of a century and a half? The label on the tree when I went there in January 2006 described it as a fig native to Asia, the India rubber tree, *Ficus elastica*. The label was apparently put there by the Department of Water Affairs and Forestry, the formidable DWAF. Recently DWAF officials have been making a survey of all the largest trees in South Africa, including exotics introduced from abroad, and they have decided that this remarkable fig tree is one of the two largest trees in the whole of South Africa. In fact they have made it co-champion with a South African native — the Sagole Giant, the colossal baobab near the River Limpopo. I must confess the decision surprises me. The girth of this magnificent fig is only about half the girth of the Sagole Giant. But I suppose DWAF knows what it's doing. Or does it? In February 2007 an article appeared in a Cape Town newspaper with the astonishing revelation that DWAF had put the wrong label on the tree. It's not *Ficus elastica*, the

India rubber tree from Asia. It's *Ficus macrophylla*, a Moreton Bay fig from eastern Australia.

The two giant figs are very similar. Both trees can begin life as stranglers, after a fig-eating bird has dropped their seeds in the fork of an unfortunate host. Both trees develop aerial roots to support the huge weight of their branches (though not to the same extent as the banyan, *Ficus benghalensis*). Both trees can prove invasive, meaning that their fruit can be distributed by birds and mamals in places that threaten our environment. But — and it's a big but — they are invasive only if they have their own specific wasp to pollinate their figs. And, thank heavens, neither of these two malignant wasps has, I believe, yet reached South Africa.

My heart goes out to the good people of DWAF. I could have made the same stupid mistake myself.

The giant Moreton Bay fig at Arderne Gardens, Cape Town, recently declared co-champion tree of South Africa.

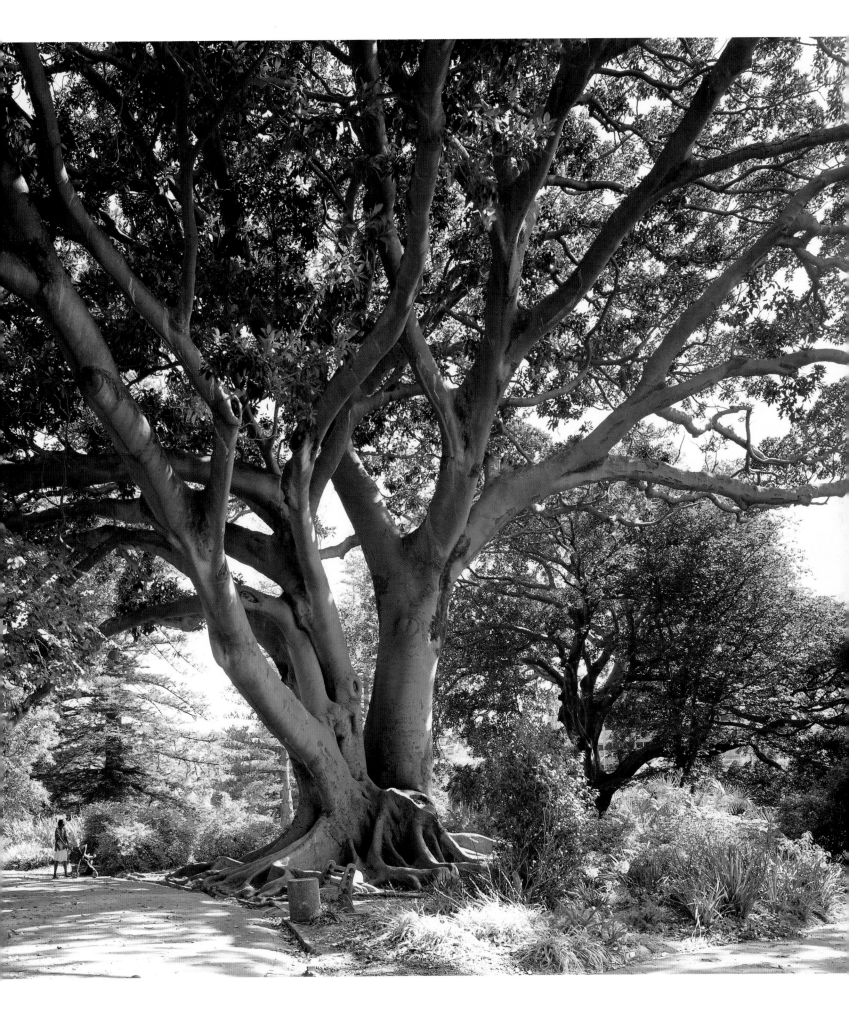

For the Rainbow Nation

In 1994 when Archbishop Desmond Tutu coined the inspiring phrase, 'the Rainbow Nation', he was not, I feel sure, thinking of gum trees. He had in mind two kinds of metaphors. The first is religious and comes from Genesis, Chapter IX: God promises that the flood is over, and uses the rainbow to confirm his covenant with Noah and every living creature ('I do set my bow in the cloud'). The second is political and uses the rainbow as a symbol of diversity — ethnic, racial and cultural. Both kinds of metaphor were later combined by Nelson Mandela in his famous words, spoken in his first month as President, 'a Rainbow Nation at peace with itself and the world'.

What's the connection between all this and the humble (and often hated) gum tree? In Durban Botanic Garden you can see one of the rarest of the genus, introduced from New Guinea about seventy years ago, and it will turn any eucalypto-phobe into a devoted fan. It's called the rainbow gum (*Eucalyptus deglupta*). This is not just a fanciful name. The bark is a dazzling prism of colour, ranging from green and scarlet to blue and yellow. I defy anyone to look at the tree for more than a minute without feeling at peace with themselves — and indeed the world. I wish it could be seen by the Talibans who are trying to purge South Africa of alien plants. I'm sure it would soften their puritanical zeal. Unfortunately the plant is a delicate creature from the tropics. It depends for survival on the balmy air of Durban and the north coast. A night in Johannesburg could prove fatal. Otherwise the tree could serve as a perfect symbol for the new pluralism in South Africa that Tutu and Mandela have helped to inspire.

Left and right: *The rainbow gum from New Guinea in Durban Botanic Garden — symbol of a new pluralism?*

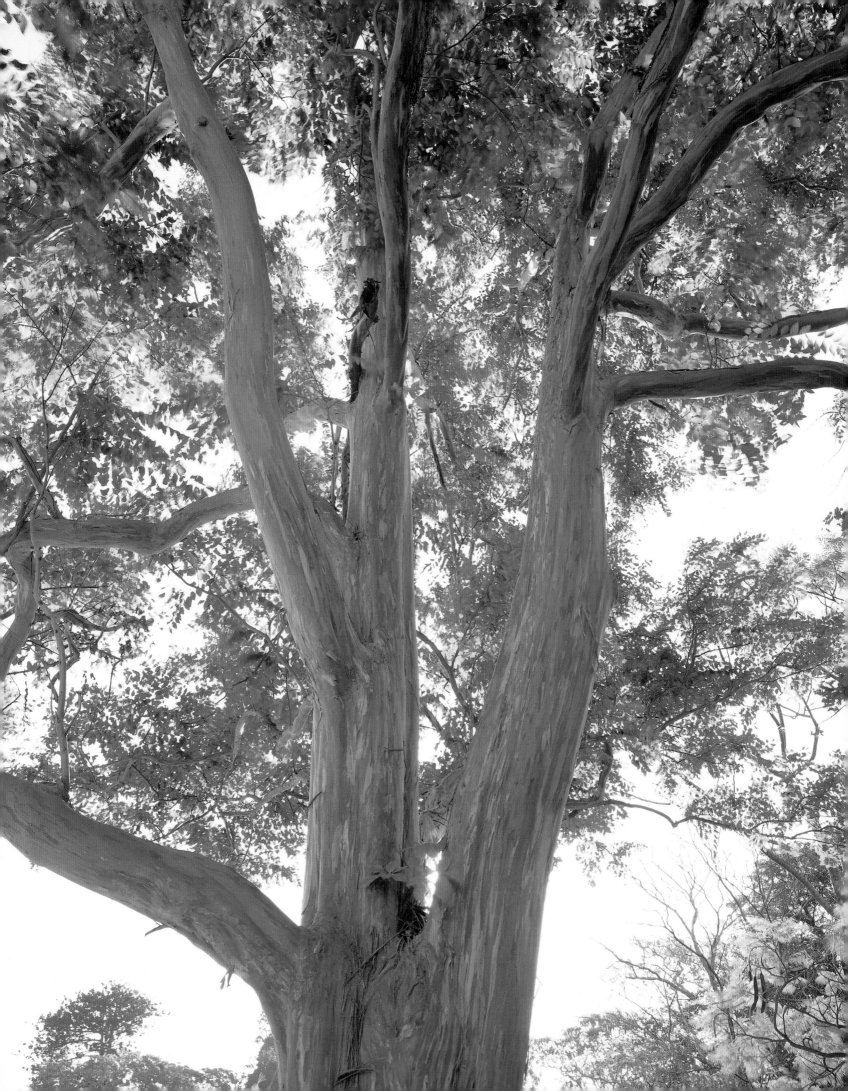

The Tree that Came to Dinner

A TASMANIAN BLUE GUM is not everyone's cup of tea — not at any rate a Tasmanian blue gum 100 feet high nudging the dining-room of your house. But the owners of the Houw Hoek Inn, near Grabouw in the Western Cape, are proud of the tree. The inn is one of the oldest in South Africa — and so is the gum tree.

You will find them close to Sir Lowry's Pass, just off the main road (N2) running south-east from Cape Town, on the 'garden route'. Sir Lowry Cole was one of Wellington's Peninsular generals who helped shore up the British Empire after the war ended in 1815. He had been trained as an engineer and found building roads and harbours, as Governor of the Cape, congenial employment. No doubt he stayed at the Houw Hoek Inn in the 1830s when he was hacking his way over the mountain to make the pass that now bears his name. And there is a story that he gave the owners the Tasmanian blue gum to plant by the inn. He had brought it as a seed from Tasmania, the first eucalyptus to set foot in South Africa.

What is certain is that the species, *Eucalyptus globulus,* was a rarity at this date anywhere beyond south-eastern Australia. It was only discovered by a European botanist in 1795. However, the seed (housed in an elegant brown capsule the shape of a top) germinated readily. Although too tender for most parts of Britain and Europe, the Tasmanian blue gum grew nearly 200 feet high and took to its heart the warm temperate and subtropical regions of the world. By the 1860s it was being planted for construction work on a large scale in China and the East. By the early twentieth century it was the main source of timber and firewood for impoverished countries like Ethiopia.

At the Houw Hoek Inn they regard the tree rather like a large —very large — family pet. It's well fed and well looked after. I am sure there is no danger to the inn. But I am reminded of the story of Henry Grattan, the Irish statesman who

flourished at the end of the eighteenth century. One day his steward warned him that the magnificent beech tree on the lawn was now threatening his house. 'Yes, it will have to go', said Grattan sadly — 'I mean, the house.'

I hope that the Houw Hoek Inn will be spared for many years.

Right: *The 170-year-old Tasmanian blue gum nudging the Houw Hoek Inn on the road south-east from Cape Town.*
Left: *The tree approaching the door of the dining room.*

The champion river red gum in the market place at Stellenbosch, Western Cape. Does it have no admirers?

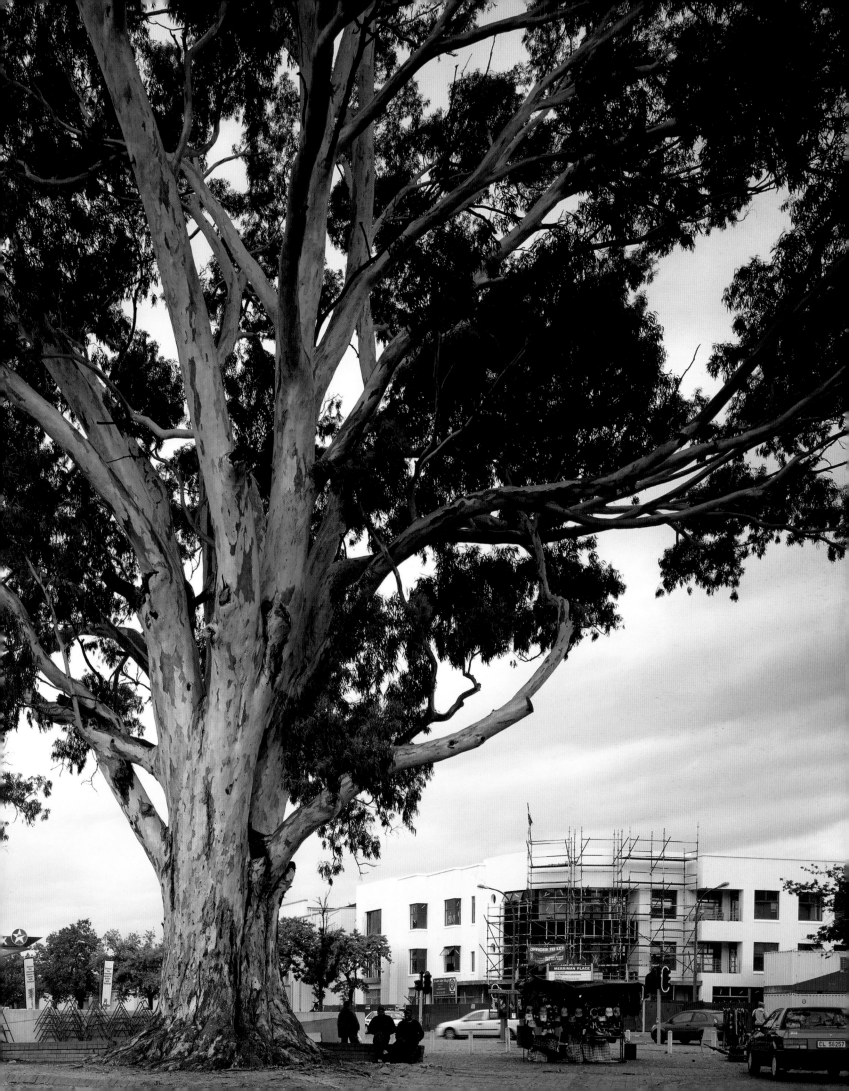

On Death Row

The Beautiful and the Doomed

A FEW YEARS AGO one of South Africa's leading newspapers published a striking story. The paper reported that the municipal authorities in Pretoria had reluctantly agreed to cut down the famous avenues of jacarandas, which cover the city and its suburbs in swirling ribbons of blue and mauve every October and November. The trees were aliens — and, worse, they were invasive aliens. They threatened to outbreed, or even choke to death, the much loved indigenous flora of the region. So there was really no choice in the matter.

Readers were reminded that it was already illegal to sell a jacaranda in any plant nursery in South Africa because of the threat it represented. It was also illegal to sell a house in KwaZulu-Natal, the province which includes Durban, without first cutting down any jacarandas that happened to be growing in the garden. So cutting down the avenues in Pretoria, the nation's capital, was a foregone conclusion. That's what the leading newspaper said.

Many were shocked, some outraged. Others felt that the jacarandas had it coming to them. After all they were aliens. The municipal authorities were roundly denounced on phone-in programmes, defended by others. Then the hullaballoo evaporated as quickly as it had begun. Somebody noticed the date. It was April 1, April Fool's Day. There was no truth whatsoever in the story.

Or was there? In fact, the reason so many had been fooled is that so much of it was true. It *is* illegal to sell a jacaranda anywhere in a South African plant nursery. The tree is a prohibited alien — one of the hundred or so invasive species originally introduced from outside the region and now naturalized.

The jacaranda (*Jacaranda mimosifolia*) comes from the north-west of Argentina and has found admirers all over the subtropical world. It's pre-eminently the tree of the street, brightening the drab pavements from the Mediterranean to China. It reached South Africa about 1880, and was instantly taken to heart by Boers and British alike. Soon it was the symbol of spring in Pretoria and Johannesburg. It even symbolized, for President Mandela, the diversity of the South African identity. 'Each of us,' he said in that famous speech about the Rainbow Nation in 1994, 'is as intimately attached to the soil of this beautiful country as are the famous jacaranda trees of Pretoria and the mimosa trees of the bushveld.'

But, unlike most introduced ornamental trees, the jacaranda was proving to be the victim of its own success. Its winged seeds, released in millions from its oval seed pods every autumn, flew out into the wild and took root. Out there, in dry bushveld and parched river valleys, the blue flower became the enemy. It steals our water, say the water authorities. It shades out our wild flowers, say the botanists. And out there it is to be exterminated — or so the authorities hope.

Last October I stood close to the centre of Pretoria in the garden of Melrose House, a merchant prince's villa that served as Lord Kitchener's H.Q. in the last year and a half of the Boer War. The peace was signed in the dining room here on May 31, 1902, and the house is preserved as a museum. In the garden I was greeted by an explosion of flowers from a war veteran, a century-old jacaranda.

What is to be its fate, this pale blue symbol of spring — and of peace? Indeed what is to be the fate of all those stunning jacarandas that line the streets and gardens of South Africa? I hope the authorities will relent. If it's illegal to buy or sell the plant, no young jacarandas can be planted, and the species, in the long run, is doomed. Yes, I hope the jacaranda will be reprieved by the Talibans. But I wouldn't bet on it.

The jacaranda in the garden of Melrose House, Pretoria. The house was Kitchener's H.Q. during the Boer War and peace was signed here on May 31, 1902. But the war against jacarandas still goes on.

Left and above: *Two views of the western suburbs of Pretoria with the jacarandas in full bloom. But is the species doomed?*

How Can You Say No to the Apple Gum?

ONE OF THE LEAST KNOWN but most elegant of the thousands of species belonging to the myrtle family is an Australian apple gum, *Angophora costata*. Its blushing pink bark draws the eye like a magnet. So does its lithe figure and sinous curves. But it's a modest tree — almost a pygmy by eucalyptus standards. Sixty feet is a good height for an apple gum.

Until the 1980s it was known as a eucalyptus. But then, with twelve other apple gums, it was split off from the 700-strong *Eucalyptus* genus and sent to join a newly invented genus, called *Angophora*. Some Aussie botanists had been unhappy about the way the petals in these thirteen trees failed to fuse together like those of a properly behaved eucalyptus. (It was not a problem for the rest of us, as the petals are virtually invisible.) Anyway the botanical splitters got their way back in the 1980s. But having your own genus doesn't necessarily make your life easier.

The finest *Angophoras* that I have seen in South Africa are in the Tokai Arboretum on the slopes of Table Mountain, a mile or two beyond the suburbs of Cape Town. The collection is world famous — and so it should be. You can see in half an hour's walk about 100 species of *Eucalyptus*, *Angophora* and another new genus split off from the eucalyptus genus, the bloodwoods, now called *Corymbia*. All these exotic creatures were brought as seed from Australia about a hundred years ago. And no poor immigrants from Holland or Britain have ever adapted better to their new country. In fact, I don't believe there is any arboretum in the world, including those in Australia, with so many species of gum trees so perfectly adapted to soil and climate.

But go to Tokai and listen. Can that be the angry whine of the chain saw? Is it possible that these trees *inside* the arboretum are not protected? It turns out that the when the boundaries of Table Mountain National Park were decided in the 1990s Tokai Arboretum was included within the park. And the authorities who manage this national park are seized by one simple idea supplied them by the Talibans: restore the former glory of Table Mountain by removing all the trees within the boundaries of the park that are not indigenous to the region.

The result: what appears to be a slow death for the arboretum. Seedling trees from its own exotic collection are being regularly cut back, and no replacements are evident. By contrast seedlings from indigenous trees like yellowwoods are being encouraged.

The apple gums here are of course in a different predicament from the jacarandas in city streets. They are not, like the jacarandas, denounced as invasive. But they stand in the way of a simple idea and must go. In twenty years I fear that the glorious gum trees of Tokai — and all the other rarities — will have been quietly replaced by a motley collection of small indigenous trees that will please nobody but the extremists.

Australian apple gums at the Tokai arboretum outside Cape Town, threatened by the Talibans who wish to replace them with native trees.

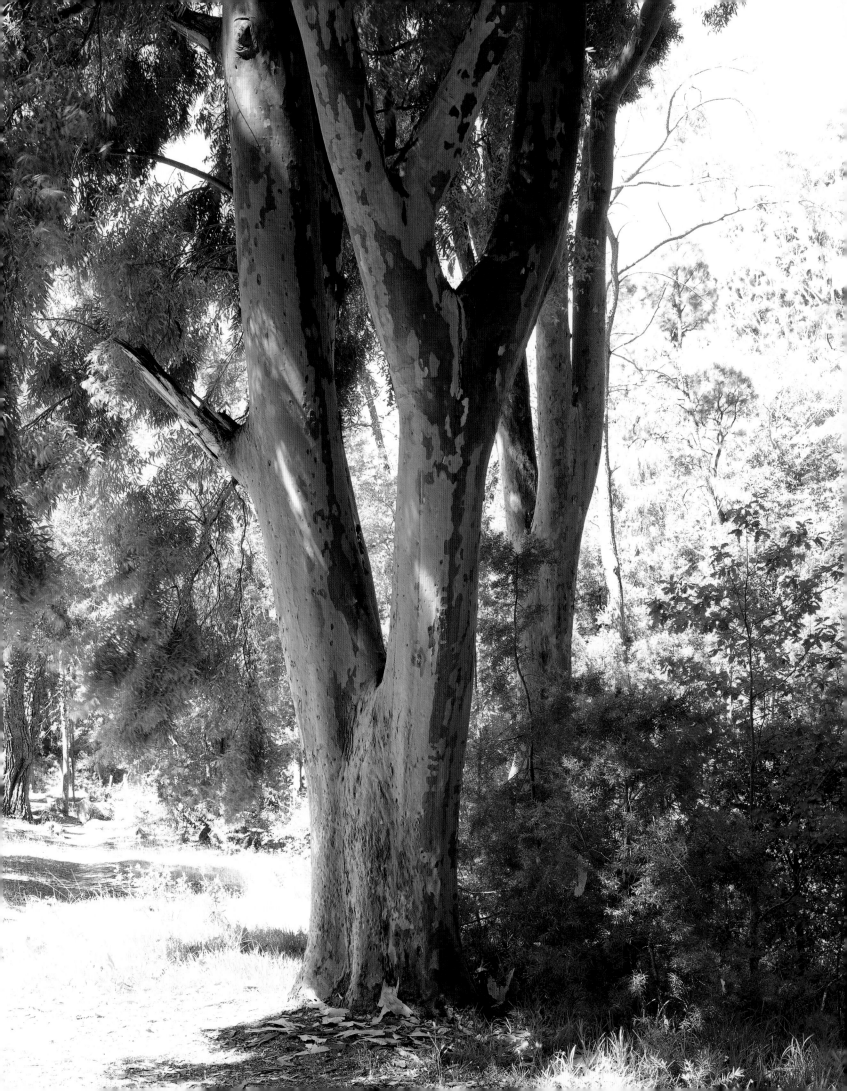

Humbling the Colossus

UNLIKE THE Tokai Arboretum, which has only a trickle of visitors each day, the Rhodes Memorial attracts trippers in their thousands. It's only minutes away from the centre of Cape Town. And here, 500 feet above the city, under the crags of Devil's Peak, is one of the great views of the world, the heart-stopping view of Cape Town and Table Bay. The memorial itself commands the finest view. It's a spectacular granite shrine dedicated to Cape Colony's most famous (and infamous) Prime Minister, Cecil Rhodes. The shrine was built years after his death. (It incorporates George Watt's bizarre statue of a naked man on a horse entitled 'Physical Energy', originally intended to represent Attila the Hun or Genghis Khan, then supposed to be modelled on Rhodes). But the trees around it are untainted with megalomania. They are tall, handsome pines and evergreen oaks, planted in

his lifetime, with still a century of good life in them. But they'll be gone in a few years if the Talibans get their way.

Rhodes, Alfred Beit and their cronies gambled everything on a conspiracy to take over the Transvaal. They plotted a coup in Johannesburg precipitated by a raid from Bechuanaland led by Dr. Jameson. And of course it all proved a fiasco. At a stroke Rhodes destroyed himself politically. However, the Colossus (as Rhodes fancied himself) did have his good points. And one of them was that he had a strong aesthetic sense (stronger, it would be fair to say, than his moral sense). It was as an aesthete that he loved trees, and lavished pines and other exotics, especially trees from the Mediterranean, on his own house, Groote Schuur. He also lavished pines and oaks on the lower slopes of Table Mountain, including the land where his memorial now stands.

Left and above: *The Rhodes Memorial and Mediterranean pines that Rhodes planted on the slopes of Table Mountain —another target for the Talibans.*

These pines were Rhodes's pride and joy. They grew even better up here, in his eyrie above Groote Schuur, than beside the Parthenon in Greece and on the seven hills of Rome. Look at my pines, he could say — they are pines fit for an emperor. And for more than a century they have enriched the landscape, a swirling green scarf thrown carelessly over the bare shoulders of the mountain.

But now they lie under exactly the same threat as the gum trees of Tokai. The Rhodes Memorial is in the fiefdom of the same Table Mountain National Park. And the park's authorities have decided that in the long run all exotics must be banished from the mountain.

Is there no compromise to be made? It so happens that Rhodes chose two different species of pine for his artistic schemes. The more vigorous is the cluster pine (*Pinus pinaster*) which can prove invasive; after a fire its winged seeds take to the air and can fly for miles. The more poetic is the umbrella pine or stone pine (*Pinus pinea*) which has no ambitions to people the mountainside.

(In fact, its seeds are pine nuts: heavy, wingless and they taste delicious.) It makes good sense to cut down the cluster pine where it's threatening the indigenous *fynbos,* the rare and interesting scrub native to this area. But why not spare the umbrella pine, especially at the memorial itself, and the university grounds immediately to the west? The present plan seems to be to eradicate all pines. Some are to be cut down, including the pines belonging to the university. Others are to be removed by a process of attrition, that is, by preventing them reproducing themselves.

Of course the plan to remove the pines may not be simply to save the indigenous *fynbos*. It may be the aim is to cut Cecil Rhodes down to size. But Rhodes died a broken man 105 years ago. Why punish his trees for the sins of their father?

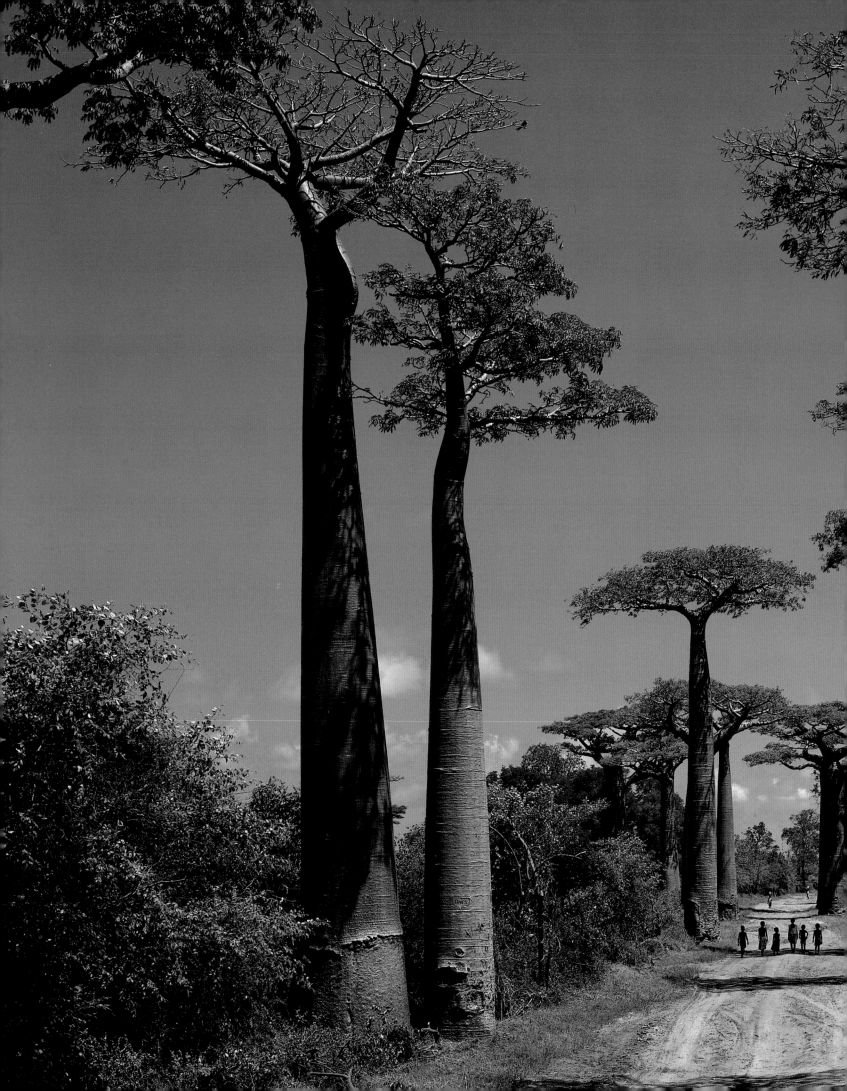

The
Endangered

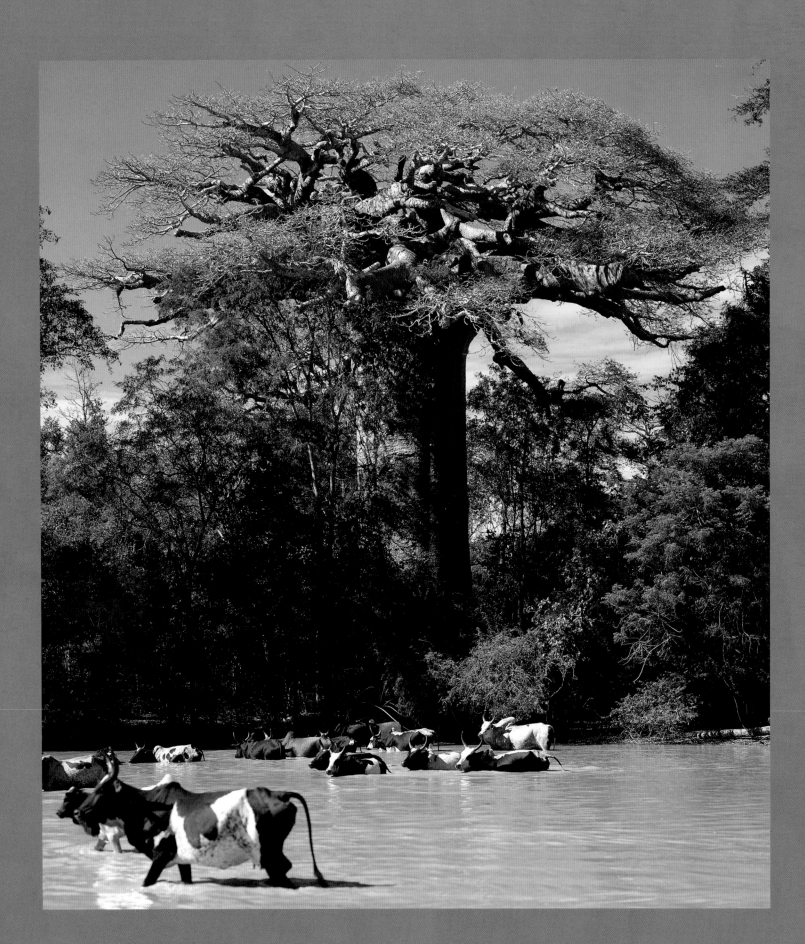

Bottle Trees, Halfmens

A Shrine like a Factory Chimney

Previous pages: *The celebrated Avenue of the Baobabs near Morondava in western Madagascar, threatened by effluent from a sugar factory as well as by global warming.*

Left: *The sacred tree near Morondava and the sacred pool.*
Below: *The avenue in April 2005, slowly deteriorating.*

IF I HAD TO NAME the great experiences of my life, sunset at the Avenue of the Baobabs at Morondava, in south-west Madagascar, would go high on that list. I have told the story in *Remarkable Trees of the World*: how a large lady from Belgium with a very small camera very nearly deprived me, by blocking my view, of a picture of a lifetime. All that, with its happy ending, was in August 2000.

Five years later, in April 2005, I returned to Morondava to see more of those tubular baobabs, and the experience was in some ways a sad one. The great avenue is very slowly deteriorating. This would be bad enough if the species of baobab at Morondava, *Adansonia grandidieri*, was common in Madagascar. In fact, like two other endemic species of Madagascar, it's on the international list of endangered trees. The baobabs at Morondava are under visible stress. Since my last visit two of the trees had begun to lose their foliage. I'm not sure why. Nothing can be done, at least locally, if it's the result of climate change, and of the more rapid rise of temperatures in the hotter parts of the southern hemisphere. But I read a report in a Malagasy newspaper that effluent from a nearby sugar factory is part of the problem.

To cheer myself up, I drove off in a local taxi to revisit a single baobab venerated as a shrine. It was of enormous size, the biggest Grandidier's baobab I have ever seen, but impossible to photograph, as the base of the holy tree was kept shrouded by bushes. It was about a mile from the avenue. Or was it? The tree seemed to have vanished into the air. We made some enquiries from a farmer tending his sugar cane. 'Oh, yes. It's gone… Collapsed about two years ago. You can see the remains if you crawl through those bushes.' I saw the remains: a huge pile of rotten pith, like a pile of old newspapers. The place now belonged to some wasps. I retreated to the taxi before the wasps could teach me a lesson.

'But the other holy tree's still there,' said the farmer. We drove off a few miles down the red dirt road beyond the avenue. And there it was indeed: a holy tree not as large as the first, but still massive enough, rising like a factory chimney, from a small wood at the edge of a sacred pool. I crawled through the undergrowth to the base of its trunk. Yes, it was a shrine. I saw offerings of flowers and rice. But who were the worshippers here?

I set up my camera on the tripod and the gods smiled. A herd of white cattle had appeared from nowhere and were drinking in the sacred pool.

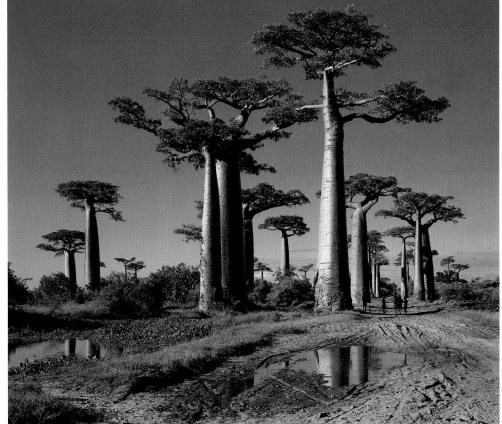

The Spoor of the Giant

THERE ARE SIX endemic species of baobab at Madagascar — six out of eight in the world — and I knew four of them from my earlier visit, including, of course, the threatened *Adansonia grandidieri* at Morondava. What of the other two, both endangered: *Adansonia suarezensis* and *Adansonia perrieri*?

Adansonia suarezensis, though rare enough, makes an easy target for the tree-hunter. There are two good specimens on the hillside — small, pink, stunted trees with flattened tops — within half an hour's drive of the northern city of Diego Suarez (now Antsiranana). Fortunately these are regarded by the local farmers as sacred trees; otherwise they would have been cut down, like the rest, to make a few extra acres of farmland. They are like smaller versions of Grandidier's baobab and would be impressive if they were the first baobabs you had ever encountered.

Adansonia perrieri is almost extinct. In fact, this species, the largest of the northern ones, is also the rarest. There are only four known groups of these trees which probably total less than 100. They lurk, like a rare breed of elephants, in the rain-soaked mountains south of Diego, the Montagne d'Ambre — a national park created by the French colonial authorities, who had handed over most of the natural forests to the loggers. I hired a knowledgeable guide, a beautiful young cook, and a calm driver with some fine camping equipment, and set off in April 2005 with an adventurous friend, Tricia Daunt, to track down one of these giants.

Welcomed by mosquitos and leeches, we tramped for two days through the rainforest. Then we saw our quarry. It rose out of the jungle, unmistakably huge and grey, on the other side of a foaming stream, haunted by tricolour butterflies and covered with spiders' webs. Our party plunged in the stream, and I followed cautiously, feeling my way over the slippery rocks. Yes, it must be *Adansonia perrieri*. It was at least 80 feet high and its seed pods were much rounder than those of *Adansonia digitata* (the African baobab introduced to Madagascar); its five-lobed leaves spangled the canopy above us. But how to photograph this creature of the jungle? We took turns with a machete, and after half an hour the tree was in the bag.

Right: Adansonia perrieri, *rarest of Madagascar's six endemic species of baobab, hunted down on the banks of a foaming stream in the Montagne d'Ambre.*
Left: *Seed pods.*

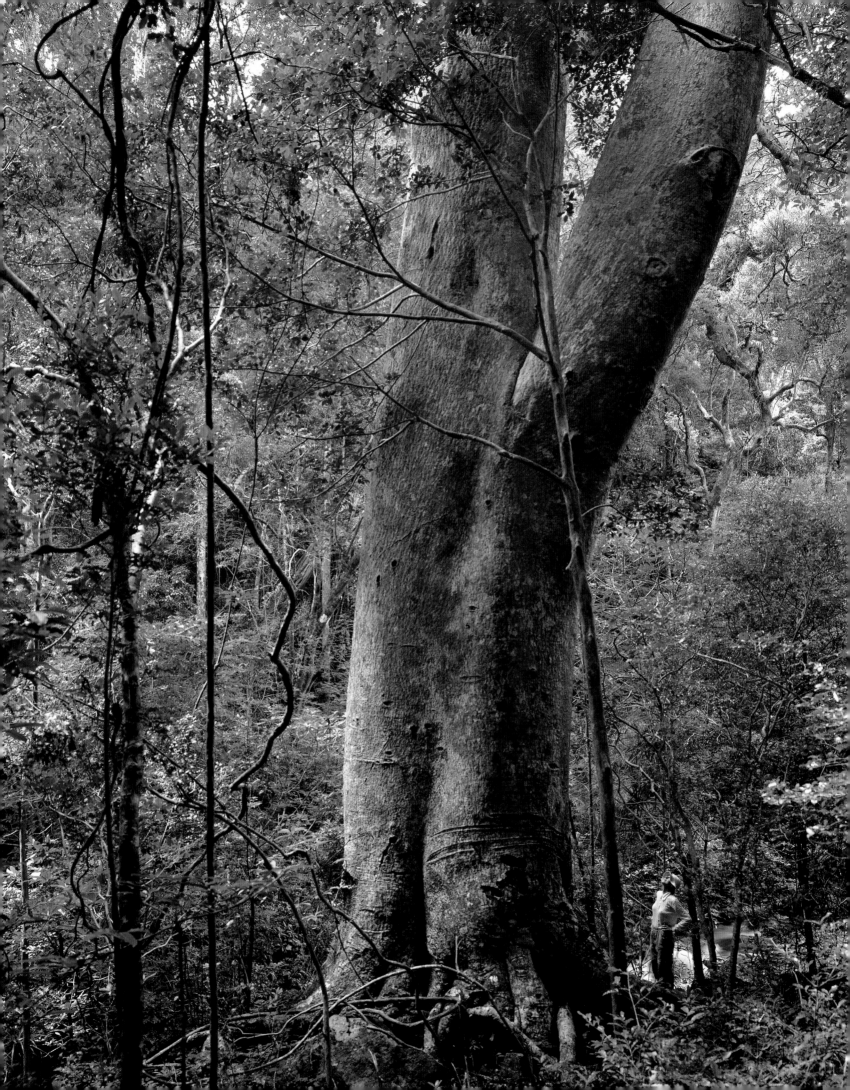

A Short Walk in the *tsingy*

SIXTY MILES SOUTH of Diego is Ankarana Special Reserve, a small island of dry deciduous forest containing rare trees and lemurs, which have somehow survived the loggers. This is the heartland of the limestone karst or *tsingy*: a lunar landscape of eroded limestone intersected by deep canyons. My main quarry was a rare bottle-shaped succulent, the local *Pachypodium decaryi* (or elephant's foot). I had heard that some of the most striking specimens

we set off on the four-hour trek to the *tsingy*. The track led through a forest teeming with unusual forms of life. We passed a small lemur which peered sleepily out of its nest at the top of a rotten tree. Francois, our local guide, said it was nocturnal: a northern sportive lemur. After two hours we came to a huge fig tree, its buttress roots splayed out like fingers. Francois showed us a forest crab which had surfaced in one of the

Left: *Forest crab emerging from the roots of a giant fig tree.*
Right: *The giant fig in the forest on the way to the* tsingy.

grow out of the pinnacles of eroded limestone, rather like the blue gentians in Ireland, that frisk about in the limestone pavements of the Burren.

In the dry season you can drive all the way to the main campsite, Campement Anilotra. But this was April, and we were still in the wet season. We stayed in bamboo huts on the east side of the reserve. On our second morning, under a hot sun,

buttresses. In the dry season, he said, the water table goes down and the crabs with it, only re-emerging when the rains resume.

But the oddest experience lay ahead, as we approached the *tsingy* itself. We heard girlish laughter, and there were twenty American college girls striding ahead of us, beautifully turned out, as though this was a stroll in Central Park. They were

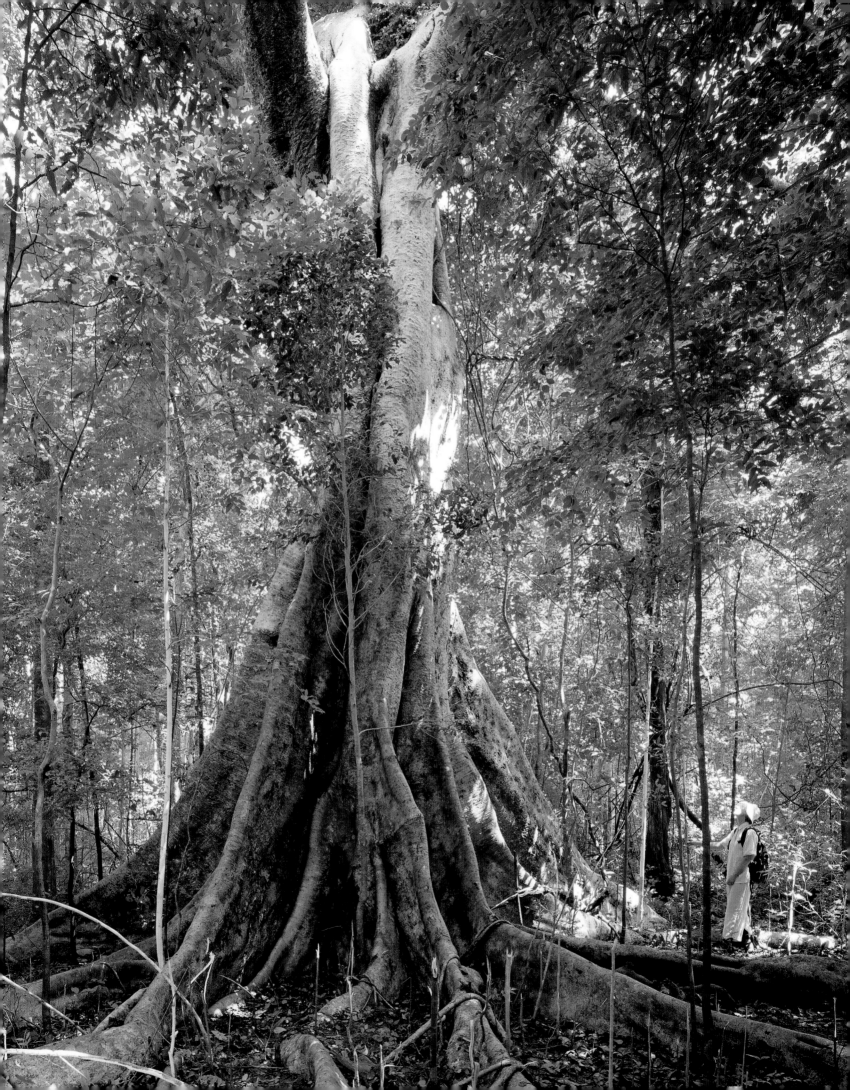

Left: Pachypodium decaryi *flowering on the* tsingy. Right: *Two of the American college girls and a crown lemur.*

apparently on a six-month course to study culture in the third world under the guidance of a solitary male professor. (*He* looked somewhat glum.) In due course the *tsingy* delighted the rest of us. It was rather like an ice flow made of limestone — full of jagged spikes and deep crevasses — and you advanced in a series of small jumps. But there were brown lemurs to share the girls' picnics and several *Pachypodiums* for my lens.

Two were possible to photograph without too much risk of breaking my ankle — or indeed my neck. For they grew right up to the edge of the limestone 'ice flow' on which we were standing. Below, there was a deep canyon that looked impenetrable. Both *Pachypodiums* had produced elegant white flowers. Otherwise they might have looked merely grotesque, as they squatted among

the chaos of limestone, their bloated trunks giving them the air of miniature baobabs.

I had just taken my second photograph when the heavens darkened and opened. I have often been wet on a walk, but never so completely soaked to the skin. I can't say I really enjoyed that four-hour trek back to our huts, along a clay track now as slippery as ice. And the girls, the lemurs and the glum professor had vanished like a dream.

Aloe, Aloe, Can You Hear Me?

BEFORE YOU GET to Hell's Kloof, and the entrance to the Richtersveld National Park in the Northern Cape, with the wild mountains of Namibia beckoning from across the Orange River, you come to a rather ordinary hill called Cornellskop. Or rather, it would be an ordinary hill if it wasn't the place where a new species of aloe tree was discovered in the 1920s by botanist called Neville Pillans. The trees are still there, famously rare and famously easy to find; they are now christened, very properly, after their discoverer, *Aloe pillansii*.

Of course they were well known before they were discovered. People thought they were just unusually tall and gaunt specimens of the common kokerboom, *Aloe dichotoma*. But Pillans spotted crucial differences. When the trees are in bloom in spring, the curving racemes of yellow flowers

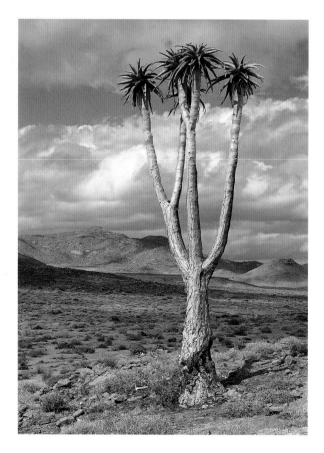

project from the axils of the lowest leaves, and hang downwards. By contrast the flowers of the kokerboom are brighter yellow, bloom in late autumn and point straight up like the flame of a candle.

I would have loved to have stood on Cornellskop and seen these aloes in spring, just as Pillans must have seen them at that Eureka moment which was to bring him immortality. 'Great heavens!' he must have cried out (or the Afrikaans equivalent). 'Is it possible? Am I going mad? Or am I the only man in the world who has noticed these flowers are hanging down and not pointing up?'

But it was in mid-winter when I stood on that stony hillside myself (called Cornellskop after Sam Cornell, a famous mining prospector) and photographed two of the finest specimens. Even when out of flower they didn't look much like kokerbooms. True, they had the same kind of spectacular flaking, yellow bark. But they had nothing of the jolly gnome about them. Their mood is more elegiac, more sombre. Sadly, the trees seem to have lost the means — or the will — to propagate themselves. How do we convey to them that, now we know their true identity, we shall do everything to save them? Despite valiant attempts by conservationists to protect the species, the species doesn't seem to be listening.

Perhaps the trees are doomed. It may be another example of the effects of global warming in a region where drought was always commonplace. At any rate, the few hundred trees on the stony hillsides here and across the Orange River seem to be gradually dying out.

Left and right: *Two of the surviving examples of* Aloe pillansii *at Cornellskop in the Richtersveld, Northern Cape. The species is apparently another victim of global warming*

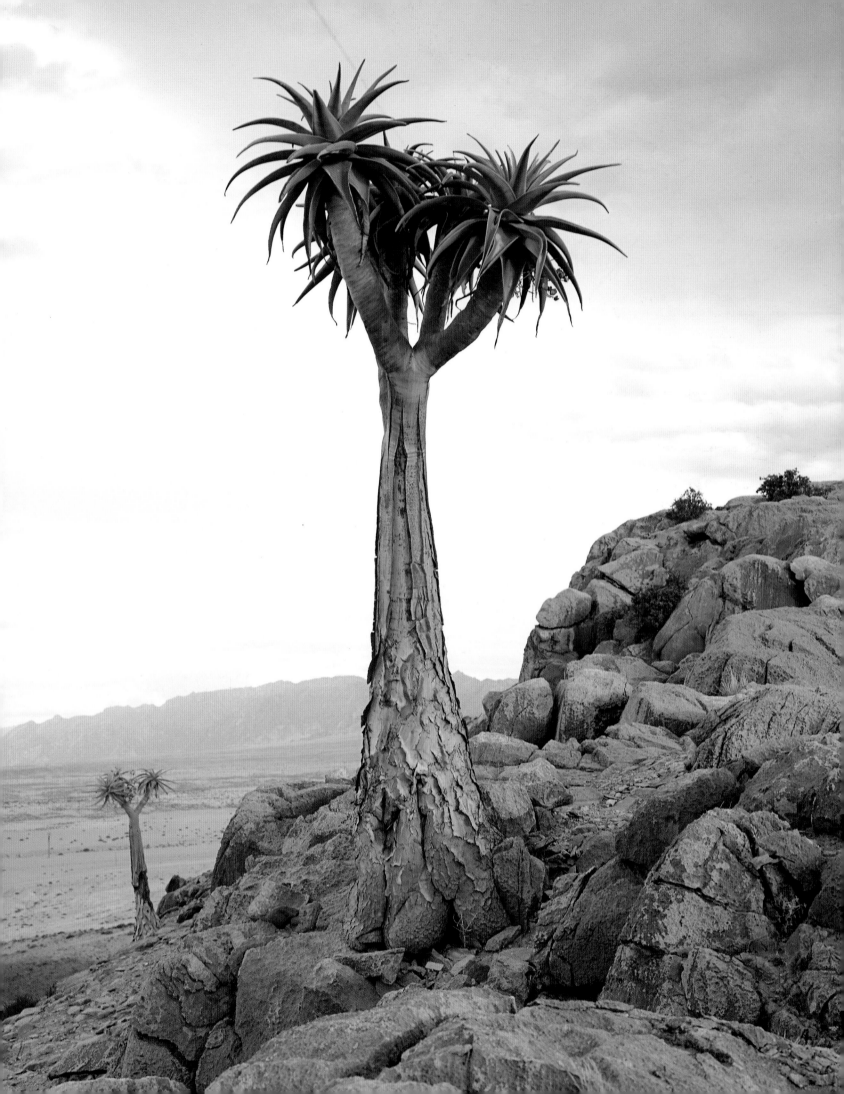

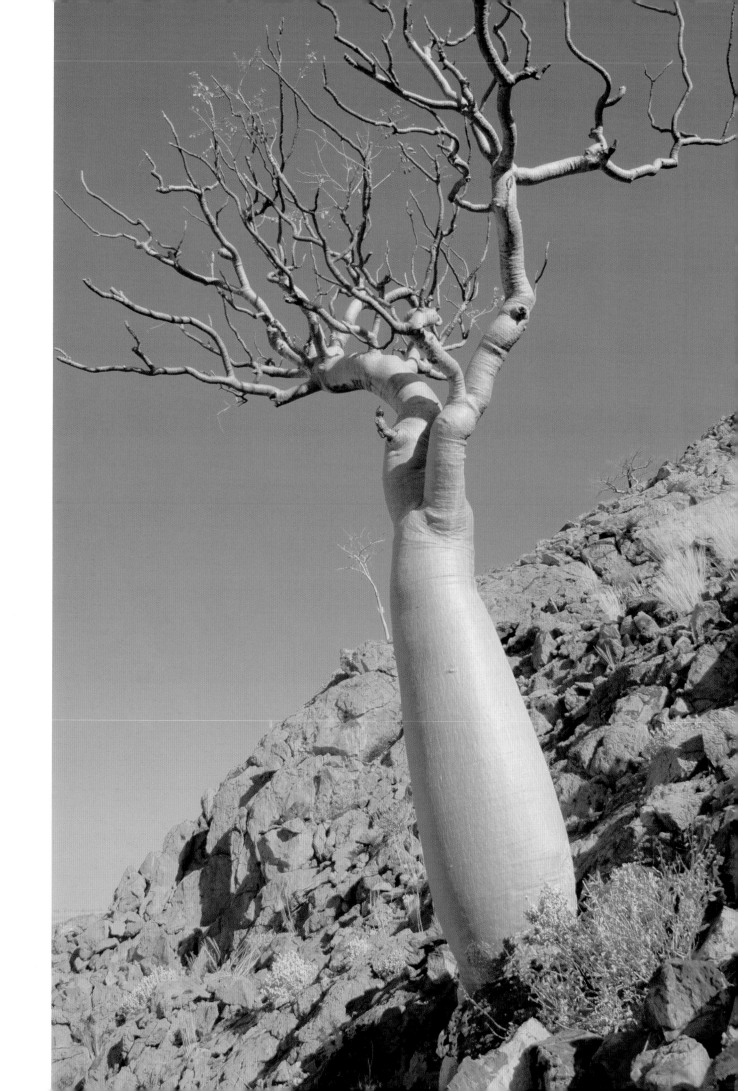

Halfmens who Face to the North

MADAGASCAR can boast no less than six species of large *Pachypodiums* or elephants feet — including the bizarre species, *Pachypodium decaryi,* which I had tracked down growing on the *tsingy*. Southern Africa is deprived by comparison. From coast to coast there are only two species which reach, if you

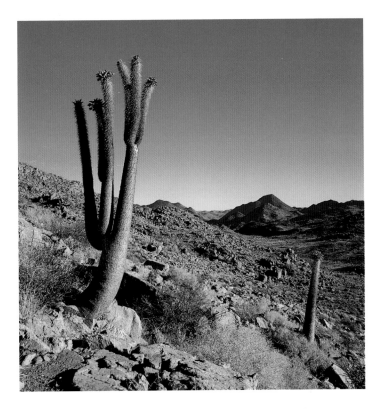

to northern Namibia and southern Angola. I have seen a spectacular photograph of one in the border area. You could call it a double bottle tree; its bloated twin trunks are almost identical. These trunks are designed to store water: broad at the base and tapering to a narrow neck. By contrast, the branches are designed to conserve it. So they are small and spindly, with spikes to keep off intruders. I longed to make a pilgrimage to this tree, but it was inaccessible. Then fortune smiled.

One day, late in the afternoon, I was driving along a dusty road in the middle of nowhere — I was more or less lost in central Namibia — when I saw what I took to be a bottle tree sprouting from the red rocks on the steep hillside above me. A bottle tree? No, this was impossible, if you believed what it said in the standard books on the subject. We were several hundred miles south of its southerly limit. However, miracles occur. Somehow I climbed that steep, slippery hillside (like an idiot I was wearing sandals) and captured the precious creature with my camera. As you see on the page opposite, it has smooth, shiny skin, a thin neck, spindly arms and a large bottom: not an Adonis but without a doubt a healthy, young bottle tree.

The other species is smaller, but stranger still. It's *Pachypodium namaquanum*, known as the half-mens tree. It straddles the wild, dessicated border-land at the north-west corner of Cape Province and Namibia (the same semi-desert that's home for the kokerbooms). Its odd name, halfmens, comes from the legend that the trees were once men who came from a country somewhere to the north and were changed into plants. Now they are doomed to stand

give them the benefit of the doubt, the size of a small tree. Both are succulents thriving somehow on the very edge of the desert, and both are rare and supposedly protected. But recently they have the caught the eye of keen gardeners. So they are dug up — quite illegally — in the wild, and given false papers like a stolen Mercedes. Then they turn up a few months later, as if raised in a nursery, the pride of some rich man's garden in Johannesburg. (Later they die, almost certainly, because they cannot cope with the cool nights of the highveld.)

The largest is called *Pachypodium lealii* and known as the bottleboom or bottle tree. Its endemic

Left: Bottle trees, Pachypodium lealii, *in north-west Namibia. Right: Halfmens in the eastern Richtersveld. But what had happened to the finest specimen?*

First Slash, then Burn

IN AFRICA there was a traditional way to manage the bush. It was called 'chitemene', meaning 'slash and burn'. The farmer cut down and burnt the trees, and their ashes enriched the soil. Then he planted his crops between the stumps of the trees. After a year or two, the land was exhausted and he moved on. The trees came back from the stumps. Then the cycle repeated itself. But when the loggers came and took the great evergreen forests in South Africa, and fires followed, the trees did not come back. This is the tragedy of the *Widdringtonia*.

Despite its absurdly pedestrian name, the *Widdringtonia* genus is one of the rarest and most distinguished genera in southern Africa. It's the only representative there of the tree family which dominates some of the world's finest evergreen forests — the cypress family. There are three species, none of them more than a dot on the atlas of the regional flora, and two of them hardly more than large bushes. But the third species, the Clanwilliam cedar (*Widdringtonia cedarbergensis*), is — or rather was — a giant of the forest. (Incidentally, the term 'cedar' is confusing. To a botanist, the real cedars come from the Atlas Mountains, Lebanon and the East; they are confined to the northern hemisphere and belong to the pine family.)

If you drive 150 miles northwards from Cape Town, you pass a series of romantic mountain ranges, but the largest and wildest is the Cedarberg, rising to more than 7,000 feet from the coastal plain around the small town of Clanwilliam. It is here, from the stony hillsides at 3,000 feet almost to the crags on the summit ridges, that the last poetic remants of the Clanwilliam cedar lie scattered.

When you reach the mountain range, you will find it split by a green valley into twin mountains, the Tafelberg and the Sneuberg. I drove there with a party of friends one summer day in January 2006, and we stayed at Algeria, the hutted camp down in the green valley. Next day, we took an official guide from the camp who promised to show us the finest specimens. But do any remain?

From the first years of European settlement, the trees were plundered for their timber. In 1830, a traveller reported: 'In former times the whole mountain chain, to which the Cedar Mountains belong, was studded with trees'. By 1883 the Conservator of Forests (an ironic term for the man who presided over their destruction) reported that all the accessible cedars worth anything had now been logged. Those that remained were crooked, blemished or too young for the saw mill. The largest survivor was 18 feet in girth but this was a 'dwarf compared with the big trees whose stumps

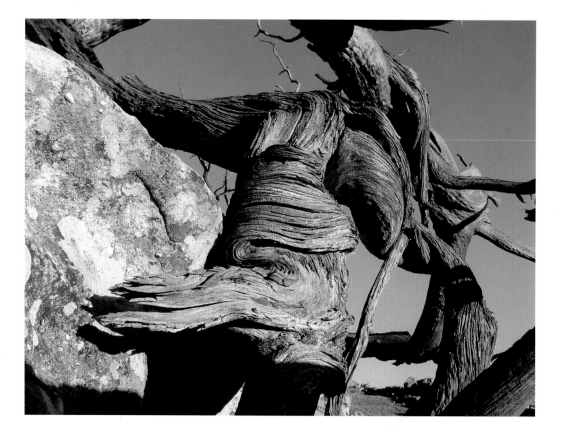

Below and right: Dead Clanwilliam cedars in the Cedarberg, Western Cape, victims of 200 years of logging as well as modern climate change.

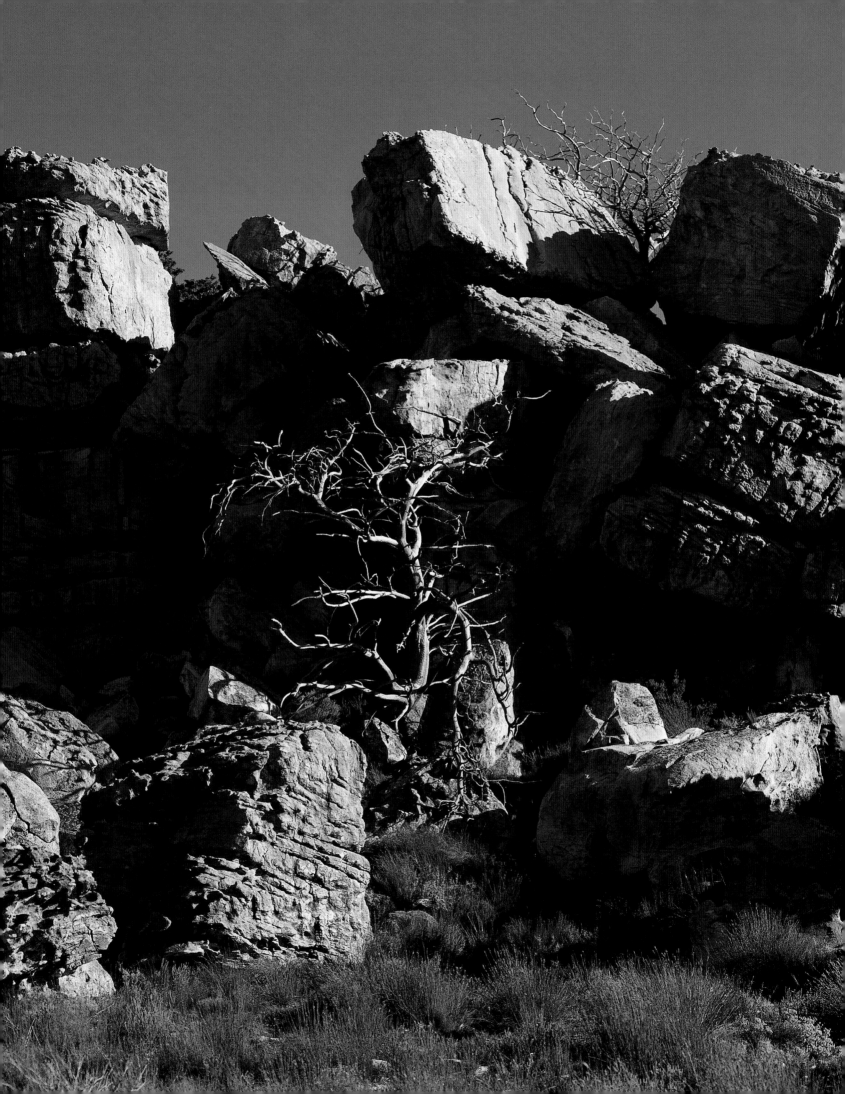

are still standing'. These 'past giants must have been nearly double the girth' of any survivors of the 1880s.

Like the yellowwoods in the maritime forests of the eastern Cape, the cedars had the misfortune to have fine wood — the finest, some would say, in South Africa. Cedar wood would make anything from furniture to fence posts. The timber was pale yellow, took a good polish and was almost impervious to rot. And it smelt delicious to everyone except a termite.

The setting for the trees is melodramatic. Their twisted brown arms and grey roots, contrasting with billows of bright green foliage, extend to the edge of the precipices. However, we spent two days scouring the mountains for fine specimens and we saw not a single large tree. We were assured that a few did exist, but it would be more than a day's hike to see one. The great majority we saw were of modest size — less than ten feet in girth.

And most were dead. A series of devastating fires has swept the mountains in recent years, killing most of the trees except those protected by rocks and boulders. The sight of their blackened corpses was devastating indeed. And the worst part of these fires is that they make natural regeneration impossible. First to die in the fire are the seedling trees and with them dies all hope for the future.

Am I being too pessimistic? I was told by the chief ranger that some trials have been made with *ex situ* conservation — gathering seed and propagating seedlings in nurseries. The trials have been successful and some good young trees have been planted where the seeds came from. But South Africa is a third world country and the budget for conservation is small. The overwhelming threat is global warming. With higher temperatures it's harder for trees to regenerate naturally; and the fire cycle, natural to the area, has now intensified. Veld fires are more frequent and more destructive. And there is no great incentive for the authorities to spend money putting out the fires, as no one lives at cedar level in the Cedarberg.

I walked back down the stony track in gathering darkness, then watched a full moon rise over the highest ridges of the Tafelberg, its shadows slicing the valley below into a series of mysterious triangles. These mountains will remain beautiful even if the worst happens and all the cedars die. But the magic will have left them.

A modest-sized cedar on the edge of the escarpment facing the Sneuberg range in the centre of the Cedarberg. The giants have long gone.

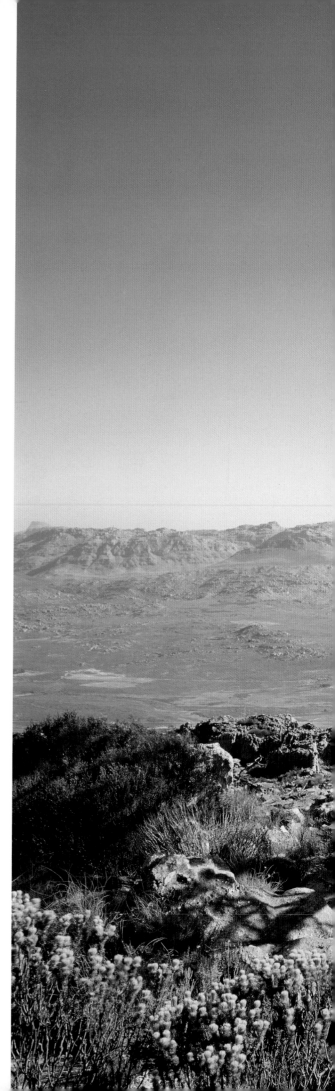

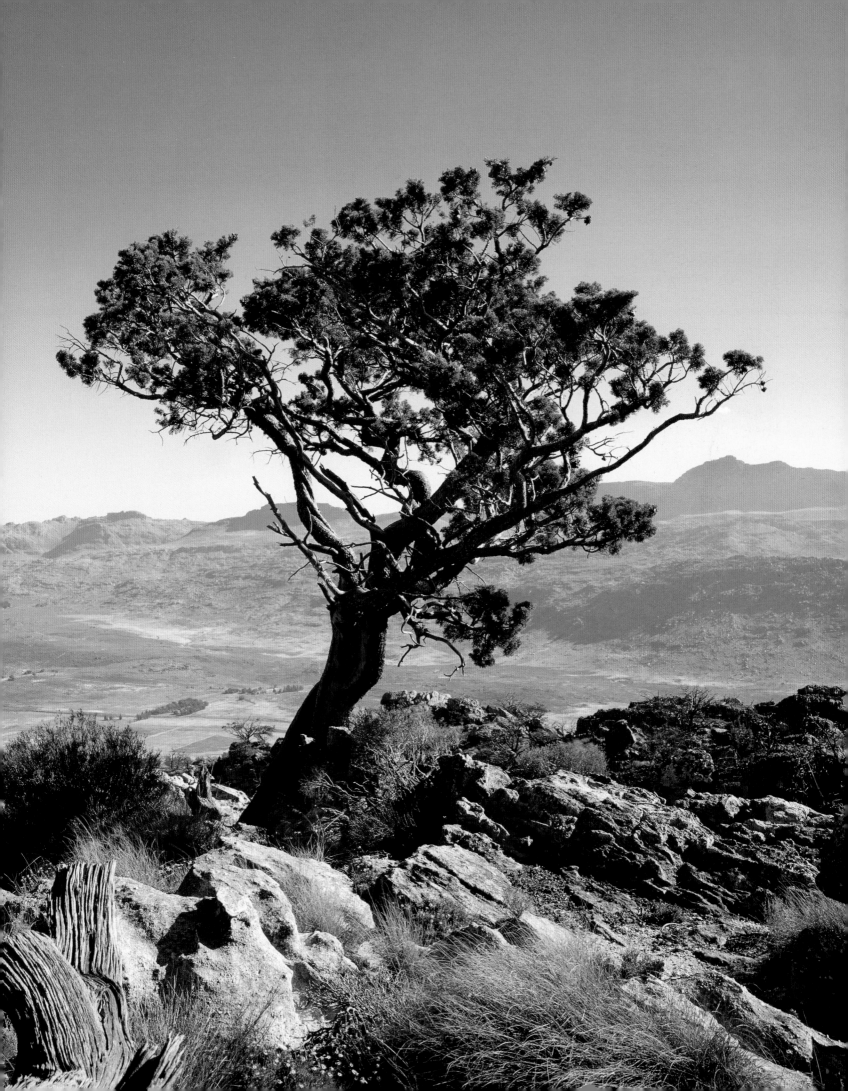

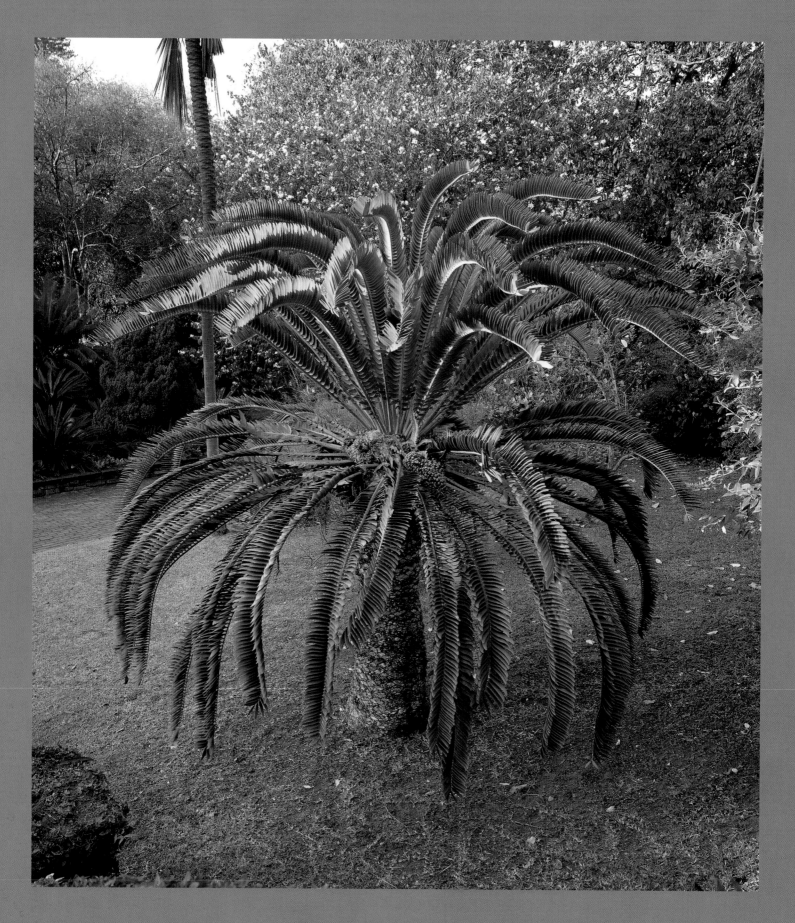

Cycads Up for Grabs

Million Dollar Tree?

DURBAN BOTANIC GARDEN, as we have seen, is not short of remarkable trees. But the rarest, and in financial terms the most valuable, is a species of cycad brought to the garden about a century ago from Zululand, and now extinct in the wild. It is called Wood's cycad (*Encephalartos woodii*) after the garden's grand old man: the nineteenth century curator and plant hunter, Medley Wood, who discovered it in the Ngoye Forest in 1895.

The tree originally had four trunks. Two were removed and planted in the garden in 1907 by Wood's deputy, John Wylie. From the beginning it was clear that this cycad was in a class of its own. There's an excellent photograph taken of the tree and its discoverer just before the First World War. The tree was exceptionally tall and palm-like. Its umbrella of long, drooping, dark-green leaves formed the perfect foil for the great white beard of Medley Wood.

Most cycads are dioecious, meaning they need two different plants, one male and one female, to produce fertile seed. The specimen discovered by Wood in the forest was a male. So who could find it a suitable mate? Time and again search parties have gone back to the Ngoye Forest hunting for the female of the species. Alas, all efforts have been in vain. Indeed the four-trunked specimen discovered by Wood has proved to be the last of its race, as no other males have ever been found. (Even the other two trunks are now missing from the forest, though one has turned up, it appears, at the National Botanical Research Institute in Pretoria.)

Of course cycads, like most plants, have one advantage compared to us. They have no need to bother about sex in order to reproduce themselves, as they can do it by cloning. And this where the collectors of cycads suddenly become interested. Most of them are American and money is not their problem. A cycad extinct in the wild? The clone might be worth a million dollars — or any sum you cared to name.

In 2005, I was taken by Chris Dalzell, curator of Durban Botanic Garden, on a visit to pay homage to Wood's cycad. Chris doesn't have a long white beard like Medley Wood. But in other ways he's like his great predecessor; I mean, he's not a man to be trifled with. He explained to me that this was an exciting time. Wood's cycad had produced three buds, which could be used to make three new clones, and they had been promised to Melbourne or some other botanic garden in Australia.

It was early on Monday morning, as we had come to catch the early morning light for my camera. 'Wow,' I said, peering up at the vast, dark-green umbrella above our heads. But Chris didn't say, wow. He said 'Oh my God, someone's stolen those three buds we had promised those guys in Australia. And they must have been worth…'

I didn't quite catch the end of that sentence. I *think* he said a million dollars, though it might have only been a million rand.

A second generation of Wood's cycad in Durban Botanic Garden, the rarest species of all the South African cycads. This one was cloned from one of the two original trunks brought to the garden from Zululand in 1907. The species is now extinct in the wild.

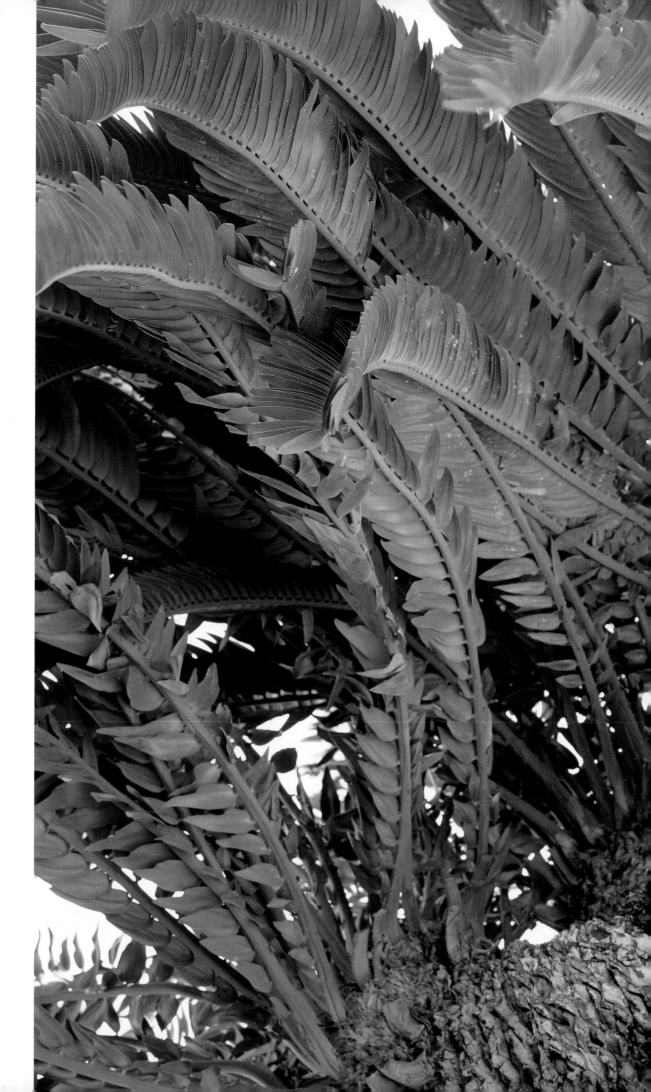

One of two original specimens of Wood's cycad in Durban Botanic Garden. The new buds are almost priceless.

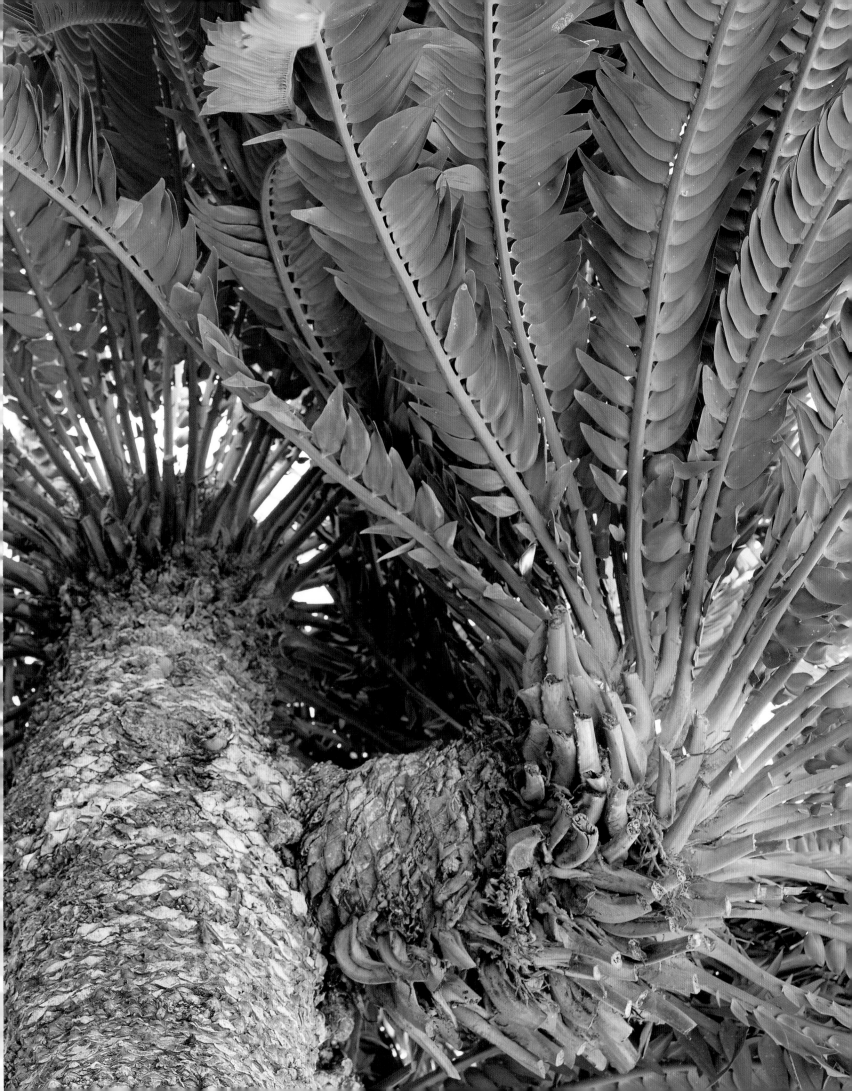

Don't Ever Say You've Seen Me

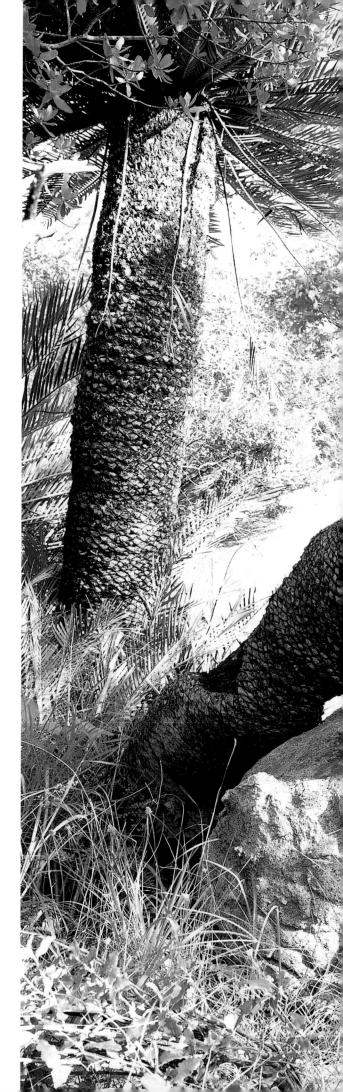

MY FINAL endangered cycad is the next rarest after Wood's. It was tracked down by a cycad expert called Dyer, who successfully claimed it was a new species; hence its botanical name, *Encephalartos dyerianus*. There's a popular name for it, but I shall not disclose it for reasons that will be clear in due course. This cycad has only survived on one known site: a grassy kopje near Mica in the north-east of Limpopo Province. But, unlike Wood's lonely male, the males of this species have plenty of female cycads to entertain them, and seedlings are not uncommon.

As you would guess, the cycad collectors are licking their lips at the thought of getting their hands on these seedlings — or indeed any larger plants from the kopje. So the kopje's location is a closely guarded secret. One of its official guardians — bodyguards, you could almost say — paid me and some friends the compliment of taking us there in January 2007. But first we had to sign a paper promising never to reveal where we had been. All I can say is that the kopje looked like any other kopje — apart from the cycads. Its first line of defence was the appalling track we followed in our four-wheel drive cars, its second the steep climb on foot up a path studded with thorns.

When we arrived panting on the flat summit, and I set up my camera on its tripod, the bodyguard explained anxiously that I mustn't photograph the view. 'You've no idea how clever these people are. They might be able to find the site just by looking at your photograph.' I was tempted to reply: 'Or by looking up the popular name for this cycad.' You see, the popular name, which I will of course not disclose, gives a fair clue to where the creature can be found. For once I kept my mouth shut and my camera lens shielded from the magnificent view.

Dyer's cycad is certainly a credit to its discoverer. The most striking specimens are like recumbent boa-constrictors waiting for their prey in the grass. But is the species now doomed to extinction — at least in the wild? Perhaps I'm being absurdly optimistic, but I think I know the way these cycads might yet be saved from the cycad-stealers.

The present threat stems from Dyer's successful claim to split off these cycads from a more common cycad and declare them the sole members of a new species. Of course this made the cycad collectors lick their lips. Dyer was what botanists call a 'splitter' who beat the 'lumpers'. But suppose in the next generation the tug-of-war goes the other way, as often happens. A lumper beats the splitters and strips Dyer's cycad of its right to be a separate species. Well, doesn't that save this cycad from the cycad collectors? I mean, who's going to pay somebody to steal a cycad from a remote kopje when that cycad is now only a common or garden one you could buy at any shopping centre?

Dyer's cycad in a secret
location near Mica,
Limpopo Province.

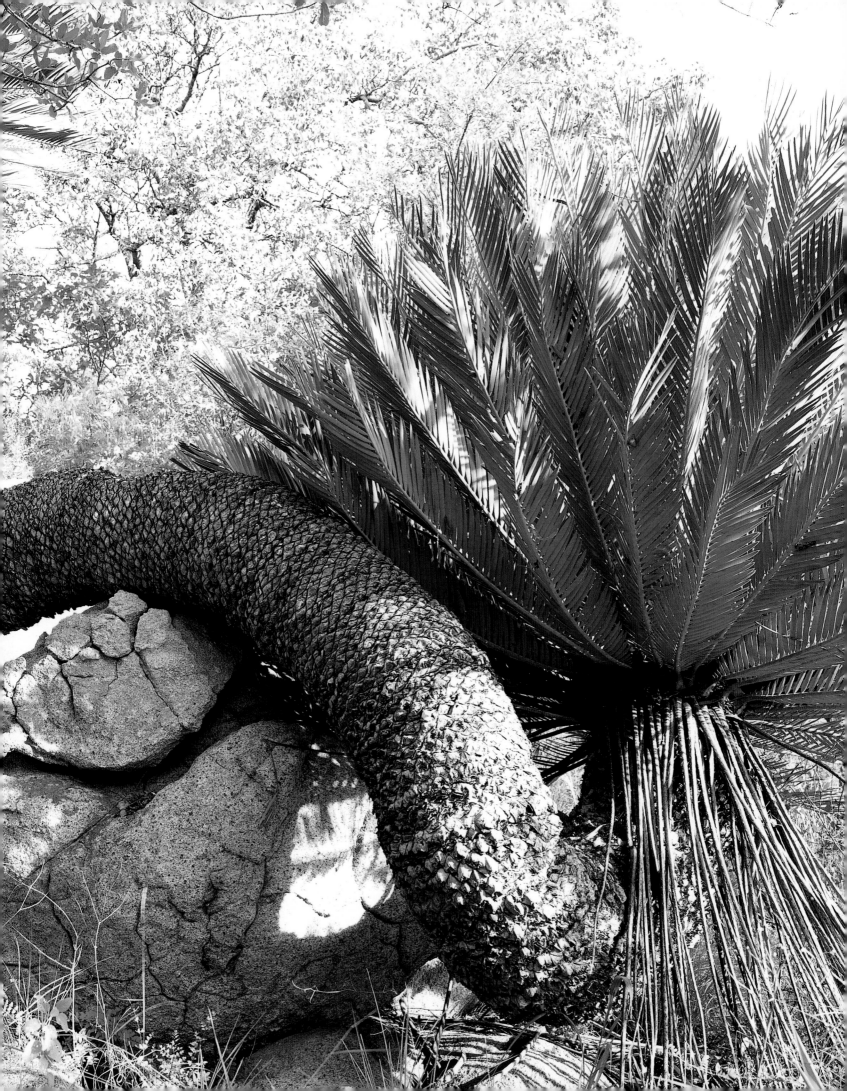

Time Lords

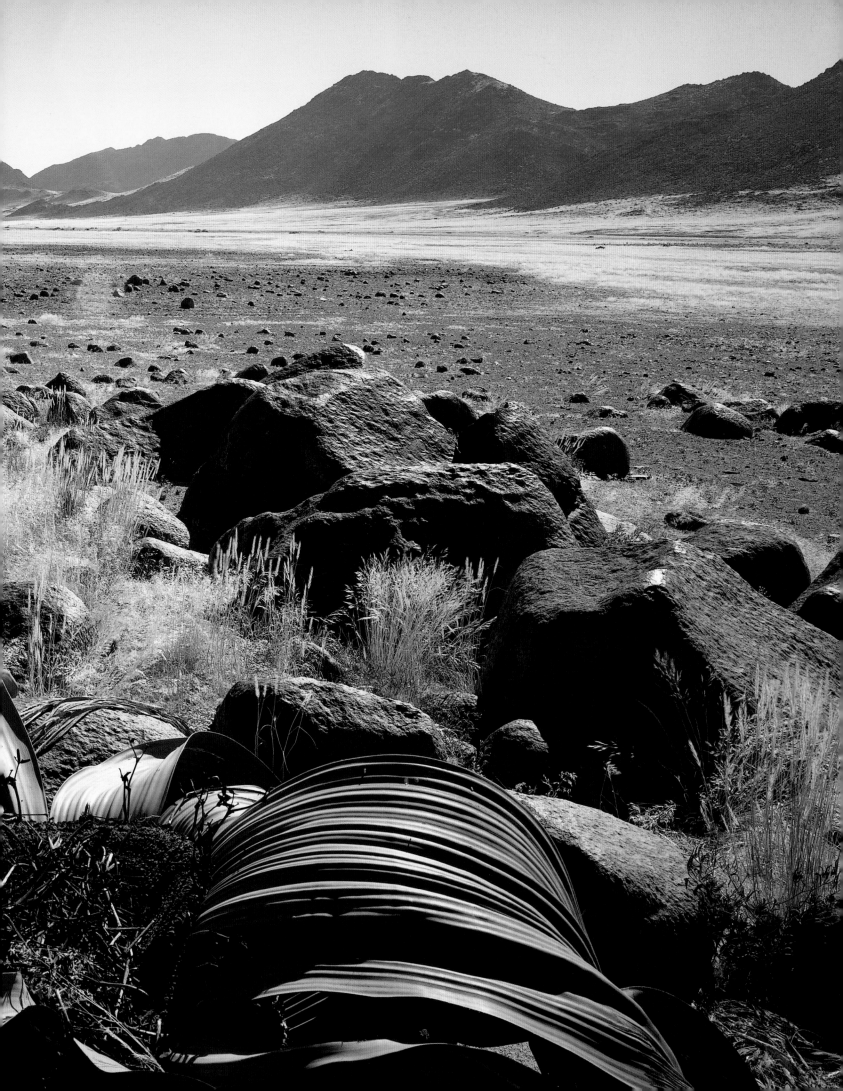

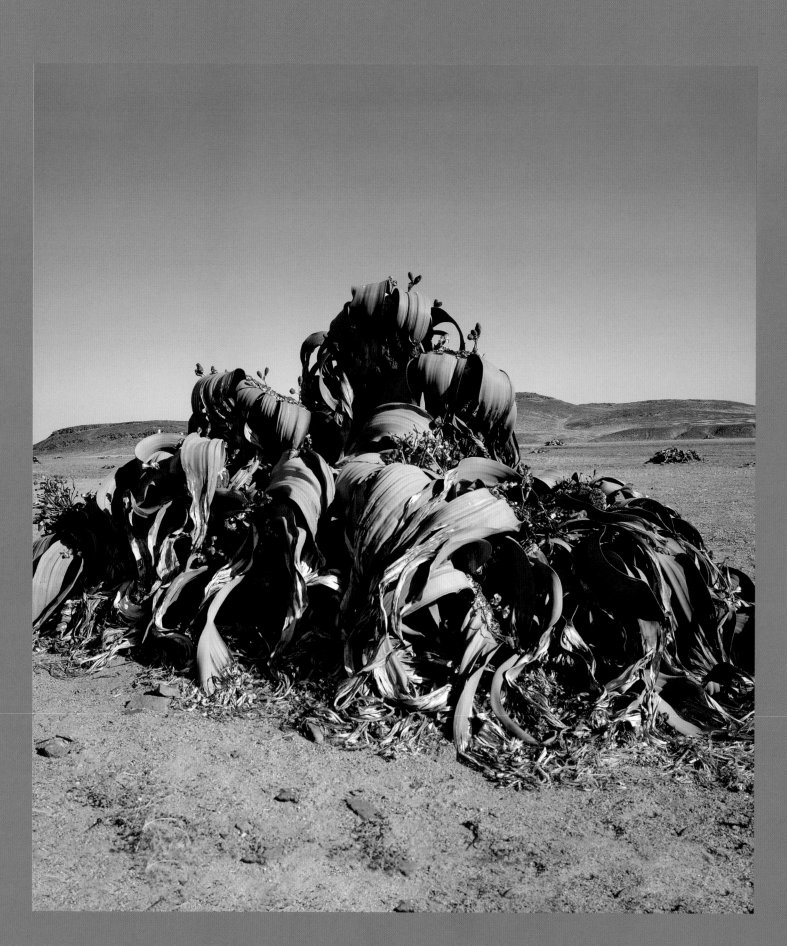

Mirabilis!

Would you Call me a Tree?

'A DISCOVERY', announced Dr. Joseph Hooker to a packed meeting of the Linnean Society in London on January 16, 1862, 'the most wonderful, in a botanical point of view, that has been brought to light during the present century'. It was generous praise indeed from a man who, with his eminent father, Sir William Hooker, had made so many astonishing botanical discoveries of his own. Hooker had just christened the amazing new plant *Welwitschia mirabilis*, after its discoverer, an obscure Austrian botanist, Dr Friedrich Welwitsch who had stumbled on it in southern Angola. Eighteen months earlier he had sent Hooker a description which must have made Hooker's mouth water. The new plant, according to Welwitsch, was not merely a new species, in a new genus, and from a new family all of its own. It looked like nothing on earth.

Hooker read an 80-page paper to the Linnean Society on the astounding newcomer. It was a woody plant with a trunk normally about two feet long. This trunk only rose a few inches above the surface. But sometimes it could be 14 feet in circumference and it was dark brown, hard and cracked over the whole surface (much like the burnt crust of a loaf of bread). There were 'two deep grooves' in this strange structure and out of them rose 'two enormous leaves' about 6 foot long, flat, leathery and 'split to the base into innumerable thongs'. Above the leaves, sprang a forked cyme (stalk) carrying cones like those of the common spruce, salmon-coloured in the male plants, blue-green in the female ones.

We now know that the plant straddles an area of desert and semi-desert stretching from near Walvis Bay in Namibia, 700 miles north to the sandy plateau at Cape Negro in Angola. Its dwarf-like form (to minimize heat loss) and strap-like leaves (to catch water) represent a unique adaptation to a climate well-likened to Dante's Inferno. In some years there is no rain at all but only a dense sea-fog flowing east from the icy Benguela current. The plant is so wizened by

drought that the smallest plant can be a century old.

I flew to Walvis Bay in Namibia in July 2006, and the fog hid the palm trees as we drove up the well-named Skeleton Coast.My guide, Nico, suggested we head north to an extinct volcano, the Messum Crater. We saw our first Welwitschia after three

hours of driving through a featureless desert. It was as extraordinary as Welwitsch had described, although I thought that what he called burnt loaves of bread were more like the twin soles of an elephant's foot. The setting in the crater of the volcano was extraordinary, too. We might have just landed on Mars.

Two days later we stumbled on what is, I believe, the largest known specimen of a Weltwitschia. It was between the Messum Crater and the coast, in a dried-up river valley. From a distance it looked like a heap of rubbish about 6 feet high and 20 feet around. Close up, one realized a vital fact. The plant did not have only *two* enormous leaves, as Welwitsch and modern botanical books emphasize. It was so large and old (perhaps a thousand years) that it had a dozen pairs of leaves, each pair rising from a separate pair of woody grooves. But were these grooves in the trunks — or in the branches? Indeed was the Welwitschia a tree? With the Welwitschia, language fails.

Previous pages: *Welwitschia inside the extinct volcano at Messum in north-west Namibia.*

Left: *For a Welwitschia, this specimen in the desert of north-west Namibia has made exceptional progress. It has grown nearly 6 feet in about 1,000 years.*
Inset right: *Trunk of a dead Welwitschia showing the series of deep grooves from which, over hundreds of years, the pairs of leaves have unrolled.*

Monkey Puzzles from Outer Space

IF 1,000 YEARS seems old for a tree — and some botanists reckon an old Welwitschia is even older than that — then take a trip to the forest north-east of the town of Khorixas in northern Namibia. It took us a day and a half's drive from Messum Crater. Gradually the winter landscape began to take on a faint flush of green. There were occasional trees, their roots dug deep into the clefts of the red rocks; green-leaved camelthorns and yellow paperbarks and several kinds of succulent, including the sinister *Euphorbia virosa* — 'giftboom' in Afrikaans, meaning the poison tree. (It makes straight for the tops of kopjes and is the most venomous of a venomous breed, the *Euphorbias*. Africans were supposed to find it perfect for their arrow tips.)

We came to the forest on the second morning. I say, 'forest', but there were hardly more than fifty tree trunks and they were all lying flat on the ground. One of them, which I photographed, was extremely long: 42 metres (136 feet) according to the guide. Most were in sections — good clean lengths originally— but now much broken and decayed. What was odd was that there were no roots or branches. But you could still count the annual growth rings and I counted up to sixty on one. Excellent growth! They must have been fast-growing conifers. But *were* they sixty years old? If I hadn't known the answer I might have been fooled. From a distance they looked as if they had been felled and then left by the loggers a good many years before. But go closer and kick them with your foot. They are made of stone. For this is the famous petrified forest.

I looked again at the sixty growth rings, incredulous. I suppose I thought trees from that era would be unrecognisable compared to trees from our own. A palaeobotanist, inured to wonders, sees things differently. The petrified trees were apparently an early form of *Araucaria*, belonging to the monkey puzzle family. Similar petrified forests are found in several other parts of the world including Arizona.

This was part of a forest that grew long before the jurassic era, before dinosaurs, before ginkgos, before even Gondwana — at a time when the whole world was united in one continent, Pangaia. But these trees didn't grow here in what is now Namibia. We would see their roots if they had. Where did they come from? Outer space? I should like to believe that. But the kill-joys say they were brought here in a flood, perhaps along a river which then abandoned them here. And they must have been very like the monkey puzzles of today, these fast-growing conifers that had rocketed up for sixty years and then rested for 250 million.

Right: *Section of one of the monkey puzzles in the petrified forest in northern Namibia. Rapid growth was followed by a long period of rest.*

Following pages: *The tallest monkey puzzle in the petrified forest—136 feet long— with a young Welwitschia in the foreground. But will we ever know where the trees came from?*

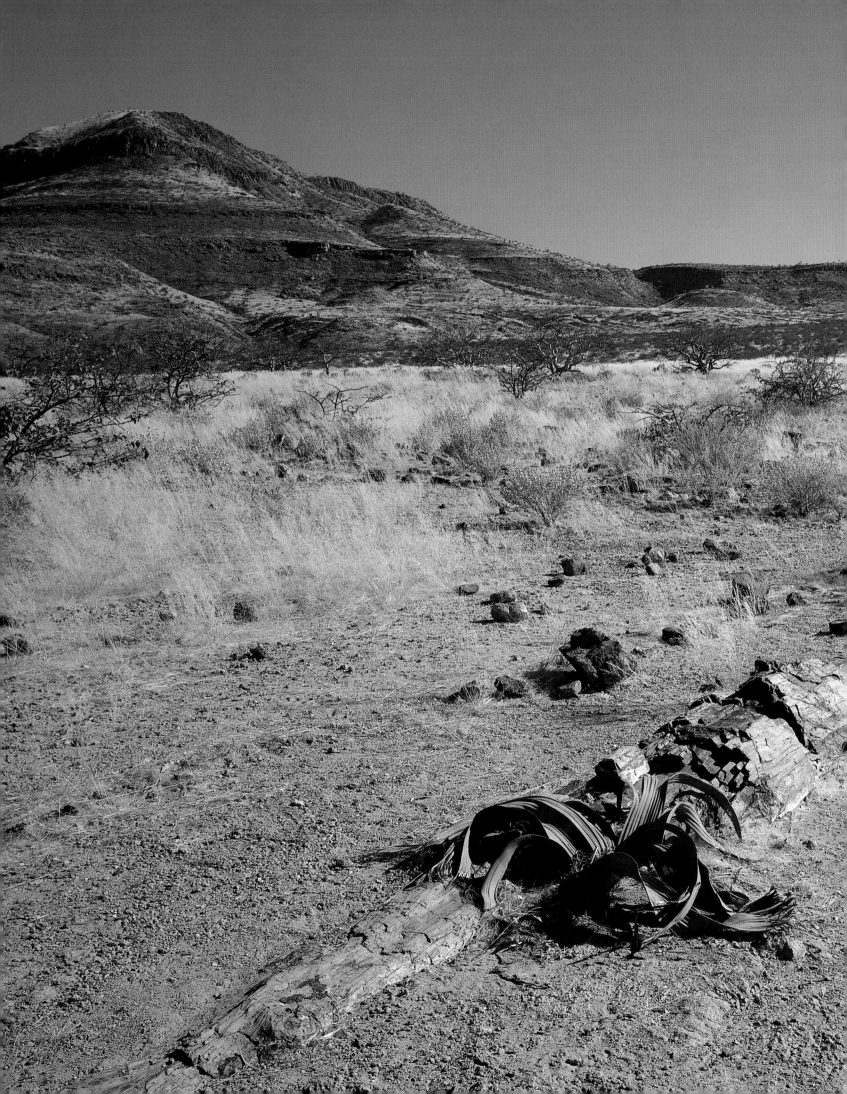

Index

Text and photographs copyright © 2007 by Thomas Pakenham

Photographs on pages 6 (top), 7, 8, and 9 copyright © 2007 by Prospero Bailey

Painting on page 18 © Royal Geographical Society

Design and layout © 2007 by Weidenfeld & Nicholson

Published by Walker Publishing Company, Inc., New York Distributed to the trade by Holtzbrinck Publishers

All papers used by Walker & Company are natural, recyclable products made from wood grown in well-managed forests. The manufacturing processes conform to the environmental regulations of the country of origin.

LIBRARY OF CONGRESS CATALOGING-IN-PUBLICATION DATA HAS BEEN APPLIED FOR.

ISBN-10: 0-8027-1692-X
ISBN-13: 978-0-8027-1692-7

EDITORIAL BY Julie Bennett and Robin Douglas-Withers
DESIGN DIRECTION BY David Rowley
DESIGN ASSISTANCE BY Justin Hunt
TYPOGRAPHY AND MAP BY Ken Wilson

Visit Walker & Company's Web site at www.walkerbooks.com

First U.S. edition 2007

10 9 8 7 6 5 4 3 2 1

PRINTED BY Printer Trento Srl
BOUND BY L.E.G.O. SpA, Italy.
COLOUR REPRODUCTION BY Altaimage UK.

CAPTIONS
page 1: A family of elephants drinking from the bore-hole at Megwe camp in the Charter reserve.
pages 2–3: Dawn at Baines' baobabs in the Ntetwe pan, Botswana.
pages 4–5: Sunset at the kokerboom forest near Keetmanshoop, Namibia.